The Nubians of West Aswan

Women and Change in the Developing World

Series Editor Mary H. Moran, Colgate University

Editorial Board

Iris Berger, SUNY-Albany
Lucy Creevey, University of Connecticut
Maria Patricia Fernandez-Kelley, The Johns Hopkins University
Nüket Kardam, Monterey Institute of International Studies
Louise Lamphere, University of New Mexico
Linda Lim, University of Michigan
Kathleen A. Staudt, University of Texas-El Paso
Kay B. Warren, Princeton University

The Nubians of West Aswan

Village Women in the Midst of Change

Anne M. Jennings

Photograph credits: Ahmed Abdel Razzik for the photograph on page 41; Anne M. Jennings for all others

Published in the United States of America in 1995 by Lynne Rienner Publishers, Inc. 1800 30th Street, Boulder, Colorado 80301

and in the United Kingdom by Lynne Rienner Publishers, Inc. 3 Henrietta Street, Covent Garden, London WC2E 8LU

© 1995 by Lynne Rienner Publishers, Inc. All rights reserved

Library of Congress Cataloging-in-Publication Data

Jennings, Anne M., 1944-

The Nubians of West Aswan: village women in the midst of change / Anne M. Jennings.

p. cm.—(Women and change in the developing world)

Includes bibliographical references and index. ISBN 1-55587-570-X (hc : alk. paper)

ISBN 1-55587-592-0 (pb : alk. paper)

1. Women, Nubian—Egypt—Aswan—Social conditions. 2. Women, Nubian—Egypt—Aswan—Economic conditions. 3. Muslim women—Egypt—Aswan—Social conditions. 4. Muslim women—Egypt—Aswan—Economic conditions. 5. Social structure—Egypt—Aswan. 6. Social change—Egypt—Aswan. 7. Aswan (Egypt)—Social conditions. 8. Aswan (Egypt)—Economic conditions. 1. Title. II. Series.

DT159.6.N83J45 1995
305.488965—dc20
95-18672

95-18672 CIP

British Cataloguing in Publication Data

A Cataloguing in Publication record for this book is available from the British Library.

Printed and bound in the United States of America

The paper used in this publication meets the requirements of the American National Standard for Permanence of Paper for Printed Library Materials Z39.48-1984.

5 4 3 2 1

To Hamdi, Ahlam, and Ahmed

In the hope that their grandchildren will find something of value here

Property and the second page 15 to 1

ar file begard a tree and his his en. Profit fired han the ga an hard he

Contents

	List of Illustrations	1X
	Acknowledgments	xi
	Introduction	1
1	The History of the Nubians	19
2	The People of West Aswan	29
3	Growing Up Female in West Aswan	47
4	Growing Up Male in West Aswan	75
5	Village Networks	95
5	Culture Change and the Village	133
	Glossary of Nubian and Arabic Words and	
	Anthropological Terms	151
	Bibliography	157
	Index	171
	About the Book	179

ana na ini

Illustrations

Figure	
2.1 Kinship Chart of Hajja Fahima and Her Descendants	46
Maps	
1.1 The Nile Valley	20
2.1 The Nile River and Lake Nasser	30
5.1 The Southernmost Square of Gubba	100
Photographs	
Thotographs	
Neja Gubba, West Aswan	31
Nubian House of the Older Style	34
The Home of One Who Made the Journey to Mecca	34
Mohammed, Ani, Hamdi, Saadiya, and Sommar	41
Ahlam, in Jarjar and Tarha	49
The 'Aruusa on Her Bridal Chair	62
Sabaha, a Well-Respected Woman	66
The 'Aruusa Wearing Traditional Gold Jewelry	71
Sihan, Abd El Shaeffi, Ahmed, Mohammed Orabi,	
Hassan, Hamdi, Izzu, and Mohammed	76
Preparing a Sheep for a Feast	79
Ahmed's Good Friend, Mohammed Orabi	82
Mohammed Hassan, a Well-Respected Man	87
Hamada, Hamdi, and Saad	93
Zuba	103
Askara	105
Women Serving Food at a Wedding	112

X Illustrations

Older Women Are Treated with Affection and Respect	120
At the Old Hajja's Funeral	123
Nubian Village House	142
Khaled, Young Entrepreneur	146

Acknowledgments

A book of this nature can never be the work of only one person. I would like to acknowledge the many people who were helpful to me during the years of research, study, fieldwork, and writing that culminated in the book you are holding in your hands. First and foremost, I wish to express my deep gratitude to the Nubian people of West Aswan, many of whom are mentioned by name in this ethnography, for the openhearted way they accepted me and taught me how to become a Nubian woman. Thanks also to Ridda, Nasra, and Ramadán Mohammed Fad el Mula, and their mother, Fatima Sadiq Bilal Gabir; Hesham; Mohammed Abid; the members of the Folkloric Dance Troupe of Aswan; and the residents of Menshiyya for their generosity, forbearance, and good humor. I wish to thank Mr. Abdin Sian, director of Antiquities in Aswan Province; Mr. Hassan, director of the Aswan Palace of Culture; and Il Rayyis Mahmoud Morsy for their invaluable help.

I worked and studied at several institutions over the years of research, each of which has contributed greatly to the development of this ethnography. I am grateful to the members of the faculties of the University of California at Riverside, California State University at Fullerton, and the Social Research Center of the American University of Cairo and to the employees of the Denver Museum of Natural History for their support. Eugene Anderson, David Kronenfeld, Fadwa el Guindi, and Cynthia Nelson encouraged me to believe that my research was important, and discussions with Roger Joseph, Marjorie Franken, Richard Lobban, and Carolyn Fluehr-Lobban allowed me to see new ways of looking at old problems. Sondra Hale, Robert and Elizabeth Fernea, and Hussein Fahim were inspirational. I take this opportunity to express my profound thanks to them all. Much appreciated financial support was provided at various stages by University of California Graduate Opportunity Fellowships and University of California President's Postdoctoral Fellowships.

For their suggestions and encouragement, I thank my many friends and colleagues, especially Corinne Wood, Constance Berkley, Bill and Nettie Adams, Richard Mack, Joe Craighead, and Memory Russell. Last but not least, I wish to acknowledge the support of my husband, Richard See, for his unstinting faith in my ability to do everything; of my sisters, Zhana and Dr. Laura, for being themselves; and of my parents, Arthur and Ernestine Jennings, without whom none of this would have been possible.

Introduction

Islamic societies have been represented by many social scientists as classically male-dominant—that is, societies in which men have appropriated all powers of economic, political, and social decision-making. This has occurred, they contend, within the context of the public/private dichotomy used by many anthropologists to characterize Muslim culture. According to this model, Muslim women pursue domestic matters that keep them in or near the home (the so-called private sphere), whereas Muslim men concern themselves with the political and economic life of the community (the so-called public sphere). Women's decisionmaking is, ideologically, as circumscribed as they themselves are and affects only the private sector of society. Men's decisions, on the other hand, because they affect the public sector, ramify throughout the entire society.

This model of asymmetrical access to economic, political, and social decisionmaking powers in Islamic society is based, I believe, upon incomplete ethnographic information. Because women are, in many places, physically constrained, it has been assumed that their ability to influence others is equally constrained. Because they may be legally and formally subordinate to males, the model presumes women's social, economic, and political disenfranchisement as well. While it is true that men are accorded formal positions of authority and status within Muslim societies, it is also true that women possess informal means by which they can effectively influence the behavior of others. It is only recently, however, that social scientists have begun to focus upon the realities of Muslim women's lives.

The popular press in the United States often presents a picture of the status of women in Muslim society very similar to the one presented by Cherry and Charles Lindholm in 1980:

Muslim society considers women naturally inferior in intelligence and ability—childlike, incapable of discernment, incompetent to testify in court, prey to whims and fancies. In tribal areas, women are prohibited from inheritance . . . and in marriage they are purchased from their fathers like a commodity. (Lindholm 1980: 46)

Such statements are generally a result of the fact that the ordinary U.S. citizen has had little exposure to information about Muslim societies, and what she or he has been exposed to is mainly ideology rather than reality. As a graduate student at the University of California, already very interested in gender studies, I read such statements in both the popular press and the anthropological literature, and began to wonder how it was that women could live under such adverse conditions. I looked in vain for any account of the benefits women must receive for helping to maintain a system that was apparently so detrimental to their well-being, and decided to do field research in an Islamic society in order to find out. My research among the people of Nubia was an attempt to see beyond the ideology of male dominance, and to discover what living as a Muslim woman really entails.

The task was daunting, as women in the Nubian community I studied are in fact formally subordinate to men. Women's subordination is mandated by Islam in certain of its legal and religious texts, and by a complex of traditional values that are regarded as Islamic by the villagers. This meant that I, as a female researcher who was not seeking to challenge Nubian views of Islam, had to accept the restrictions placed upon my behavior—restrictions that my informants believed were Islamic.

These restrictions are rooted in two traditional institutions. The first is the considerable paternalism toward women that can be found in the Islamic religion itself. Although the Prophet decreed that men and women are equal in faith, the more often quoted quranic passage appoints men as "guardians over women, because of that in respect of which Allah has made some of them excel others, and because the men spend of their wealth" (Surah 4, verse 35). Intrinsic to this sacred injunction is the obligation placed upon men to take care of women, and upon women to obey men. The need to protect women, some have argued, stems from their valuable and important positions as wives and mothers (various informants, personal communication); others state that women must be constrained because they are weak-minded and without moral sense (Maher 1978; Mohsen 1967). A third hypothesis, advanced by Mernissi (1987), states that the institutions that restrict women's behavior are strategies for containing the powerful sexuality of women, which if left

uncontrolled would deflect men from their higher goal: total involvement with God. Whatever the rationale, the injunction is met by placing women under male guardianship throughout their lives. In most Muslim societies, a woman remains a member of her father's lineage even after marriage, owing him ultimate obedience. This is why it is her kinsmen who take responsibility for her, regardless of her marital status. When her father dies, the duty of protecting and controlling her falls primarily to her brothers, although her husband is expected to share part of this obligation.

In addition to the paternalistic bias of religious doctrine, the concept of honor shapes male/female relationships, encouraging

male dominance in many Muslim societies. Male honor

is realized critically and importantly through the chaste and discreet sexual behavior of womenfolk in a particular man's life: premarital chastity of the daughter and sister, fidelity of the wife, and continence of the widowed and divorced daughter or sister. These are basic principles upon which a family's reputation and status in the community depend. (Youssef 1978: 77)

This combination of the need to protect and provide for female kin, as stipulated by the Quran, and the desire to preserve personal and family honor has led to the consolidation of control over women almost exclusively by male members of the kin group, and the perpetuation of the status of women as economic dependents (Youssef 1978). In addition, the Quran also maintains the subordinate legal status of women to men by sanctioning polygyny but not polyandry, by stipulating that females may inherit only half of what males may inherit, and by giving lesser weight to women's testimony in a court of law.

A woman's status as a jural minor and her economic dependency make it appear almost impossible, in many cases, for her to have any freedom of choice regarding basic life decisions. Her parents decide whether and for how long she may go to school, and they also arrange her first (and sometimes subsequent) marriage; ideologically, her husband can prevent her from going out of the house, from working for wages, and from keeping or spending what money she does earn. A woman can be threatened with repudiation or with her husband's marrying a second wife if she is disobedient or if she does not bear sons.

It cannot be denied that these are conditions that adversely affect women's lives, and can be formidable obstacles to overcome when used against them. But the "plight of the Muslim woman"

seems to be the only aspect of her life shown to us in the West, and because of this, we tend to think of her as hopelessly oppressed. Rarely do we learn of the Islamic laws that support women's rights: inheritance and property rights, a dowry system that represents a source of financial security for the woman, and custody of children for a certain amount of time upon divorce (Fluehr-Lobban 1993) all of which are reportedly improvements over pre-Islamic conditions for women in some societies. In reality, women manage household affairs, enjoy respect in everyday life, and have historically been public agitators for social change and national liberation movements (Ahmed 1992; Fluehr-Lobban 1987). Modern laws guarantee women the right to vote, equal rights to education, and equal pay for comparable work in several Islamic countries. My argument is that, contrary to the popular model of the oppressed Muslim woman, and in spite of the very real obstacles outlined above, Muslim women are not the passive tools of men, obediently enduring ignorance and confinement. Instead, they are themselves actors, concerned with influence, persuasion, and the negotiation of social order to their own advantage (Nelson 1974; Morsy 1978; Rosaldo 1980). Women throughout the Islamic world lead productive and rewarding lives; while most work very hard, they appear to be no more oppressed than are women in non-Muslim societies. Their subordination to the dictates of a patriarchal system just takes a different form.

The image of women in Islamic society is a subject that has captured the imagination of Western travelers for centuries (Burton 1855, 1964; Doughty 1953), but few anthropologists have concerned themselves with the empirical reality of women's status until recently. The most commonly accepted anthropological model of Islamic society is that it is one of sharply divided sexual domains: the private or domestic sphere, and the public or extradomestic sphere (Bourdieu 1973; Cunnison 1966; Geertz 1979; Rosen 1978; Saunders 1980; Tapper 1978). The private sphere is considered the woman's domain and encompasses the house and garden. It is associated with intimate human relationships, the love of close kin, and domestic pursuits. The public sphere is associated with all that happens outside of the home, in the marketplace and the mosque. It is the area of business and political activity, social relationships with nonkin, and is the male domain (Deaver 1980; Makhlouf 1979; Nelson 1974).

Because of the dichotomy between male and female spheres, male anthropologists have found it difficult to collect firsthand data concerning the life of the Muslim woman, and have been dependent upon information given them by the males of that society. Thus, most descriptions of the status of Muslim women by male investigators have been presented in terms of idealized behavior norms (Zeid 1966; Bourdieu 1966; Rosenfeld 1960). Men have been described as active agents of the political life of the community, making the major decisions that affect the whole society, whereas women have been depicted as passive: While women have been accorded respect within their own domain, this very restriction to the women's sphere was said to prevent them from affecting the wider community (Douglas 1970; Fox 1969; Maher 1974; Vinogradov 1974).

Although most Islamic societies are characterized by separate gender domains, this model has been shown in recent years to be oversimplified. In addition, it has led to unfortunate characterizations of the male and female domains in value-laden terms. Several investigators described the public sphere, prohibited to women, as broad and expansive, while the private sphere, which is closed to men, was described as narrow and restrictive (Nelson 1974). Domestic duties were considered to be of less importance than public duties; female activities and pursuits, and even females themselves, were said to be devalued in Islamic society (Asad 1970; Antoun 1968; Dwyer 1978; Mohsen 1967).

Others, concerned with the subject of the status of women in cross-cultural context, have referred to these characterizations in their models. Michelle Rosaldo (1974) and Sherry Ortner (1974), building, in part, upon the literature about Muslim societies, maintained that women were devalued because of the universal division of societies into public and private realms. These realms are themselves hierarchically placed: "The family (and hence women) represents lower-level, socially fragmenting, particularistic sorts of concerns, as opposed to interfamilial relations representing higher-level, integrative, universalistic sorts of concerns" (Ortner 1974: 79), resulting ultimately in lowered social status for women. Peggy Sanday (1974) and Karen Sacks (1974) argued that women can achieve full social equality only when they can participate in labor in the public domain, an analysis that implies that the status of Muslim women is low because of the dichotomy that prevents them from acting in the more highly valued arena.

Such models have been challenged by female scholars who have actually done fieldwork in Muslim societies. These investigators contend that popular characterizations of Muslim women contain inaccuracies about such subjects as veiling, polygyny, and women's work inside and outside of the home. In addition, there has been a great

deal of discussion in the literature concerning the appropriateness and accuracy of the use of the terms "public" and "private" as descriptions or characterizations of gender domains (Ahmed 1992; Altorki 1977; Davis 1983; Joseph 1978; Makhlouf 1979; Mukhopadhyay and Higgens 1988; Wright 1981).

Field-workers who have lived in Islamic countries emphasize that there is no "typical" Muslim society in which it is possible to observe "the" status of women. Anthropologists who have been able to penetrate the veneer of ideology report a wide variety of gender role behaviors in the Islamic world. The customs of seclusion and veiling, which were practiced in the Middle East and parts of Europe before the advent of Islam, are examples of this. The seclusion of women, although an ideal in the Muslim world, is chiefly dependent upon social class and wealth; even within the same society, class and geographical distinctions can be observed. In Morocco, for example, total seclusion is practiced mainly by wealthy townspeople (Maher 1974). The man who wants to keep his wife totally secluded must hire someone else to do the shopping and other outside activities that he has no time to do himself. Villagers are generally too poor to do this and need the help of their wives in the fields, anyway. Nomadic women in Morocco, on the other hand, like their counterparts in other areas of the Muslim world, are neither secluded nor veiled; and while the townswoman who must venture out-of-doors loses some status because of this, most female nomads do not (Beck 1978; Cole 1975; Cunnison 1966; Mohsen 1967). The veil is used to provide a sense of seclusion when a woman must leave her home for some reason. The nomad camp, filled only with family members, is, ideologically, considered still "home" for the woman. The men she encounters there are all relatives, thus she need not veil herself from them. The same sense of being among family can also be found in many small villages, so a village woman need not always veil herself there, either. The towns and cities, on the other hand, are filled with strangers, against whom a woman should take appropriate precautions.

The contemporary veiling of young, mostly lower-middle-class women, however, is a more recent phenomenon with more complex behavioral meanings and several explanations. Recent studies have indicated that it can be explained as an expression of anti-Western sentiment, as a revival of cultural-religious heritage and genuine religious feeling, as a political symbol of Islamic activism, or as a means of protection in the urban jungle (El Guindi 1981; Fluehr-Lobban

1993; Hatem 1987; Macleod 1991; Mernissi 1987; Rugh 1984; Zuhur 1992).

In the instances where women are partially or totally secluded, it has appeared, to the outsider, as if they were restricted to a lifetime of isolation and ignorance. The popularly accepted model of the private sphere is that it is narrow—that women focus upon only the wants and needs of their own households, whereas the wider public sphere is the domain that deals with the whole community. Are secluded women as constrained as they appear to be? For some women, the answer is yes (Maher 1974; Smith 1954), but for most, seclusion does not prevent them from building a wide range of contacts, making informed decisions, and influencing the male domain in important ways. Female ethnographers who have lived among women in Islamic societies report that women have access to at least the households of their entire kin group and, in many places, to those of the whole community. Having access to a household leads ultimately to contact with all members of that household, including males. Women's visiting patterns take them to one another's homes (Altorki 1986; Aswad 1974; Larson 1983; Makhlouf 1979; Sweet 1974; Tapper 1978) and/or to public baths (Davis 1983), where information is exchanged on a daily basis.

The manipulation of information is a very important source of power for both men and women in many Muslim societies (Davis 1983; Nelson 1974). Males and females have access to different areas of information (Roger Joseph [1975] suggests that "Berber communication can be viewed as a media system in which there is one public TV station accessible to all, and many private circuit stations available only to subscribers. Both men, and women, through their men, have access to the public station, but only women have access to the private channels"); and each sex attempts to control the behavior of others, both female and male, through the judicious use of what they know (Davis 1983). Women exercise this skill in areas such as marriage alliances (Aswad 1974; Joseph 1974; Makhlouf 1979; Peters 1965), economic exchange (Lienhardt 1972; Maher 1974), patron/ client relationships (Maher 1974; Smith 1954), poetry and song (Joseph 1980), and social control (Ammar 1954; Cunnison 1966; Farrag 1971; Tapper 1978; Schneider 1971). This is all evidence that women do extend their influence into the public arena, although their decisions are made in the female domain.

The extent to which men are able to influence happenings in the women's sphere seems, on the other hand, to be more limited than

the accepted model suggests. The model, based upon what informants say is the societal ideal, shows men exercising absolute authority over women and bearing ultimate responsibility for their behavior. But ethnographic information, mainly from Morocco, points up differences between this ideal and what people actually do. Sexual segregation in Moroccan society encourages men to leave the day-to-day running of the household to women, resulting in the loss of male control over certain aspects of female behavior. Male household authority

is frequently undercut by other social rules which give women control over daily household interactions and limit the involvement of men in family affairs. Defined ideologically as authority figures in the household, men frequently remain aloof from intimate interactions. . . . Women . . . through the affectional bond exert control over many family interactions. (Auerbach 1980: 17)

Although men do have imposing sanctions that they can use in order to influence actions in the female sphere, women are adept at using informal ones that are often quite effective in helping them to maintain control over their domain (Crapanzano 1972; Davis 1983; Farrag 1971; Joseph 1976). Among the Bedouin 'Awlad 'Ali of Egypt's Western Desert, for example, men converse freely with one another while women are present, yet women do not exchange information in the presence of men (Abu-Lughod 1986). Men's actions may be further limited by rules of avoidance (Geertz 1979), by a lack of information about events in the women's sphere (Joseph 1975), or even by an almost incomprehensible dialect that women speak only among themselves (Makhlouf 1979).

A household head is, ideologically, responsible for all major decisions, reached after discussion with other men of like position, on the basis of information obtained in the male domain. Informants may state that males have access to much more information than do females, since women are bound to the home, and so are much better equipped to make decisions about such issues as the arrangement of marriages, large-scale expenditures of capital, travel plans, and so forth. Investigators have reported, however, that men rarely make major decisions without first consulting their wives, although they may not admit to it publicly (Rogers 1975; Sweet 1974), an indication that, despite the societal ideal, men realize that information received in the marketplace and the mosque may be only part of the total picture. Women are privy to certain kinds of information that men find difficult to elicit from other men, since men are prevented, ideolog-

ically, from discussing private household matters in the public arena (Bourdieu 1973). Although Roger Joseph (1975) speaks of one occasion in which an informant bares his private life to the anthropologist, I know of nothing else in the literature that tells us what men talk about privately to one another.

We are told, however, that women can and do discuss private affairs with one another, and it is through them that men learn what they cannot learn from other men (Altorki 1977; Nelson 1974; Geertz 1979). Information that women collect from their own sources is shared judiciously with men in the privacy of the home, enabling the latter to appear astute and knowledgeable publicly.

Another inaccuracy is the assumption that the women's domain is a devalued one in Muslim societies. This assumption has been attacked on two levels. First, investigators have pointed out the importance of ascertaining the source of statements concerning valuation: Is it the males of the society in question, both males and females, or the anthropologist? Edwin Ardener (1972) argues that a society's ideological system is not always generated by the whole society, that indeed men and women may have very different models of their own society and/or universe. The anthropologist who has access to only one of these models may, because of the nature of the discipline itself (e.g., "because anthropologists are either men, or women trained to think like men, anthropology orders the universe in a male fashion" [Rogers 1978: 130]), assume that it is the only one. Ethnographic studies have recorded the existence of separate beliefs concerning the value of males and females within the same society, as well as evidence that women, while aware of male beliefs, do not always feel the need to concur with them (Kaberry 1952; Leith-Ross 1965; Paulme 1963; Rosen 1978; Wolf 1972). Negative statements about women by Muslim male informants have many times been generalized to the entire society, on the assumption that the male view is the only view, or even the most important view. Ethnocentrically, the anthropologist (and Western readers of popular literature) assumes that since this has been the case in the West, it is so everywhere.

Susan Rogers speaks to this same problem when she suggests that the nature of our own society leads us to believe that segregation is always synonymous with devaluation:

Marked social and economic segregation is conducive to the development of separate ideological systems and of two contrasting valuations of the importance and attractiveness of each sex group and its activities. In this case, the barring of one sex group from the domain of the other does not necessarily have negative implications for the excluded group. Furthermore, it may not be legitimate to consider one group as more excluded than the other, if neither has access to the other's domains... Because these factors are so clearly present in our own society, the tendency is to facilely associate all segregation with discrimination. (1978: 145)

Information from Muslim societies indicates that the women have high self-esteem and do not consider their sphere to be any less important than the male domain (Auerbach 1980; Cunnison 1966; Deaver 1980; Makhlouf 1979; Rosen 1978; Saunders 1980; Sweet 1974). In many places, a woman can establish a position and achieve status in the world of women through her own efforts: as a midwife, as a cook for ceremonial occasions, through her knowledge of religious matters and/or magic, as the center of important information networks such as bath attendant or seamstress, through her verbal skills, and in some cases, through shrewd management of her husband's resources (Aswad 1967; Davis 1983; Farrag 1971; Joseph 1976; Mernissi 1987; Tapper 1978; Lienhardt 1972). While it has been assumed that women feel excluded from the male domain in Muslim societies, some anthropologists argue that it is men who often feel excluded from the world of women (R. Joseph, personal communication; Geertz 1979; Nelson 1974; Makhlouf 1979).

The assertion that the female domain and its inhabitants are devalued has been challenged on another level by investigators of peasant societies, who maintain that such societies are "domestic-centered." That is, the family unit in a village is the economic, political, and social core of the community, the place in which all major decisions are made (Arensberg and Kimball 1968; Dubisch 1971; Friedl 1967; Redfield 1967; Rogers 1975). As such, it is highly valued, not only in peasant societies, but also in Islamic groups that are not comprised of peasants (Asad 1970; Barth 1961; Cole 1975). Consequently, these investigators argue, those who are concerned about learning to what extent women influence their societies should focus upon male/female interactions in the women's domain, not the men's. Additionally, it is argued that modern peasants feel that they have very little power vis-à-vis the larger society; males especially feel powerless in the "outside world" (Dubisch 1971; Banfield 1958; Foster 1965; Riegelhaupt 1967). This awareness is coupled with the knowledge that male actions in the public arena of village life very often result in the accretion of prestige, which does not always translate into power in the domestic sphere (Friedl 1967). Some maintain that these factors make the female domain even more important than the male sphere.

While the most widely accepted model of Muslim society has depicted the public and private spheres as polarities, and the theorists discussed above, influenced by this model, have argued for the primacy of one sphere over the other, I believe that it would be more constructive to investigate the ways in which the spheres are complementary rather than hierarchic. Data collected in the field has shown that native informants often see the division of their societies in just this way (Antoun 1968; Auerbach 1980; Barth 1961; Cole 1975; Deaver 1980; Friedl 1967; Paulme 1963; Sweet 1974, Wright 1981). Anthropologists tell us that female and male social networks give their members access to different kinds of information-mutually interdependent and complementary—that traditionally led to differential control over separate aspects of village life. Divergent communication networks, like sexually segregated spheres, provide females and males with alternate sources of self-esteem, power, and control over alternate resources. The question remains, therefore, as to why the popular conception of Muslim society constructs the male and female spheres as hierarchically placed opposites.

I believe that the answer to this question lies partially in the history of the subject matter, briefly recounted above: The dichotomized nature of Muslim societies themselves resulted in male ethnographers talking with only male informants, and the androcentrism of both led to characterizations of the male sphere as broader, more important, and more highly valued than the female domain. When other ethnographers, mostly female, discovered, through investigations of the women's sphere, lacunae between what had been presented in the literature as fact and what was actually happening, they argued their case for the female domain with equal fervor. It may be in the nature of Western thought processes that we, when presented with two oppositions, tend to rank them hierarchically rather than considering them dialectically. It seems certain that we tend to rank male interests and pursuits higher than female ones, and we assume that people in all other societies do as well. Consequently, academic debate, coupled with our own ethnocentric tendencies, resulted in our acceptance of a hierarchic model as a true reflection of Muslim society.

In addition, the United States has been, since the late 1980s, in a political struggle with certain Middle Eastern countries and ideologies, and this struggle is reflected in the negative image of Arabs in the mass media. This popular negative image is one that goes back, in Western culture, to the era of the Crusades, when Arabs were depicted as the opposite of everything European: Their portrayal as

cruel, duplicitous voluptuaries was exemplified by their apparent debasement of women. Although today our condemnation of Islamic culture is not as blatant as that of twelfth-century Europe, Western society still reduces the complexity of the Middle East, creating stereotypes by which it attempts to control what it considers threatening (Ahmed 1992; Mernissi 1987; Said 1978). Even anthropologists, constantly exposed to the attitudes expressed in the ubiquitous popular literature, are in some way affected by them. So if we are constantly reading that Muslim women are much more oppressed than are Western women, we will at some level expect that to be the case. Popular stereotypes of Muslim society, combined with ethnocentric assumptions and androcentric bias (Ahmed 1992; Morsy 1978; Steady 1993), have resulted in a situation in which much of the anthropological literature seems to have been ignored in favor of a model of Islamic society that, although simplistic, somehow "feels" more correct than ethnographic data.

▲ Fieldwork in Nubia

I chose to do my fieldwork among the Nubians for several reasons. The first is that the Nubians are an African people. My interest in the peoples and cultures of Africa, and their history, spans more than two decades. As an African American, I feel more than just an intellectual curiosity about these topics. The civil rights and pan-African movements in the United States and my previous trips to Africa led me to think of Africans as various types of kinsfolk, not as exotic subjects of scientific study; and because of this attitude, I expected my field experience to be different from that of most Euro-American anthropologists. My training in anthropology, however, included the belief in the tenet that field-workers could be more "objective"—that is, better able to maintain the distance necessary to participant observation-when studying a society not their own. And while the indigenous field-worker undoubtedly has certain advantages (Altorki and El Solh 1988; Fahim 1982), these might be outweighed by a tendency to take for granted or overlook cultural patterns that the nonindigenous researcher, as an outsider, would see. As an African-American anthropologist in Africa, I knew that my path would be somewhere between the two: not an indigenous field-worker, but not quite an outsider. Although I wanted to maintain objectivity in participant observation, I could never buy into the discipline's "Westernus/exotic-other" dichotomy, and I wanted to do my research in Africa in order to move beyond the barrier that nonindigenous anthropologists face, partially self-erected as a result of anthropological training, and partially extant because they are outsiders.

While I did not view Africans as "other," I received various messages as I prepared for my fieldwork that Africans would see me that way. One of my professors told me that Africans would classify me as "white." despite my skin color, because I came from the United States. From time to time, articles would appear in local newspapers to the effect that most Africans despised African Americans, for a variety of reasons. In spite of these messages, I maintained my belief that I would be more readily accepted by my future informants because I looked like them and because they would feel a kinship with me. This expectation may not have been realistic for all areas of Africa, but it certainly was true for Nubia. The Nubians whom I met while living in the village, as well as the Sudanese in Aswan, were all very interested in me as a representative of Blacks in the United States. They wanted to know how we lived in the United States, how large a population we were, and whether we were still segregated. To this last question, I told the truth as I knew it. Although segregation is no longer legal, de facto segregation still exists, especially in housing and in the schools. To other questions concerning African-American daily life, I answered as truthfully as I could, reasoning that if they should ever take a trip to the United States, it would be better for them to be prepared for an occasional negative experience than to be caught off guard by it.

The Nubian villagers, because of their history, tend to be rather secretive about their behavior. However, they felt more inclined to trust me, they said, because we were of common ancestry. A song that was enjoying popularity while I was in Egypt in 1981, sung by a musician of Sudanese descent who was living in Cairo at the time, was entitled "We Are All Sudanese." While this song may have originally referred to the civil war that has been plaguing Sudan for so long, my informants and friends in Nubia perceived in it a more global interpretation. They told me that they felt that the people of African descent in North, Central, and South America, as well as in the Caribbean, are all related to one another and to them. I believe that this awareness that most of our ancestors came from the same continent (the Nubians are of mixed descent, as are most African Americans) was instrumental in allowing me access to the village and people of West Aswan. The villagers accepted me openheartedly, calling me "Nubian-American" at first, and then finally a "real Nubian woman," and giving me an ancient Nubian variation of my name:

Ani. When I wore Nubian clothing, which I always did when in the village, I disappeared into the crowd of women. People who didn't know me—both villagers and tourists—assumed that I was Nubian.

My position was an anomalous one, however; although I looked like an ordinary Nubian housewife, I was a very well educated (a "doctora" in 1986), mature, married woman, who was American. I was allowed much more freedom of movement than other women were. and my ability to relax and talk with unmarried young men of the village every afternoon was entirely because I was in an anomalous position. This status did not make mc an "honorary male," however, because I could do what males could not: No foreign or Nubian male, no matter how highly placed, would have been allowed to sit and talk freely with the unmarried girls, or the married women either, day after day. My position was better than any male's could be: I was able to hang out with the young men, the young women, and/or the mature women; the only group that I could not relax with on an ongoing basis was that of the mature men. And I believe that my appearance opened doors more quickly and more completely than would have been the case had I been a European American.

Nevertheless, I often felt ambivalent about being mistaken for a Nubian woman, as I was not a Nubian and rarely did I actually feel as I imagined Nubian women to feel; nor did I believe that the villagers who knew me really thought of me as one of them. I was seen, I think, as a caring participant, as a welcome guest, and/or as a distant relative (one of my friends related to me that, when asked who I was, he replied, "She is our relative who is visiting us from abroad!"). As such, I could be trusted, eventually, with information about their lives. These feelings of ambivalence have been discussed by other anthropologists who had also found themselves in this not-quite-indigenous but not-quite-outsider position during their fieldwork (Abu-Lughod 1986; Koentjaraningrat 1982; Marshall 1970; Morsy 1988). And in spite of my desire to move beyond that "us/other" barrier, I, like these other field-workers, managed to do it only intermittently and incompletely.

Indigenous anthropologists, and those of us who are not-quite-indigenous, are also acknowledging a unique kind of responsibility toward those among whom we have lived, a kind of responsibility that I feel will become more common as time passes. We understand that our informants will hold us accountable for what we publish about them. The closer we have come to feeling like insiders, the more we have begun to understand what full disclosure of certain kinds of information would do to "our" families and villages. This book, for

instance, is one in which the villagers are very interested, and that many of them intend to read. In fact, a part of the first draft was already read, and additional suggestions made, by two villagers who could read English (a tiny minority), and another, a scholar at El Azhar University, will be translating it into Arabic for those who cannot. The villagers want to know that this ethnography is about them, and this is the reason that I use no pseudonyms. They are proud of their history and culture, and want to share it; they see my book as their vehicle to that end. At the same time, however, they wish to see their way of life celebrated—presented in its ideal and without flaw. They feel that the honor of their village, and of all Nubians everywhere, lies in covering up the negative aspects of their lives and in setting forth only the positive.

On my first visit to the field, the women among whom I lived sought to present an idealized picture of their lives and their relationships. It was only when I returned to the village the second time that I realized how much they had shielded the more disharmonious aspects of village life from my gaze. I believe that my second trip indicated to the villagers that I cared about them, and thus they allowed me to become privy to their less-than-perfect reality. In writing this ethnography, then, my dilemma has been how to fulfill my function as a field-worker of presenting a total picture of village life, while remaining sensitive to Nubian concerns about that picture. I certainly do not portray West Aswan as a paradise, but I do omit people, situations, and/or activities that I know the villagers would not wish to acknowledge publicly.

A second reason for doing fieldwork among the Nubians is that they are Muslim. My interest in gender roles in Islamic societies has already been mentioned, and the chance to combine my interests by pursuing research in an African Islamic society was quite exciting. Very little work has been done among Nubian women (Fernea 1970; Shukairy 1963; El-Sawy 1965; El-Katsha 1969), and the recording of their daily lives, their familial and extrafamilial concerns, is still in its infancy. Research among them has given me a chance to investigate theories concerning information sharing among women in Muslim societies.

Muslim women in Africa, like women in other parts of the world, are greatly dependent upon their social networks for information sharing and for social control. Networks, which can be defined as the people with whom an individual maintains consistent contact, may also include such social aggregations as solidarity groups and voluntary associations. These are used in many places throughout the

world by women to influence situations, exert pressure, and shape events and behavior in areas that might otherwise be outside of their control. For instance, the matrons of the Iroquois Nation are legendary (Brown 1970; Richards 1974), as are the market women of West Africa (Forde 1951; Sudarkasa 1973). In parts of West and Central Africa, women's secret societies used their sanctions as a means of social control (Paulme 1963), while village voluntary associations protected their economic and social interests against inroads by physically stronger males and/or coercive governments (van Allen 1972; Steady 1993).

African Muslim women's networks are essential components of their lives, not just for the dissemination of information or for social control, but also for support within the private domain. The Hausa women of northern Nigeria maintain very extensive networks, including bond-friendships and patron/client relationships, for economic and financial support (Smith 1954; Schildkrout 1982), as do lower-class Berber women in Morocco (Maher 1978). In Sudan, female litigants in court use their networks to receive advice and support as well as information (Fluehr-Lobban 1993). My research shows that Nubian village women, also, are involved in social networks, which they begin forming in childhood, throughout their lives. Nubian women give one another needed economic and social support through their networks, especially during life-crisis occasions. During such times as the birth of a child, marriage celebrations, and mortuary observances, women aid one another in the cooking of food, the preparation of clothing, and the all-important act of being physically present, to share their emotions, at the time of ceremony. The participation of women is vital to the successful performance of these celebrations, since it is only through intensive female labor that feasting can occur. It is upon the willingness of such women to work that the status, honor, and reputation for hospitality of a man and his family rests.

Social networks among Nubian village women also allow them to share information about their fellow villagers. Information management in the private sphere enables women to arrange marriages and to contribute to the preservation of moral and social order through gossip. Both of these activities are fundamental to the maintenance of Nubian village society, and both are recognized by the society as within the rights of women to mediate. Marriages are of very great importance in a village society, as they are not simply links between two people, but political and economic alliances between groups as well. Marriage arrangements are initiated by women—usually the

mothers of the future bride and groom—based upon the information that they have garnered through their networks, information that only women possess. In the same way, the women's sphere is the marketplace of intelligence that can make or break an individual's reputation; women can and do affect the behavior of fellow villagers through the use of information about them. The day-to-day relationships of women within their friendship groups set the tenor of village life and color the emotional environment in which people live.

Although the commonly accepted model of gender roles in Islamic societies maintains that the male sphere is more important than the female sphere, my research indicates that this is not a part of the Nubian belief system. Nubian village life, like that of other peasants and other Muslims who are not peasants, is domestic-centered: The female domain, its inhabitants and concerns, are readily acknowledged as important. Sexual segregation, although seemingly detrimental to women, does not exclude them from important decisionmaking, since many of the most important decisions in village life are made in the women's sphere. The male and female spheres of Nubian society work interdependently to further the maintenance of traditional Nubian values and social organization; and Nubian women, contrary to the popular stereotype, are not prevented from engaging in important decisionmaking processes, but are expected to contribute their knowledge and expertise to them.

Lastly, I was very interested in doing research among the Nubians after having read the history and prehistory of Nubia. Archaeology has shown Nubians to be, so far as can be determined, the most ancient people in the Nile valley. Many people believe them to be the ancestors of the pharaonic Egyptians and the major contributors to that civilization. I have been fascinated by ancient Egypt since childhood and, like many other African Americans (and Africans), view it as ancient Africa's proudest achievement. As the history of the Nubians is a record of their syncretic adaptations of foreign influences melded with their own ancient ways, I had hoped to be able to identify pharaonic "survivals" among the modern Nubians. I saw very few that I could recognize as pharaonic (hairstyles, names, and certain articles of clothing), but I was pleased to be able to identify some pre-Islamic, pre-Christian observances (which may also be pharaonic) that are still being practiced in the village.

Nubians have been known for selecting only certain aspects of foreign cultures, while preserving the basics of their own way of life, throughout innumerable invasions. With the recent influx of tourism to the area, they are once again being inundated with a flood of for-

eign peoples, foreign merchandise, and foreign ideas. Rapid culture change is affecting all of the people of this area, and I am interested to see how they will be handling the stresses engendered by such changes in the future. Tourism, especially, has presented new challenges, and Nubian women are becoming more involved in the tourist trade.

Development strategies for Muslim countries have rarely included women, and it is only recently that this oversight has been acknowledged (Ahmed 1992; Moghadam 1993; Salem-Murdock 1990). For several reasons, it has been difficult to obtain accurate figures for the female workforce in both the formal and the informal sectors of Muslim societies, and even harder to discover information on women's activities in the tourist trade (Nelson 1981; Singh and Kelles-Viitanen 1987; Young 1988). Those who are involved in the creation of development projects may wish to consider supporting women's tourist trade activities in Nubia. By including women and women's concerns in development strategies, the government would be acknowledging the importance of women's informal sector work, and enabling more women to earn their own money. Future research must question the extent to which women's increased moneymaking activities would affect not only individual relationships in the home, but also the complementarity of the male and female spheres of the entire community. As rapid change continues to impact Nubia, I believe that the Nubians will continue to embrace change while trying to control it (Boddy 1989; Rugh 1984), syncretizing innovation and foreign influences, yet maintaining the core of their culture, as they have done so many times in the past.

1

The History of the Nubians

This chapter outlines a brief history of Nubia, from prehistoric times through the resettlement. Most books and articles on this topic present the histories of ancient Egypt and ancient Nubia as separate entities, as if they had never interacted. Herein, I would like to show that these Nile valley civilizations were entwined in a symbiotic relationship that went on for centuries, and that makes their histories that much more interesting as a result. This is the reason I include so much of the history of ancient Egypt in a chapter that is ostensibly concerned with ancient Nubia.

The modern Nubian homeland (Old Nubia) extends some 700 miles along the Nile River from the First Cataract near Aswan to the Fourth Cataract in the Republic of Sudan (see Map 1.1). In ancient times, the Nubian homeland extended to the Sixth Cataract, beyond the site of ancient Meroë, almost to modern Khartoum. The area now called New Nubia lies 30 miles to the north of Aswan, near the town of Kom Ombo, where almost 50,000 Nubians were resettled in 1964, before the erection of the Aswan High Dam. Because I did my fieldwork among the Kenuzi Nubians of southern Egypt, my discussion of modern Nubia will focus upon them only.

The scientific investigation of early Nubian prehistory is still in its infancy. Systematic archaeological exploration has focused mainly on the 300-mile area between the First and Third Cataracts. Scientists agree that throughout the Pleistocene, there were several periods of increased rainfall in the Sahara, alternating with periods of desiccation. Typical Mediterranean flora and fauna, as well as giraffe, gazelle, elephant, hippopotamus, and rhinoceros, lived there during the moist, cool phases, and people from the north and south were able to move into the desert to hunt and fish. When the Sahara went into its final, hot, dry phase, people began moving into the Nile valley. Archaeological evidence indicates that the Nile corridor has been continuously inhabited since the late Paleolithic (25,000–

Map 1.1 The Nile Valley

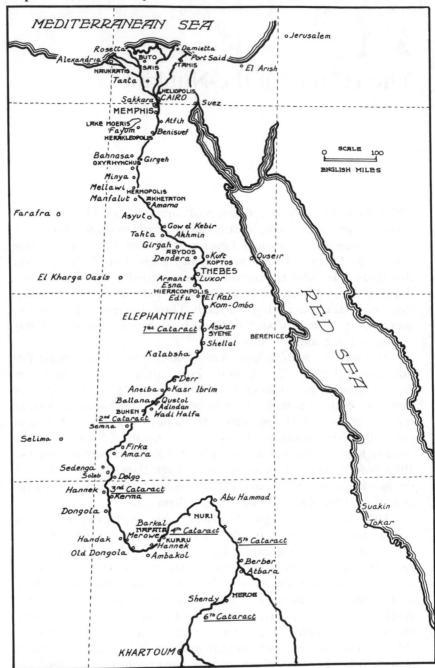

Source: Reprinted from Walter B. Emery, Lost and Emerging. Reprinted by permission of Curtis Brown Ltd. Copyright © 1967 by Hutchinson & Co. Publishers, Ltd.

16,000 B.C.), and it is from this time that we find evidence of the beginnings of a uniquely Nubian culture (Wendorf 1968).

It was also during this time that the populations of the area began what Wendorf calls "the Nilotic Adjustment" to the microenvironment of the Nile valley. Communities were small and compact, with occupations that were brief but repeated, and there is evidence of a mixed economy based upon the hunting of large savanna and aquatic animals, fishing, and the gathering of wild grains. The Khartoum Mesolithic, dated to circa 7000 B.C., is characterized by the development of beautiful and sophisticated pottery before the beginnings of agriculture, at Shaheinab near modern Khartoum. Archaeologists have found similar ceramics farther north, along the Nile between the First and Second Cataracts.

Although there is evidence of the utilization of wild grain, hunting, fishing, and the making of pottery, permanent village life, with agriculture, developed later. The earliest Neolithic site in Nubia has been dated to circa 6100 B.C. (Wendorf and Schild 1984), but the archaeological dates for this area are being revised yearly.

Many educated Nubians, and some Western scholars, believe that prehistoric Nubian peoples were the major contributors to the civilization of ancient Egypt (Ben-Jochannan 1989; Drake 1987). They argue that ancestral Nile valley people migrated from the Nubian homeland, settling in what is now known as Upper Egypt (the area between the First Cataract and Cairo) and developing a lifestyle that combined agriculture, fishing, and animal husbandry. When Menes and his Upper Egyptian forces conquered those of Lower Egypt (the area between Cairo and the Mediterranean Sea) circa 3200 B.C., these were the people of whom his forces were composed. The conquerors, whose ancestors had migrated from Nubia generations ago, imposed their cultural values, religious cosmology, and system of government upon those whom they had conquered. Ultimately, this amalgamation gave rise to the legendary ancient Egyptian civilization—Kemit, as it was known to its contemporaries.

Certainly, when the Two Lands were unified, an independent state already existed in Lower Nubia, which the ancient Egyptians called Ta-Seti, or "the Land of the Bow." Lower Nubia is the area between the First and Second Cataracts. This is the culture called the "Nubian A Horizon" by William Y. Adams (1977) and the "A-Group" by George A. Reisner (1910). The A Horizon sites are found in abundance throughout Lower Nubia. The people cultivated cereal grains, made a distinctive black and red pottery, and buried their dead along with grave offerings. The graves show great differentiation in terms

of wealth, leading Reisner to mistakenly hypothesize his "B-Group" as an intrusive element. Graves of wealthy people contain many articles of Egyptian manufacture, such as faience beads, suggesting that trading between the two areas was going on at the time, as well as indigenous pottery, jewelry, ivory combs, and stone tools. Some sites indicate that the inhabitants were transhumant, while others show evidence of more permanence, with houses with stone walls and up to six rooms.

By the time of the Old Kingdom in Egypt, Ta-Seti was considered enemy territory. The influence of Kemit grew increasingly oppressive as the pharaoh consolidated his power and enlarged his ambitions, finally invading the Land of the Bow and making it a colony.

The C Horizon appears abruptly in Lower Nubia, following a period of several centuries when the region was culturally impoverished and largely depopulated as a result of Egyptian imperialism. Around 2100 B.C., however, the central authority of the Egyptian state deteriorated, and for 800 years Nubia was able to live in peace and prosperity. The archaeological record shows a gradual increase in the size of settlements, and stone walls and granaries. Graves have tumuli and offerings, the largest of which include cattle skulls and clay models of cows. Most clothing was made of leather, and much of the art on pottery, rocks, and grave stelae is of cows, bulls, and herding activities. These people, called "Wawat" by the ancient Egyptians, probably developed a lifestyle that combined agriculture, fishing, and animal husbandry, similar to the one that was lived, until recently, by the transhumant "cattle complex" cultures of East Africa.

The people who inhabited the lands south of the First Cataract and those who lived north of it, although of the same ancestry, evolved, over the centuries, differing customs and languages. This natural evolution, coupled with the immigration of diverse peoples and cultures from other parts of Africa and from Asia, eventually led them to view themselves as separate peoples. The ancient Kemites became a powerful nation-state by circa 3000 B.C., while ancient Nubia, or Kush (in reality, three separate kingdoms: Kerma, circa 2500–1500 B.C.; Napata, circa 1000–500 B.C.; and Meroë, circa 270 B.C.–A.D. 300), flowered later. The two lands alternately traded and warred with each other; Egyptian hieroglyphic texts mention the empire of Kush as one of her traditional enemies. Nubian mines supplied Egypt with her gold; Nubian captives became her slaves.

During the First Intermediate Period in Kemit, the political equilibrium that had been maintained between the royal court and the provincial nomes was upset; the nomes in the south became stronger,

and Thebes gained prominence for the first time. The rulers of Thebes went to war against the pharaohs of the Tenth Dynasty, resulting in two kingdoms, with Tenth Dynasty kings in the north fighting Eleventh Dynasty kings in the south. Finally, the third pharaoh of the Eleventh Dynasty, Nebhapetre Mentuhotep II (a southerner who was most probably Nubian), gained victory over the kings of the Tenth Dynasty and reunited the Two Lands. This indicates the beginning of the Egyptian Middle Kingdom.

During the Middle Kingdom, the C Horizon culture of Lower Nubia was perceived as a threat to Egyptian gold-mining activities in the deserts of northern Nubia. The first pharaoh of the Twelfth Dynasty, Amenemhet I, was from the southernmost nome and also may have been Nubian. Nevertheless, he and his descendants invaded Nubia, building a series of large mud-brick fortifications in the region of the Second Cataract. These were designed as garrisons, to house troops for the purpose of monitoring river traffic and collec-

tion posts for the gold.

To the south of the Third Cataract, another culture was developing near the town of Kerma. The Kerma culture was probably the first flowering of the Kingdom of Kush, which emerged as an independent, self-governing state of considerable wealth and strength. As such, it attracted craftspeople, administrators, and soldiers from Kemit, who settled at the court and in the countryside. Contemporary with the Second Intermediate Period in Kemit, Kush flourished during the political turmoil of its northern neighbor. The state of Kerma was destroyed finally by Kamose and his immediate successors in the Eighteenth Dynasty, when they reunited the Two Lands.

During the Egyptian New Kingdom, Kemit became a colonial power in Nubia, with the aim of assimilating the Nubians to Egyptian culture. Nubian land was appropriated by the state, and Nubians became peasants. Others were taken as prisoners of war or slaves and sent to the court and temples north of the First Cataract. Pharaohs formed alliances with Kushite kings, giving them positions of authority within Kemitic governmental bureaucracy. In order to further the process of colonialization and assimilation, pharaohs married Nubian princesses, while Nubian princes were sent to be educated at the courts of pharaoh. The wars in Libya, Palestine, and Syria were financed by Nubian gold, while prisoners of those wars were sent as slaves to the mines near the Second Cataract.

Even before the Eighteenth Dynasty, Egyptian cultural elements had spread to Nubia, carried by priests, soldiers, traders, and travelers. Nubian culture was also spread to Kemit by Nubians as well as by Egyptian travelers returning from Nubia; in this way, both societies assimilated items of culture from each other. The priests of Amon in Thebes were especially influential in the courts of Kush, and during the Third Intermediate Period, when Kemit retreated from Nubia, Kushite rulers continued to maintain these ties. The Nubian king Kashta was confirmed as pharaoh (Patron of Amon, Defender of Thebes, etc.) by the priests of Amon, and when he died (circa 751 B.C.) his son Piankhi assumed those titles.

Piankhi spent the first twenty years of his reign in Napata, the capital city of Kush at this time. Through control over gold production and trade in cattle, hides, ebony, slaves, and other products from the south, Napata had become wealthy. Although there are several royal monuments and pyramids, as well as cemeteries scattered over a 15-mile area on both sides of the Nile near the Fourth Cataract, our knowledge about Napata still remains limited. The Kushite monarchy was perhaps matrilineal; there were at least five reigning queens. Kushite royal women had very high status, and queens' tombs in the royal cemeteries contained great wealth.

Piankhi invaded Kemit when the priests of Amun notified him that Thebes was being attacked by an army from the Delta; he used this as an excuse to continue north until the whole of Egypt was united under his command. Although he assumed all of the titles of pharaoh and is regarded as the founder of the Twenty-fifth Dynasty, Piankhi returned home to Napata after his campaigning was over, from whence he reigned for another ten years. Even though the Kushites were rulers in Kemit for only about 100 years, their achievements were considerable. They united the country, bringing order and stability for the first time in more than 300 years. They also brought economic and cultural revival, and renewed veneration for ancient traditions, religion, literature, and the arts. The Kushites also began to record the history of Kush during this time, using Egyptian hieroglyphs.

The last Kushite pharaoh, Taharqa, was a ruler of great ability, but came to the throne just when the forces of Assyria were massing to invade Egypt (his older brother had been intriguing with Palestine and Syria against this powerful empire). After losing to Ashurbanipal, he retreated to Nubia. Although the Kingdom of Kush remained strong and vital in Nubia for the next 1,000 years, its forces never again attempted to invade the lands to the north of the First Cataract. The kingdom never relinquished its pharaonic titles, either, however.

The Meroitic period was the golden age of dynastic civilization in Nubia. While the city of Meroë was only one of several important settlements in the area between the Fifth and Sixth Cataracts, it was the oldest, and probably the most important of them. Archaeological excavations of the city itself, its cemeteries, pyramids, and tombs have been limited in scope, and much more needs to be done. However, the culture of Meroitic times is better known than that of any earlier period in Nubian ancient history.

The bases of Meroitic prosperity were agriculture and trade. The principal crops were millet and cotton, and people kept cattle and goats as well. Meroë had three prominent industries—ironworking, ceramics, and weaving—and the products of these were traded to Abyssinia, Arabia, Egypt, and the Mediterranean world. Nubia also obtained tropical items, such as ivory, ebony, and incense, from its trade into the interior of Africa via the Blue and White Niles. Gold was mined extensively, and goldsmithing was an art; scribes wrote in Meroitic script, which has not yet been translated. Meroitic religion was a syncretism of Kemitic and Kushitic beliefs, with the mortuary cult and its attendant rituals very important.

In Meroë, we see the development of urbanism in this area, with large cities, monumental architecture, and the growth of a powerful and wealthy middle class. The Kingdom of Kush, in both its Napatan and Meroitic periods, was a political entity of remarkable stability, with a monarchy that continued unbroken for close to 1,200 years. This is far longer than any of Egypt's unified kingdoms. Ancient Kush and pharaonic Kemit were entwined in a symbiotic relationship that involved the exchange of human knowledge and expertise, as well as of gold, copper, ivory, and other material goods, for almost 5,000 years. Nubians who lived and farmed in the northern Nile valley were administrators at the court of pharaoh, priests and priestesses in Egyptian temples, and mercenaries in Egypt's armies. During times of dynastic upheaval in Kemit, northern Nile valley peoples fled to Kushite kingdoms, where they, too, worked as administrators and craftspeople at court, clergy in the temples, and soldiers in southern armies. It seems that the periods of Nubia's greatest prosperity tended to come when Egypt was weakest and vice versa.

Kush eventually broke up into smaller kingdoms: Nobatia, Makouria, and Alwa—all becoming Christian in the sixth century A.D., and remaining so for the next 900 years, until the time of the Arab conquest of Sudan. Following the subjugation of Egypt in A.D. 642, General Amr ibn el-As sent a cavalry force of 20,000 to Nubia. After penetrating as far as Dongola, they were beaten back. A second

battle of Dongola, in A.D. 651–652, was similarly disastrous for the invaders, and it ended in a negotiated truce—the *Baqt*. This truce, which lasted for six centuries, set up trade relations between Egypt and Nubia, involving the exchange of wheat, barley, wine, horses, and linen from Egypt for 360 slaves per year from Nubia, an arrangement that was greatly in Nubia's favor. The *Baqt* treaty was without precedent in the early history of Islam: "Alone among the world's peoples, the Nubians were excluded alike from the Dar el-Islam (house of the faithful) and from the Dar el-Harb (house of the enemy), the two categories into which the rest of the world was divided" (Adams 1977: 452). Although individual Arabs, mainly traders, settled in northern Nubia and intermarried with the populace throughout the years, Nubia in general remained free from the Islamic presence for 600 years.

In the early Middle Ages, part of the Rabi'a tribe migrated from the Arabian peninsula to Upper Egypt, where they intermarried with the Beja, a pastoral group residing in the Red Sea Hills. The resulting amalgamation, called the Beni Kanz, grew strong enough over the next century to challenge the authority of the central government in Cairo; but they were promptly defeated, and the survivors took refuge with the sedentary Nubian farmers who lived around Aswan.

The Beni Kanz soon intermarried with the local Nubian population and in time became partly Nubianized in language and culture, though they retained their Islamic faith. The result of this . . . is the Kenzi (pl. Kenuz) Nubians, who in modern times occupied the northernmost part of Nubia, between Aswan and Maharraqa.

(Adam 1977: 525)

This kind of intermarriage ultimately and peacefully transformed the Nubians into Muslims. Even so, it is believed that, as with Christianity, it was mainly the elites who converted at first, while the villagers remained pagan for a much longer time. In addition, since the Muslim invaders were always men who took Nubian women as wives, it was the women who, remaining a stable and permanent force in the society, retained their own language and culture and passed them on to their children. Uxorilocality undoubtedly aided the maintenance of Nubian traditions, as women were not forced to leave their kin group and friends when they married the invaders.

From the thirteenth to the fourteenth century, Arab nomads in Egypt, expelled by the Mamluks, migrated to Sudan. They also amalgamated with the pastoral tribes living to the east of the Christian

Nubian kingdoms and gradually converted them to Islam. By the late fourteenth century, Dongola, having disintegrated due to internal troubles, had been overrun by Muslim pastoralists; and by the fifteenth century, the last Christian kingdom in Nubia had been destroyed. From that time onward, Nubia has been Muslim. They are Sunni Muslims and followers of the Malki school of doctrinal inter-

pretation.

We know very little about Nubian history during the interval from 1500 to 1800. Slave raids were a continuing fact of life for many of the villages, although others, because they could prove that they were Muslim, escaped this horror, as Muslims may not enslave other Muslims. The Kenuz were, fortunately, Muslim. The European travelers John L. Burckhardt (1822) and J. A. St. John (1834) reported conditions that varied between extreme poverty and healthy growth in this area, mainly as a direct result of this differential raiding for slaves. Between 1880 and 1900, Great Britain assumed control in Egypt and Sudan, and finally ended the slave trade along the Nile. Egyptian Nubians, considered a relatively unimportant minority, were left free to pursue their own affairs for the next fifty to sixty years.

▲ Modern Nubia

Because there is almost no rainfall, the Nile is everything. Nothing grows without the help of the river—and the non-green places are those to which the Nile water has no mastery. On the east bank, the desert hills reach out toward the river and sometimes come flush against the river's edge. On the west bank, the encroachment is of a different kind, a slow creeping of dunes that can occasionally destroy a house or a crop. (Horton 1964: 2)

Villages grew up along the Nile from south to north, as close to the water as possible. Traditionally, the Nubian economy involved a combination of subsistence farming, animal husbandry, and date production. But because of the difficulties in farming the land, Nubian men for centuries had sought employment outside of Nubia, returning to their homeland only periodically. In pharaonic times they were mercenaries; later on they were enslaved (in which cases they could not return home), and then became personal servants. Although many Nubian men today are still servants, waiters, hotel employees, and doormen, they are entering the civil service and professions in greater numbers.

The Nubian language is Sudanic and is divided into three speech groups:

For the first 145 kilometers south from Aswan, the dialect spoken is Kenuzi and the people call themselves Kenuz. . . . The next reach, stretching [425 kilometers] is occupied by Nubians who speak Mahasi, a language of several mutually intelligible dialects which is sometimes called Fadija. The last Nubian reach of about 350 kilometers is inhabited by persons who speak Dongolawi and call themselves Danagla. (Greenberg 1963: 3)

The people of Egyptian Nubia, who are mostly Kenuz, were relocated when their homeland was flooded as a result of the elevation of the Aswan Dam in 1964. The erection of the first dam in 1903, and subsequent elevations in 1913 and 1933, crippled the agricultural system and gave impetus to the migratory trend discussed above. In 1933, Nubian women began migrating between cities and the countryside, and by 1950 most of the Kenuz—both male and female—had left Nubia to settle in the cities, leaving only 20 percent in the homeland. At the time of resettlement, approximately 70,000 Egyptian Nubians were living outside of Nubia; those who remained in the villages—mostly women, children, and old men—were overwhelmingly dependent upon remittances from migrants (Fernea and Kennedy 1966).

Many Nubians returned to their homeland when the resettlement began, and approximately 50,000 were resettled in the thirtythree villages built to accommodate them near Kom Ombo. Not all of the Nubians moved from Aswan, however; several villages, situated north of the High Dam, were in no danger of inundation and so were not evacuated.

The Kenuz are organized into a segmentary tribal structure, with five major patrilineages. The tribe itself is distributed over a number of villages, divided into major and minor patrilineal groups, and finally separated into individual families. Ideologically, patrilineal parallel-cousin marriage is preferred, but in reality, endogamous marriages occur with whichever relative is available, with a slight matrilateral bias. Close ties are maintained with matrilateral kin, as marriage is traditionally followed by a period of uxorilocality that may last for five years or longer.

A 2

The People of West Aswan

The felucca dipped sharply to the left as its sails caught the wind. As it lunged forward, the other women on board shifted nervously in their seats, clutching their veils around their heads and shoulders with stiff fingers. The men, riding behind them in the men's section, murmured approvingly as the boat picked up speed, but the women were obviously uneasy with its rapid pace. I, too, wished that the boat would slow down, but not because I was afraid. On the contrary: For me, crossing the Nile in the Nubian sailboat was a welcomed interlude of tranquility. The journey from the east bank to the west bank of the river took approximately twenty minutes if the wind was right, and during that time, the bureaucratic concerns associated with the town melted away, and I could focus upon the village on the other side with pleasant anticipation. When I climbed out of the boat at the landing, I would walk the half mile or so to the house in which I lived. Passing the gardens of date palms and mango trees, I would soon step off the road onto the hot sands (in summer, burningly so), which surround the village. My neighbors would call out in greeting as I walked past, a mixture of Arabic and Nubian: "Ani! Ahlan ya Ani! Rigray! Er minabu?" As I entered my house, the two sisters with whom I lived, Saadiya and Rohiyya, would greet me warmly, and their children would crowd around me in the hope that I had brought sweets from town.

The town of Aswan is situated on the Nile River, approximately 560 miles south of Cairo. It has a heterogenous population, composed mainly of Saidis (Upper Egyptians), Bishari (nomadic and seminomadic pastoralists), people of Sudanese descent, and Nubians, totaling, in 1982, approximately 200,000 people (Director of Antiquities Abdin Sian, personal communication). Aswan is surrounded by several Nubian and Saidi villages. Most of the Nubians who lived farther south were relocated in 1963–1964 when the Aswan High Dam was built, but the villages that lie in the vicinity of Aswan

Map 2.1 The Nile River and Lake Nasser

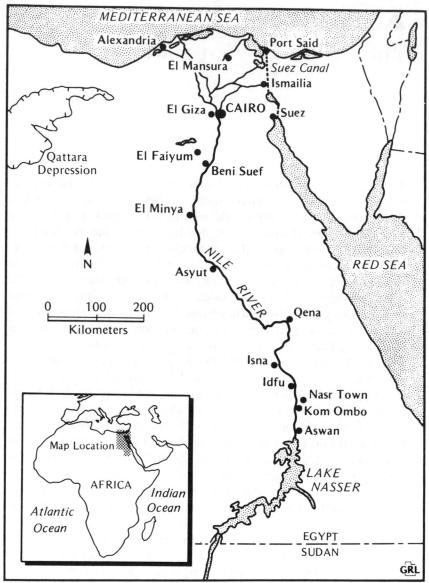

Source: Reprinted from Hussein Fahim, Egyptian Nubians: Resettlement and Years of Coping. Salt Lake City: University of Utah Press, 1983. Permission courtesy of the University of Utah Press.

were not evacuated. In 1986, there were approximately 85,000 Nubians living in Aswan and in the surrounding villages (Mohammed S. Khader, Department of Development, personal communication).

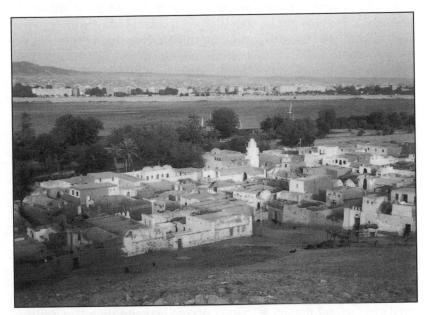

Neja Gubba, West Aswan

The village of West Aswan lies directly across the Nile from Aswan, on the west bank of the river. It is quite a large village, extending northward for approximately 11 kilometers, and is divided into eighteen hamlets (nejas); the population is approximately 30,000. Each neja is separated from its neighbors by an expanse of open desert; each has a name as well. The neja closest to Aswan, and the one in which I lived, is called Gubba.

The village is governed by two councils. The Executive Council has nine members, each of whom is appointed by the governor of Aswan. The Local Council has sixteen members, each of whom is elected by the villagers, and at least one of whom must be female. The council members are all villagers. Nine years ago, *Il Rayyis* Mahmoud Morsy, an official whose title might be glossed as "mayor," was also appointed by the governor. *Il Rayyis* sees as his main duty the

provision of services that help to make the villagers' lives easier. It was he who acted as liaison between a local doctor, who wished to find a place to open a private clinic, and the villagers, who wanted a doctor in Gubba. He also installed the water-purifying plant, which provides clean water to each *neja*, and enlarged and paved the road that now runs 23 kilometers northward from Gubba to the Saidi village of Kubaniyya. He brought in *taxis* (flatbed trucks installed with wooden slat seats) to take the villagers along this road, so that they would no longer have to walk or bicycle from one *neja* to another. In addition, he hears petitioners and settles disputes when necessary.

The traditional titles of *omda* and *sheik el balad* are now mainly honorary here. Although the men who hold these positions are still accorded a measure of respect, their duties have largely been taken over by *Il Rayyis* Mahmoud. West Aswan has the right to police itself, so the *omda's* peacekeeping force, the *graffir*, is still required. This traditional constabulary numbers only three or four men; consequently, every male villager is on call to volunteer his aid whenever greater social control is needed. The police from Aswan very rarely enter the village.

The first time I saw West Aswan, I was reminded of pictures of the ancient West African Muslim towns of Kano and Timbuktu. Most of the houses are made of clay bricks that have been dried in the sun and then plastered over with more clay to make a smooth surface for painting. Many houses are surrounded by high walls, which afford total privacy, and narrow alleyways stretch between these enclosures. While neighboring Saidi villages are characterized by rubble in the streets, trash middens, partially collapsed old houses, and roofs made of dessicated palm fronds, in Nubian villages the streets always seem newly swept and sprinkled with clean sand. The climate is dry and hot, and the environment is typically desert, with sand dunes rising up at the very edge of the village boundaries. The air is clear, with no hint of pollution as yet, so that the daytime sky is a brilliant blue. This color is reflected in the clear waters of the Nile and makes an arresting contrast with the warm brown of the hills and dunes. Because the houses are made of earth, they seem to be one with the landscape, much as the pueblos of the southwestern United States seem to be, rather than appearing as an imposition upon the terrain. Even those houses that are painted seem somehow to melt into the desert hills in the glare of the sun.

When entering a Nubian home, the visitor steps through a large wooden door in the wall into a hallway, off of which is a guest room where visitors are entertained. Males who are strangers to the family rarely venture beyond this visiting area, but a female visitor will be allowed into the inner parts of the house, where the family resides. Farther along, the hall opens onto a wide, sandy-floored courtyard (hosh). Traditional Nubian houses are very large, consisting of several rooms opening onto the courtyard (occasionally there are two or three room-courtyard complexes of this kind), the whole surrounded by the high wall. Most of the rooms are bedrooms, but there is always a kitchen and the guest room. Bedroom and kitchen floors are of hard-packed earth that is renewed once a year, but the guest room floor is often tiled. Most homes also have a latrine area that is usually a room with a hole in the floor, surrounded by high walls that may be roofed or unroofed. Each room has a barrel-vaulted ceiling with small windows near the top of the room, which very effectively allows the air to circulate freely. Two or three large clay water jars (zeers) can be found in every home, readily accessible to any household member or visitor. Beads of water collect upon the outsides of these zeers, evaporating and keeping the water inside cool and fresh.

There is also often a room-sized, barrel-vaulted, open-ended structure (hoha) standing in the courtyard, where women may gather during the day to converse while doing household chores. The high ceiling and open ends of the hoha allow the air to circulate, making it a favorite spot to rest during the heat of a summer day. Some households install zeers in this area, and the evaporating water cools the hoha even further.

In the late afternoon, the houses become very warm, as the clay bricks have been absorbing the heat of the sun all day. In the winter, this is delightful, but during the summer months the out-of-doors is more comfortable. Both men and women congregate upon the *mastabas*—benches of smoothly plastered clay that are built along the fronts of the outside walls—in the evenings, to share tasks and good conversation, and to catch the evening breezes that seem to freshen just in time.

There are several newer houses in Gubba, and these depart from the plan of the more traditional ones. Newer houses tend to be smaller, and built of stone and concrete rather than mud brick, although they are still plastered over with clay and painted. They are much more uncomfortable than the old houses, as stone tends to be hotter than adobe, and they are roofed with tin. Nevertheless, stone and concrete walls are stronger and enable the family to add a second, and even a third, story to the home. This is important in Gubba, as land that can be built upon is limited. The newer houses still maintain the traditional room/courtyard complex, but courtyards tend to be much smaller and may have tiled floors rather than sand.

Many of the houses in Gubba have paintings on their walls.

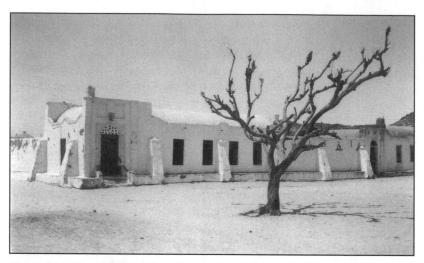

Typical Nubian house of the older style

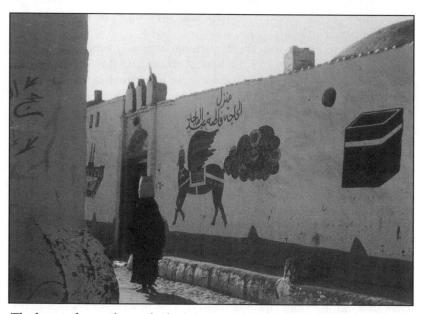

The home of one who made the journey to Mecca. Her painting shows the cube-shaped Ka'ba and al-Buraq.

These are done when the owner of the house has made a pilgrimage to Mecca (one of the duties enjoined upon all Muslims). Thereafter, it is the pilgrim's right to display a painting of the Ka'ba, the sacred structure in Mecca that is covered with black and gold hangings, as an announcement of his or her journey. There may also be a picture of the pilgrim's method of transportation to Mecca, whether plane or boat, and there is usually a verse from the Quran. Many walls also display a colorful representation of al-Buraq—the mythical being, part human and part animal—who, according to legend, took Muhammad to heaven on her back. The paintings are made by men in the village who are particularly adept at wall paintings.

Within the *neja* of Gubba, houses have been built in such a way that every nine or ten of them surrounds a large, open area. The focus of each of these "squares" (*melaga*) differs; it might be a large, shady tree, or a small kiosk selling canned milk and candy, or the mosque. The southernmost square in Gubba, and the one whose families I came to know best, has as its focus a water spigot. Although this spigot provides fresh, purified water, in 1982 few of the women I knew got their water from it. They preferred to make the longer trip to the canal or to the river itself, saying that the river water tasted better. They were right, it did taste better, but in 1986 I saw evidence that convenience was winning out over taste: Many of my friends had had plumbing put into their homes, and so they no longer needed to go down to the river for water. The water is not piped in directly from the Nile, but comes from the spigot instead.

The women who live in the houses surrounding each *melaga* form a neighborhood in the sense that their primary dealings are with one another. Although there are no restrictions upon them concerning where they can travel within the village, convenience dictates most of their actions.

According to informants, the first inhabitants of Gubba were a man named Omar and his wife. One hundred seventy-five years ago they moved from Old Nubia, where they had been living in one of the villages between the First and Second Cataracts. They eventually had five daughters and a son, and it is from these (and various inmarrying people) that the people of Gubba are descended.

This "origin myth" was repeated to me several times by various people; I also was told, however, that several large families founded Gubba in 1903 when the first Aswan Dam was built and their land was flooded, and others emigrated in 1933 under the same circumstances. Whether or not one believes in the accuracy of the Gubba "origin myth," it is instructive to learn that the people of this *neja* are

not among those who insist that their ancestors "have always lived here."

Fields and fruit trees can be seen along the Nile, lying between the river and the canal that irrigates the fields. Cattle-powered waterwheels (eskalay) bring the water up from the canal to the crops. Fields produce onions, corn, molokhia (jutelana Corchorus olitorius), okra, beans, karkaday (Hibiscus sabdariffa), tomatoes, peppers, eggplant, squash, and fodder for the animals. Fruit trees bear mangoes, guavas, lemons, dates, peaches, and figs; grapes are also grown. Nevertheless, the people of Gubba are not able to support themselves entirely through farming. There is not enough land in Gubba for this, and cash is needed for the purchase of staple foods, such as flour, rice, sugar, and tea, as well as for clothing and electrical appliances (refrigerators, lamps, fans, televisions). Thus, most of Gubba's males work outside of the village, at salaried jobs rather than as farmers. The fertilizer factory provides jobs for many Aswalis (inhabitants of Aswan), as do the hotels, the hospitals, and the airport. Nubian men can be seen as waiters, porters, and doormen in the hotels, and are usually cooks as well. Approximately half of all the wage-earning men of Gubba have government jobs: at the High Dam, on the railroad, or in the government hospital, or as teachers, office workers, or police. But they are also cab drivers, tour guides, and boatmen. Informants reported that, while Nubians are well represented in every job in Aswan, the majority tends to be clustered at the lowest levels of those jobs, with few in positions of leadership or influence. On the other hand, 99 percent of all the feluccas in the area are Nubian owned, so they make much of their money from tourism.

Gubba is the only neja in West Aswan that caters to tourists and may be the only one that is as greatly dependent upon male employment in Aswan. Other nejas have more extensive fields and are farther away from the center of Aswan, and men can be seen farming there much more often. In these nejas, many men are full-time farmers. Others go to the fields in the afternoons when they return from wage employment. Women also possess fields and gardens, which they may keep separate from those of their husbands, in which they grow produce to feed their families and fodder for their animals.

Gubba also has a mosque and a primary school (first to sixth grades). In 1982, there were 65 families and 372 people. In 1986, the number of residents had risen to 380 and the number of families to 79. The people of Gubba are devout Muslims, although few are fundamentalists. Women, as well as men, are very religious, and although they do not go to the mosque, they pray conscientiously

within the privacy of their homes. Right outside of Gubba, to the south, stand two shrines (qubba) to three local saints: One qubba belongs to Sheiks Nejm and Hassanoon, and the other to Sheik Ibrahim. Islamic saints are people venerated as having been especially exemplary in their lives, and after their deaths their tombs become places to which pilgrimages may be made. It may be that the name of this neja, "Gubba," is a shortened version of "El Qubba"—the identification of the place where the shrines lay.

In Old Nubia, saints' shrine activities were mostly confined to women; those near Gubba appear to involve young brides, who visit them around the time of their weddings. The bride, and whoever else wishes to accompany her, walks around the larger shrine several times, to ensure the saints' blessing upon her marriage. These shrines were built next to a large and shady tree, under which stands a water jar. The jar is kept full of water by the *nakiba*—the custodian of the shrine—for any thirsty traveler. The *nakiba* is usually a destitute elderly woman, who gets a pittance for this and other services to the shrine (Callender 1966). The *nakiba* of the Gubba shrines was indeed such a woman, and lived with the family next door to mine.

▲ Arriving in Aswan

I arrived in Aswan for the first time on a clear, warm morning in early October. Walking from the train station, I checked into the nearest hotel and then went outside to look around. The town is growing fast: The shops and stores along its two main streets are stocked with foreign and domestic goods, and most of the hotels are inviting and well run. Yet, in the part of town that tourists rarely see, the majority of Aswalis live in small, mud-brick homes with hard-packed earthen floors. While rent is cheap and electricity abundant, many homes do not have running water. Roads are unpaved, and paths are furrowed and muddy from the water that is flung outside after washing. Houses are cold in winter (temperatures fall to around 40°F), leading to bronchitis and flu, and hot in summer (when temperatures may rise as high as 120°F); unlike the Nubian villages, people don't live close enough to the Nile to catch the cooling river breezes.

The shops that Aswalis frequent have a limited supply of goods, but are cheaper than those on the main thoroughfare. The market is arranged so that similar kinds of goods are sold within the same area. One back street is filled with dark and dirty machine repair shops, plumbing shops, ironworks, and automobile repair places, where var-

ious parts, pipes, and wheels are piled up in front of doorways. On another street, tailors sit at their sewing machines, with examples of their craft hanging from hooks above their heads. These men, while excellent at sewing the traditional gallebeya—a long, shirtlike garment—are less practiced at Western-style clothing. There are notions shops, where women can purchase buttons, ribbon, or lace for their dresses and scarves, and jewelers, where 18- and 22-karat gold is sold by weight. A major section of the market is reserved for the fruit and vegetable sellers, right behind the government store, which sells government-subsidized chickens, eggs, and dairy products. Street vendors sell fast food of various kinds, and each neighborhood has a bread store that bakes the flat baladi bread fresh two or three times per day. Aswan's marketplace is small, crowded, and bustling, but also inviting and friendly: Shopkeepers invariably proffer tea to visiting strangers and remember the special preferences of repeat customers.

Members of the various ethnic groups that live in and around Aswan can often be recognized by their distinctive clothing styles. In contrast to Cairo, where almost everyone is in Western dress, here traditional clothing is the rule. Most men walk about in the gallebeya, and most women wear various kinds of black overclothes. Saidi men can usually be recognized by their wide gallebeya, which catch the breeze and billow out in graceful swirls as they stride along. These garments also have very wide sleeves, which the men fold back over their shoulders when they are working or eating, and a collarless neckline. Nubian men tend to wear narrower gallebeya, with narrow sleeves and small mandarin collars. Bishari and Sudanese men generally wear this latter style, and many also wear a cloth upon their heads (the emma) as protection from the sun. Occasionally Bishari nomads can be seen in town, wearing loose white pants with long loose shirts, with turbans on their heads and distinctive large white shawls wrapped crisscross over their chests. Although most traditional women in Aswan wear black, female visitors from Sudan rarely do. They dress instead in the tob—a beautiful and graceful garment, very similar to the sari-of brightly colored cotton or silk, one end of which they draw over their heads and shoulders.

Aswan also has two hospitals—a public one and a private one—and several movie theaters. A large and impressive mosque, which is lit up at night, sits on a small hill in the center of town. There are many other smaller mosques in Aswan, as well, and every neighborhood has its own. There is also the Aswan Palace of Culture, a cultural center in the middle of town that displays photographs and maps of the area, the surrounding villages, and the various tourist attractions around Aswan.

It was here that I stopped on my first morning in town. As I stood gazing at the photos, I was suddenly surrounded by a group of young Aswalis, all eager to communicate with me. They were attracted by the sight of me, an obviously foreign black woman, and they were trying to find out from where I came. My halting Arabic must have been difficult for them to understand, but they never tired of asking questions about me, my life, and what life was like for Black people in the United States. I later discovered that the U.S. miniseries "Roots" had recently been shown on Egyptian television (a surprisingly high percentage of U.S. movies and television programs shown in Egypt are those that feature African Americans), and it had left them with unanswered questions. These young people were members of a folkloric dance troupe that performed at the cultural center every evening. Two young women in the group, Sukkar and Nasra, were sisters, and invited me home with them to meet their mother. I fell into a pattern of visiting with this family every two to three days, and through them, with their friends. The family, of Sudanese origin, included the two sisters, their mother, and their brother, who was rarely there.

After visiting in this way for about a month, the mother, Fatima, invited me to stay with them in their home, rather than living in my hotel ("Here, you will have people to talk to; in a hotel, you have nothing but the walls!"). At first, I assumed that she was extending a polite, ritual invitation, not to be taken seriously. But after she had said it five or six times, I accepted. I lived with the family for six months, during which time I became much more proficient in Arabic (they spoke no English), and attempted to adjust to the climate of Aswan, as well as to the culture of the people among whom I found myself.

I had informed them that I had come to learn about the culture and lifeways of Nubian people, so they were not surprised when I made periodic trips to the various Nubian villages in the vicinity. In addition, Fatima and her family had many Nubian friends, to whom they introduced me. It was one such friend, Mohammed Abid, who took me to the home into which I would eventually move.

▲ Saadiya's Family

I met Saadiya and her family when Mohammed Abid took me to their house for tea one afternoon. It turned out that they were relatives—Saadiya's mother's mother and Mohammed Abid's mother's father were siblings—but he lived in another village. For several weeks after

that, I visited the household, usually arriving in the afternoon for tea and sometimes staying for dinner, gradually meeting most of the family members.

Saadiya was at that time living in her mother's home with one of her four sisters, and was often visited by two others while I was there. The sisters were fond, in the beginning, of asking me if I remembered their names, knowing full well that I was easily confused because they looked so alike in their voluminous black overclothes (later I found out that this was a common method which the villager used in order to judge the intelligence of children).

After I had stayed overnight with them twice and enjoyed several days of village life, Saadiya invited me to move in. I was provided with my own room, which included a bed, a table and chair, and a closet. Bed linens, towels, a rug for the hard-packed clay floor, and some clothing were easily and cheaply bought in Aswan. After I had settled in, I was able to have the typical black Nubian woman's overclothes made up by a seamstress in the village. My room had a small courtyard right outside the door that was surrounded by high walls, affording me complete privacy when I wanted it. In summer, I slept in the courtyard at night, as my room held the afternoon heat well into early morning.

I lived in neja Gubba for nine months in 1982 and for twelve months in 1986. The family that I became a part of was large and somewhat dispersed. The aged mother, Hajja Fahima, had eight living grown children—three sons and five daughters. Most were still living in West Aswan, near her, but others lived off and on in Cairo, and one permanently in Saudi Arabia. During my first fieldwork, her household consisted of two of her daughters, Saadiya and Rohiyya, and their children: eleven-year-old Hamdi and eight-year-old Mohammed, who are Saadiya's sons, and eight-year-old Samaa, Rohiyya's daughter. In addition, twelve-year-old Ahlam, daughter of another sister, was spending the summer with the sisters to help the old Hajja, who was senile and sometimes querulous. Below, I introduce the members of my Nubian family. A kinship chart (Figure 2.1) is provided on the last page of this chapter, in order to aid in identification.

Saadiya

Saadiya Hassan Ahmed Jamal, born in 1947 (no. 8 on the kinship chart), had at the age of sixteen married Hegazi, her father's brother's son. It had been a love match, one of the few in the village, and was still talked about, upon occasion, by her sisters. The couple, after

living uxorilocally for five years, moved to Cairo where Hegazi worked as a meter reader. Several years after this, Saadiya incurred her husband's wrath by disobeying him: She left Cairo and returned home to see her mother without his permission. As a result, he ordered her to stay there and married again in Cairo. In 1982, Saadiya had been living in her mother's house for the past eleven years. She was in the process of building a new house for herself and her sons (see Map 5.1, no. 11) on the melaga, where she hoped to attract some of the tourist trade. Toward the end of my stay, however, Hegazi's second wife died, and Saadiya was hoping that he would return to Gubba and live in the new house with them. Then, Saadiya's mother, the old Hajja, died, and there was no longer any compelling reason for Saadiya to remain in West Aswan. Hegazi thus summoned them all instead to Cairo, which left the new house vacant and unfinished. Upon my return to the field in 1986, I found Saadiya and her children living again in Gubba, in her new house. She and Hegazi had decided that it would be less expensive for them if she were to live in the village with the children during the school year and live in Cairo during the summer vacations. She gave birth to a baby girl, Sommar (Figure 2.1, no. 15), in 1985.

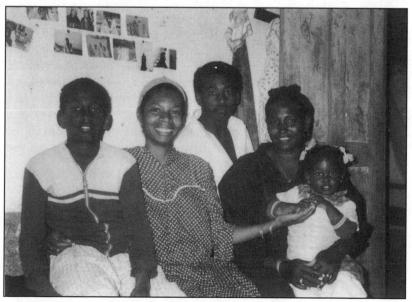

Mohammed, Ani, Hamdi, Saadiya, and Sommar

Rohiyya

Rohiyya Hassan Ahmed Jamal, born in 1945 (no. 7), was also married at sixteen, and she and her husband, Ahmed, also lived uxorilocally in Gubba for five years right after marriage. They then moved to Cairo, but after three years Rohiyya came back to Gubba, as she and her mother-in-law could not get along. Throughout the years of her marriage, Rohivva made several attempts to live with Ahmed and his mother in Cairo, but she always wound up back home in West Aswan after four or five months. In 1982, she and her daughter, Samaa, made yet another trip to Cairo for what was to be a permanent stay. However, when the old Hajja died four months later, they returned, and they were still there when I left the field. When I saw Rohiyya again in 1986, she was living permanently in Cairo with her husband (his mother had died). Samaa had remained in the village for school and lived in another neja with her mother's sister Nabawiyya. During the summer she would accompany Saadiya and her children to Cairo, where she would stay with her parents until school began again.

Two more sisters, Saida, born in 1942 (no. 6), and Nabawiyya, born in 1943 (no. 5), live in a *neja* farther north, called Kutagele.

Saida

Saida and Rohiyya were married at the same time, to a pair of brothers. Saida and her husband, Mohammed, lived uxorilocally for only three months, after which they moved to his home in Kutagele, where she and her three of her four children still reside; Mohammed is now working in Saudi Arabia. Rohiyya and Ahmed also lived for a brief time in this house, along with the contentious mother-in-law, before moving to Cairo. Saida was the only one of the sisters with whom I could not converse, as she had a hearing problem and spoke little Arabic. It was her daughter, Ahlam, who lived with us during the summer.

Nabawiyya

Nabawiyya lives nearby in a house of the older style: one-storied, rambling, with sandy-floored courtyards and separate sections for the boys and girls of the family. She was married at the age of fifteen, to a man thirty years her senior whom she had never met. She says that she agreed to the marriage without really understanding what was

involved ("I was a kid!"), and I got the impression that her connubial duties came as something of a shock to her. Nabawiyya and her husband, Abdel Razzik, lived uxorilocally for five years before moving to his father's house in Kutagele. During that time, the three oldest children were born. The Kutagele house was originally just four rooms—a kitchen and three bedrooms; as the family expanded, Nabawiyya added rooms. She has had seven children in twenty-four years of marriage.

Fazozia

The eldest sister, Fawzia (no. 4), has been living in Cairo for the past thirty years with her husband, Fuad, who is a doorman. Like her sisters, she married young and lived uxorilocally for a short time before moving away. When Hajja Fahima became ill, Fawzia returned from Cairo and lived with us until the *arbaeen*, the ceremony that marks the end of the mourning period. She and Fuad had, some years earlier, made the holy pilgrimage to Mecca, but it was only after her mother's death that people began referring to Fawzia as "Hajja." She has had no children.

In addition to her four sisters, Saadiya also has three brothers. The eldest, Abdel Raouf (no. 3), is working in Saudi Arabia. His wife and children all live in Cairo, and although I met them at the funeral services for Hajja Fahima, I have never met him.

Mohammed Hassan

Mohammed Hassan, born in 1931 (no. 2), is the second-born son and is married to FatHiyya, Hajja Fahima's brother's daughter (no. 13). He was born in Gubba and lived there for the first eighteen years of his life, until he left to find work in Cairo. He worked there as a chauffeur and car mechanic, until an accident caused him to return home, where he spent a year recuperating. It was not clear to me whether he had married FatHiyya before or after his accident; nevertheless, since his return home he has been living in FatHiyya's house with their children. Mohammed Hassan's nickname is Shatir, which means "clever" in Arabic, and it is apt; reputedly particularly talented with mechanical matters, he was the logical one to go to when my typewriter broke down. In spite of this, his mangled foot and limp have prevented him from finding anything but menial jobs in Aswan.

Abdul Hafuz

The third brother is Abdul Hafuz, born in 1933 (no. 9). He and Mohammed Hassan were married at the same time, in a joint ceremony. He married, at the age of twenty-four, Samira (no. 14), the daughter of Hajja Fahima's sister, who was ten years old at the time. Because of the bride's age, both husband and wife remained in their respective parents' homes for the next six to seven years, after which they moved into his grandfather's home, down the hill from the Hajja's (see Map 5.1, no. 14). Abdul Hafuz faithfully visited his mother and the two sisters who were living with her every day, often twice a day. In the morning before he went into Aswan he would come by to see if we needed anything from the market that day, and in the evening he would eat dinner with us.

When I returned to the village in 1986, I found Abdul Hafuz and his family living in his mother's old house, which had been left vacant by the departure of both Saadiya and Rohiyya. His eldest daughter, recently married, was now living in his old home. Abdul Hafuz owns three feluccas that are rented by tourists to Aswan. He is *il rayyis*—"the boss"—however, and so does not actually sail any of them.

This is the family with whom I lived and who became my family while I lived in Egypt. Through talking with them and observing their interactions with one another and with their close friends, I came to understand something about the lives of Nubian people. It was because of their support and patronage that other doors were opened to me, and I was received as a friend rather than as a stranger. In addition, the fact that I am an African-American woman influenced them to extend their hospitality to me. Especially during my first stay, villagers would often say, "We like you, Ani, and want you to live with us because our skins are the same color. We are the same people." When I wore Nubian clothing, I blended in completely, to the unending delight and amusement of the villagers themselves.

This does not mean, however, that they accepted me immediately, or totally. There was a period during which I was watched and cautioned, until people were sure that I would behave in an appropriate manner. And there were always aspects of their lives that were never shared with me; furthermore, some villagers remained hostile and suspicious during both my first and second visits. Most, however, were friendly, curious, and helpful.

Eventually, I was able to speak with and enjoy the company of a varied group of village women. My most constant male informants

were family members and one or two of their very close friends. This is consistent with the ideal behavior of women in this society, whereby they are expected to seek the aid of related, rather than unrelated, males. There was enough of a variety of such men and boys, however, that I believe that I was able to get a fairly well-rounded picture of male life in the village. Nevertheless, my main concentration was upon the women of the family and the community, and the way they lived their lives.

Figure 2.1 Kinship Chart of Hajja Fahima and Her Descendants

1. HAWA FAHIMA 2. MOHAMMED HASSAN 3. AEDEL RAOUF 4. FAWZIA

5. MABAWIYYA 6. SAIDA 7. ROHIYYA 8. SAADIYA 9. ABOUL HAFUZ 10. HAMDI

II. MOHAMMED
IZ. AHLAM
I3. FATHIYYA
I4. SAMIRA
IS. SOMMER

▲ 3

Growing Up Female in West Aswan

The Nubian village woman is easily recognized by her clothing. Although she does not wear a face veil, she does wear distinctive garments that serve to identify her as a modest and respectable Nubian woman. She may wear as many as three layers of clothing, and although this makes her very hot in the summertime, when temperatures can rise as high as 120°F, tradition decrees that she do so. Directly over her underwear, she wears a simple, long-sleeved cotton dress (fustan). This is usually of some brightly colored print, and looks very much like a U.S. housedress of the 1940s, except that it is ankle-length. These dresses are usually bought in one of the department stores in Aswan. The second layer is a long-sleeved dress shaped like a smock, made of an opaque black fabric; sometimes it has a little bright trimming on the bodice. This is called a gallebeya sufra and is sewn by a seamstress in the village. Although the shape of the garment is prescribed by custom, a great deal of variation can be achieved in the kind of fabric a woman chooses.

When a woman goes shopping for fabric to make a gallebeya sufra, she pays a lot of attention to such characteristics as pattern, weave, and texture of cloth. Since both style and color must remain fixed, the only way she can make her costume different from her friends' is by choosing a distinctive cloth. Until I began to shop for fabric to have my own gallebeya sufra made, I had never before realized how very many modulations of tone and texture black fabric can have. The situation in which the apparel will be worn is also important: Ceremonial occasions call for silk and cut velvet or shimmering fabric from Saudi Arabia, whereas easy-care polyester is best for everyday wear. These two layers—the cotton fustan and the black gallebeya sufra—are worn constantly when a woman is at home.

When a woman leaves the village, or even her own hamlet, she dons a second black covering, the *kumikol*, over her *gallebeya sufra*. This voluminous, square-shaped article is worn by married, settled

matrons and identifies the woman who wears it as a Nubian. Along with the *kumikol* she draws a veil, the *tarha*, around her head and shoulders, and upon her head she carries a folded shawl, the *milaya*, for use in any emergency. There is never any bright trimming on a *kumikol*, but it often sports underarm gussets of some contrasting fabric.

The younger Nubian village woman, and townswomen of all ethnic groups, wear a kind of overdress called a *jarjar* when they leave their homes, instead of the *gallebeya sufra* and *humikol*. It is loose, but still manages to be flirtatious, as it has a large ruffle at the bottom that sways gracefully as she walks. In addition, it is usually made of some semitransparent, lacy fabric, which enables the young girls to show off their pretty dresses underneath. Although the style of this, too, is ordained by custom, deviation can be achieved in such things as the length of the ruffle or the number of horizontal tucks in the body of the dress. Choosing fabric for the *jarjar* is, for a young woman, a chance to exercise some creativity in her choice of traditional clothing.

Many a woman will wear a brightly colored kerchief (mandil) on her head, covering her hair. Older women tend to wear a black mandil, and occasionally a young woman will go out bareheaded, with only her tarha as covering.

A Nubian woman tries to have her children, especially the first-born, in her natal home. If she is not already living there, she will travel to her parents' home about a month before she gives birth. There, surrounded by her female kin and succored by her mother, she feels safer than she would elsewhere. Thus, traditionally, most babies were born in their maternal grandmother's home; even today, very few Nubian women give birth in hospitals.

Baby girls are clitoridectomized and infibulated while they are still quite young—between the ages of one and two years old, sometimes earlier. The procedure involves the cutting away of the clitoris and labia minora, leaving the labia majora to cover the wound and vaginal opening. The legs of the patient are then tied together in order to keep them immobile until the scar tissue has fused and healed. This closes the genital orifice completely, except for a small opening that is purposefully left for the emission of urine and, later on, menstrual blood.

This operation, performed throughout Egypt and Sudan, is also called female or pharaonic circumcision in the literature and by the natives of Egypt and Sudan, although there is little evidence that this was ever practiced in ancient times. It is the most extreme of the

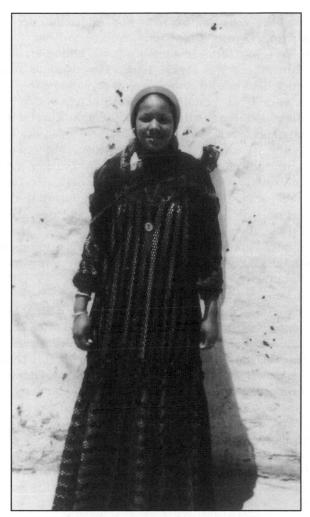

Ahlam, in jarjar and tarha

genital operations found in this area of the world, and seems to be the oldest. The less extensive operation, clitoridectomy, or excision, which involves the removal of the clitoris only, is also called sunna circumcision because it is considered to be recommended by Islam. There is a passage in the Quran that has been interpreted in this way by some, although others argue that Muhammad opposed the practice (El-Saadawi 1980). Infibulation is also thought to be condoned

by Islam by some villagers, but it is not. Both clitoridectomy and infibulation appear to be pre-Islamic customs and can be found in greater or less severe forms in parts of Arabia, Ethiopia, and areas of both East and West Africa (Hicks 1993). Most Muslims around the world practice neither, and clitoridectomy can also be found in non-Islamic societies: It was practiced in the United States, for instance, from the late 1800s until the mid-1930s as a "cure" for certain women's ailments (Early 1992).

When the procedure is successful, a little girl's genital area appears completely closed. The condition protects her modesty, as she generally runs around without underpants or diapers for the first two years or so of her life, and protects her virginity until she is married. My informants accepted it as a normal and desirable part of their way of life, discussing it with me with the same openness with which they talked about sex. They know that Western women do not undergo the operation and were as curious about my physical state as I was about theirs.

Clitoridectomy and infibulation may lead to severe complications, much discussed in the literature (El Dareer 1982; El-Saadawi 1980; Gruenbaum 1982), including abscesses and cysts, keloids that can close the small aperture, urinary tract infections, pelvic inflammatory disease, and death from hemorrhage or septicemia. Infibulation makes childbirth particularly painful and dangerous, as the woman must be cut open along the original scar tissue in order to permit the passage of the baby.

There is also much discussion in the literature concerning the reasons for this operation (Boddy 1982, 1989; Early 1923; El-Saadawi 1980; Gruenbaum 1988, 1991; Hicks 1993; Kennedy 1970; Toubia 1985). Here, I shall only briefly summarize the more salient arguments. The most widespread and most widely accepted explanation is that the procedure controls women's sexuality. In societies in which male honor is supremely important, clitoridectomy and infibulation blunts a woman's sexual feelings and thus prevents her from engaging in premarital affairs or extramarital infidelities. This ensures that any child a woman may bear will be that of her husband's lineage and not of someone else's.

While most explanations for clitoridectomy and infibulation focus upon control of female sexual feelings, little is said concerning any attempt to control male sexuality. Nawal El-Saadawi, one of the few writers to broach this topic, states that society's double standard for morality, which encourages men to seek sexual "conquests" but discourages women, is at the root of this custom:

The males are let loose in search of sexual experience, in any form and no matter at what price, in an attempt to prove their virility. . . . Men are engaged in a perpetual chase after women. . . . In this continuous urge to posses a woman, the male will tempt a poor servant, . . . victimize a young child, or entice a girl with promises of marriage. (1980: 31)

Since male sexual behavior rarely reflects negatively upon family honor, it seems that males are allowed wide latitude in this area. It has been my experience that a certain percentage of the Egyptian male population is sexually predatory, especially in the urban areas. Both Egyptian and foreign women have many a story to tell concerning sexually suggestive language and actions directed toward them in the streets, as well as in offices and private homes. When a young girl's or woman's vagina is closed, she is that much more protected from the importunities of men, which can happen at any time, and seduction and/or rape is that much more difficult to effect. While this may or may not be the reason that infibulation was originally performed, I believe that this is one of the purposes it serves at the present time and may be one of the reasons that the practice continues.

Another argument put forth from the female perspective is that of Janice Boddy (1982, 1989), who offers an explanation as to why it is the women of the villages in Egypt and Sudan who maintain the practice in spite of numerous attempts by health workers to eradicate it. Clitoridectomy and infibulation are part of a richly symbolic belief system and a central institution in the development of femaleness. By de-emphasizing a woman's sexuality, the focus is upon her fertility, her social indispensability as a mother of a future lineage. Thus do women achieve respect and recognition: not by behaving or becoming like men, but by becoming less like men physically, sexually, and socially (1989: 56). Boddy's explanations of the reasoning behind the custom, that is, the protection of not just a woman's chastity but also her fertility, seem closer to the truth of village women's lives, as I have experienced it, than any other explanations I've read so far.

Thus, pharaonic circumcision is for women . . . an assertive, symbolic act. Through it they emphasize and embody in their daughters what they hold to be the essence of femininity: uncontaminated, morally appropriate fertility, the right and the physical potential to reproduce the lineage or found a lineage section. In that infibulation purifies, smooths, and makes clean the outer surface of the womb, the enclosure or *hosh* of the house of childbirth, it socializes

... a woman's fertility. Through occlusion ... of the vaginal meatus, her womb becomes ... an ideal social space: enclosed, impervious, virtually impenetrable. ... The infibulated virginal bride, enclosed, pure, ostensibly fertile, is a key symbol in the ... cultural system. (Boddy 1989: 74)

The debate that rages in feminist circles concerning clitoridectomy, infibulation, and the most effective ways to eradicate them, is only slowly beginning to focus upon the price a woman must pay for not having these procedures done (Gruenbaum 1994). At the present time, a young girl who has not been at least excised may be rejected as a marriage partner and assumed to be immoral. A woman who has not been reinfibulated after childbirth may find that she is not considered sexually desirable by her husband, who may then divorce her and/or marry again. A woman's decision, although it may concern her own body, reflects most deeply upon her family: Any family that permits its daughters to forgo the operation is held in contempt—its men without honor and its women unmarriageable. Since marriage means high social status and economic security for women in this part of the world, feminist calls to end clitoridectomy and infibulation, while prompted by a very real concern for women, strike at the very foundation of their safety. As a partial result of these calls, however, there is now a very rich and variegated debate going on in Sudan concerning what steps should be taken to deal with this dilemma (Gruenbaum in press). This is a situation that must be resolved by the women and men who are most immediately concerned, as they are the ones who will be able to fashion viable alternatives. "Wherever possible, indigenous women and women's organizations should be involved in all stages of the research, from formulation of the problem to development of policy" (Gruenbaum 1982). Until this is allowed to happen, these practices will, unfortunately, continue.

In Gubba the procedure is done privately and quietly, by an older woman of the community who is reputed to be knowledgeable in this area. Afterward, the infant's mother should hand out candy to family members as an announcement of the operation: "Everyone must eat sweets so that they will be happy," I was told. Female friends and neighbors visit, and may give the mother small amounts of money. On the third day after Saadiya's daughter was operated upon, she took her to the *qubbas* of Sheiks Nejm, Ibrahim, and Hassanoon, and walked around each one. Then, Saadiya washed her own face and hands in the Nile, and washed her baby's face, hands, and feet as well. Traditionally, mother and child should cross the Nile at the time of the first new moon following the operation, which Saadiya did, in

order to undo the effects of any supernatural harm—the pre-Islamic and perhaps originally Nubian concept of *mushahra* (Callender and El Guindi, 1971)—to which a newly excised child is considered vulnerable.

A great deal of attention is paid to babies in West Aswan. Whenever adults see a baby in the vicinity, they will invariably invite the child to their side to be hugged and kissed. There are usually older children around the house or neighborhood to play with them, and both boys and girls delight in carrying smaller siblings as they form play groups within the village. Babies are socialized by the entire community. Both women and men of the extended family take responsibility for teaching a child what to do, but anyone who lives in the village may reprimand or instruct a village youngster. I realized that I had been accepted by the people of Gubba when I could tell young girls to go down to the river to get water for me. On the other hand, I was always vulnerable to instruction myself, as the villagers continued to direct my actions throughout the time I lived there. Indeed, every person in the community has the right to tell one another what to do, a fact of village life that took me a long time to get used to.

In general, children are breast-fed until they are approximately three years old, although softened solid foods are introduced after the first year. Little girls are assigned tasks around the house as soon as they are judged able to perform them. Around the age of one and one-half, they begin to mimic the work of the older females in the home, learning by experience rather than by overt instruction. The easiest tasks, such as sweeping the floors, come early, whereas a chore such as going for water must wait until she is strong and skilled enough to carry a bucket of water on her head. The youngest female in the house is assigned the most tedious, repetitive chores, or the ones needing the least amount of skill to perform, whereas the older females do the more interesting jobs. The senior woman of the household has the right to act in a supervisory capacity, and does so constantly and insistently, whether or not there is any real need for her direction.

A young girl begins early in life to take actions that involve her in the networks of which she will be a part throughout her life. One of these is the network of older female relatives—mainly, but not exclusively, her mother, her mother's mother, and her mother's sisters. For them she works long and hard during her childhood, at any task they may require of her. For instance, if there is no young female in a household and there is a pressing need for one, it is possible for a child to be "borrowed" from another household for a while. On my

first visit to Gubba, Saadiya and Rohiyya felt that it was necessary to have someone constantly on call to attend to the old Hajja, and so Ahlam, Saida's daughter, lived there also. This twelve-year-old, in addition to caring for her grandmother, did most of the household chores, which included sweeping floors, washing dishes, drawing water daily, and washing the family's clothing weekly. When I returned to Gubba three and one-half years later, the number of the household members was reduced, but Ahlam moved in with us shortly after I arrived and again helped with the housework.

In other households, young girls may also bake bread and shop for food regularly, and they may also be the primary baby-sitters. The older women, for their part, may wish to show their appreciation for and cement the relationship with their young relative by giving her periodic gifts of old (or new) clothing, jewelry, sweets, even small amounts of money. Later on, they will reciprocate further during her wedding ceremony, or when she gives birth, or at any other time at which she may need the help and advice of experienced older women.

A Nubian female's other major network is that of her peer group—girls with whom she grows up in the village. Often, groups of little girls can be seen running around the village, involved in some game or generally getting into mischief. Girls go to the canal or river for water together, and go to the government store for sugar, rice, and oil in groups. Such groups are usually composed of four or five girls around the same age and the younger siblings for whom they are caring. In such company, younger girls learn from older ones, tasks are lightened, and there is great opportunity for diversion. A young woman tends to have a special friend or two with whom she does most of her socializing. They go to and from school together, do their homework with each other, and go visiting other girls in tandem. They borrow each other's clothes and pieces of jewelry, share secrets, and talk about boys in a frank and open manner. Teenagers and preteens are very interested in the rock and roll of the United States and enjoy listening to cassette tapes, which they have usually borrowed from their brothers. They form impromptu (all-girl) parties during which they try to sing along with the tapes and teach one another the newest dance steps.

As young girls grow into young women, their attire begins to reflect this maturation. Little girls run about bareheaded, in brightly colored dresses, but as they get older, they wear scarves more and more often and begin to borrow their mothers' *tarhas* when they leave the house. At age sixteen or seventeen, the young woman puts

on a *jarjar* when going out, gradually wearing it more as time goes on. In the past, she may have discarded the flirtatious *jarjar* for the more staid *gallebeya sufra* and *kumikol* when she got married, but nowadays, even married women can be seen in the lacy, flounced overdress. As a woman matures, however, she dons more sober clothing, until, as a matron with grown children of her own, she will only countenance solid black attire.

Traditionally, girls did not go to school, but learned everything they needed to know from the women around them. Today, however, Nubian parents encourage their daughters as well as their sons to attend school and do well. Nevertheless, very few Nubian village girls seek higher education, although there are twelve coed universities throughout Egypt. Most expect to get married upon graduation from secondary school, have children as soon as possible, and become homemakers.

▲ Courtship and Marriage

In the days before girls went to school in great numbers, they married between the ages of fourteen and eighteen. The preferred marriage partner was a relative from either side of the family; often siblings betrothed their children to each other. Although the senior female members of the family were usually the initiators and primary negotiators, it was important that both male and female seniors agreed to the match before it could take place.

The proper method of opening negotiations was for the mother of the young man to approach the mother of the young woman, never the opposite. The girl and her family must not appear too eager, even if everyone had been expecting this merger for years. When siblings marry their children to each other, it is highly probable that the young man's mother knows the young woman quite well—has watched her grow up, in fact—and knows her faults as well as her virtues. Nowadays, however, because more and more people are marrying outside of their immediate families, it is possible that the girl is not well known to her potential mother-in-law. If a woman's son approaches her with the news that he has seen the girl for him, at a wedding celebration in another neja, for instance, and asks her to investigate, she will inquire among the members of her network as to the girl's reputation and availability. If the young woman has not accepted any other suitors, and her reputation is a good one, the young man's mother will approach the young woman's mother. The

mother of the would-be bride will then speak with her husband and her daughter about the offer. The daughter herself has first right of refusal, but even if she wants the young man and her father does not, the match must be abandoned. If the girl's nuclear family wishes the union, they speak with other family members, and it is at this time that any information concerning the past behavior of the prospective groom and/or members of his family is advanced and examined. The balanced and complementary nature of the female and male spheres of Nubian society can best be seen in such cases, as the information garnered through male networks is often different from that gathered from female ones, yet both kinds are needed to contribute to this important decision.

Nowadays, parents are less and less able to impose their will upon their children in this area. Young women now tend to marry in their late teens or early twenties, and men marry much later than that, so they wish to have more of a say in their own futures. Young people may meet as students, or at village weddings, if they have not known each other from childhood, and form romantic friendships if they can. The mores of Nubian society demand that young people of opposite sex act in a constrained manner in each other's presence, but their curiosity about each other remains undiminished in spite of their outward display of indifference.

Young men and women watch each other constantly, observing the appearance, manner, clothing, and speech of members of the opposite sex. Young men watch girls as they walk along the road, as they go for water from the river or canal, as they ride to Aswan on the ferry. They gather in groups near the girls' schools at the end of the school day and may follow them with their companions as they walk home, talking with the girls and teasing them. Young women watch men and boys as they are working or relaxing and may flirt with them briefly. This is a somewhat risqué thing to do, however, since a properly raised Nubian woman should never speak publicly to unrelated men; in fact, boldness in conversation with any member of the opposite sex, in public, is considered inappropriate behavior in females. Nevertheless, unmarried men are aware of the constant scrutiny of unmarried women and know that they will be talked about by them, much as they themselves gossip about young women. Thus, they try to dress and act in a manner that will present them in their best light whenever there is a possibility of being observed.

The constraints of proper behavior are, to Nubians, of the utmost importance, and they characterize this importance by the

Arabic word "mu'addab." This term has been defined as "polite" (various informants, personal communication) or as "propriety" (Eickelman 1984); I think of it as the idea of acting in a socially appropriate manner. This includes the observation of such rules of courtesy as sitting up straight, rather than lounging, whenever an older person or a nonrelative enters the room, and standing up to shake hands upon being greeted. It also may involve more ongoing personality traits, such as eating very little when offered a meal at someone else's home, so as not to be considered greedy. Very importantly, it has to do with one's demeanor when in the company of members of the opposite sex: Both males and females assume a mask of shyness that is often completely at odds with their real personalities. Teenagers affect an air of disdain and condescension toward one another that is similar to that which U.S. adolescents show toward their parents. Older people, when in the presence of members of the opposite sex who are not family members or good friends, talk quietly and politely without the effervescence so characteristic of Nubian social exchanges in private life.

There are occasions upon which it is perfectly acceptable, however, and even desirable, for males and females to openly enjoy each other's company, but these times are highly structured. The two most frequent situations are the informal setting of the home and the setting of weddings and other joyous ceremonial occasions. The only time that women and men feel comfortable sitting together for longer than ten to fifteen minutes is in the privacy of the home, and then only if they are related to each other. In the home, a family and its close friends may relax together; people tease one another and joke together, entertain one another with witty badinage, and even interact on a physical level. Here is where a man might touch a woman on her hand or arm, or even hug her affectionately. This kind of familiarity, even in the home, is done in groups, however, as an unmarried couple (siblings excepted) should never be alone in the same room together. And whenever strangers are present, all adhere to the formality that characterizes public behavior.

At weddings, people of opposite sex are expected to talk and joke together, but not for long periods of time. Men and women sit separately at all social functions, but interact as they move from one part of the courtyard to another, visiting friends. Older people banter good-naturedly, while younger ones flirt. This is where a young man might be able to exchange a few words with the girl he's had his eye on, or a young woman, in her new dress, may contrive to walk

past one of her admirers. A teenager may for many weeks cherish the memory of a brief flirtation, the intensity of the encounter heightened by its very brevity, convinced that this is true love.

When a young man sees a girl that he thinks he might like to know better, he first of all consults two or three close friends about her. After ascertaining that her reputation is good, he proceeds with his courtship. If he is serious about her, he will try to see her daily, and she will often be able to judge his intent by this. In the early stages of their courtship, he may just speak to her briefly as she goes for water in the afternoon, but as time goes on they will talk for longer periods of time. If he respects her, he will always be sure to approach her when she is in the company of other people, and she, for her part, will never talk to him alone.

The young suitor may get to know one of her brothers well and spend time with him, attempting in this way to see more of his beloved. He may eventually begin to speak of her, and if the brother likes the young man, he will give a kind of tacit approval to his friend's expectations. The young man will also encourage his sisters to befriend the object of his devotion and act as go-betweens for them. After several months, it becomes generally known that the two young people have an exclusive relationship, and any other young man who might be interested in her will refrain from pressing his suit. This is the most dangerous phase of the relationship for the young woman, for until this time she could slow it down or break it off at her discretion. But after it becomes known that the couple is "going together," her reputation suffers if the liaison is ended.

Nubians tend to be intensely romantic, and young men in love press their suit with poetry, songs, and beautifully worded compliments. Nevertheless, it is the young woman who sets the pace of the courtship, and the more reluctant she seems, the more virtuous she is judged to be. In spite of the fact that many young people in the community are favorably disposed toward romantic friendships of this sort, many other villagers tend to adhere to the "good girl/bad girl" double standard. The young man, while applauded for his faithfulness and unswerving devotion to his beloved, is nevertheless excused an occasional lapse, but a young woman who entertains more than one suitor at a time is branded a hussy. Indeed, her first romance is supposed to be her only one, and lead directly to marriage. If it does not, people gossip, and this is the main reason that most young women are reluctant to enter into this kind of long-term romantic involvement. Village gossip is a powerful means of social control, and is aimed at controlling the behavior of both males and

females. Women talk primarily about the behavior of other women, as this is what they most often observe, whereas men talk about the behavior of other men. In a case in which a girl and boy are "going together," the couple's doings are fodder for both male and female networks. According to my informants, however, the girl's reputation remains protected by her fellow villagers; while they may have their opinions of her virtue, these opinions will not be shared with outsiders. Thus, if a man from another area should approach her family with an offer of marriage, he will never be told of the young woman's past behavior.

A romantic relationship of this nature is never the sole business of the couple involved. For instance, if an older male relative or the parents of the young woman are suspicious of the young man's motives or of his readiness to marry within a certain period of time, they have the right to refuse him access to her. Or, parents may be ignorant of the friendship, particularly in its earlier stages, and accept the suit of some other man who is ready to marry immediately. In a case like this, the young woman must decide between a budding romance that may or may not lead to marriage (and that will damage her reputation if it does not) and a definite proposal of marriage from a man she hardly knows (but that will ensure her a respected place in the community). Since most young women are obedient to the wishes of their elders, she would most probably heed their advice in such a situation. The young people, both female and male, with whom I spoke were clearly aware of this quandary, and while desiring romantic love in marriage, seemed resigned to ultimate filial obedience, if they should have to make the choice. Most of the parents with whom I spoke expressed concern that, in such a situation, a girl's head may be turned by honeyed words or a handsome face, and she will insist upon marrying someone who cannot support her; thus, the selection of a marriage partner should be left to those older and wiser. On the other hand, several parents stated that they would be quite happy to allow their children to find their own spouses, saying that romantic love is an important component of a successful marriage. People referred to the few love matches in the village as examples of situations that worked out well, whereas those of the opposite opinion noted that these were very few indeed. In any case, marriage is still the ultimate aim, for both males and females, of any romantic relationship between the sexes.

A young woman's networks come into full play during her engagement (*shebka*) and wedding (*farraH*) ceremonies. Charles Callender and Fadwa El Guindi (1971) examined these celebrations,

and their accompanying round of feasts and prestations, in detail for the village of Dahmit in Old Nubia; here, I will focus primarily upon the exchanges of food and other items between the families of the bride ('aruusa) and the groom ('ariis). This series of exchanges constitutes a public announcement of the union and the acceptance of this union by the entire kin group, and it is made possible only by the unstinting labor of the women of those families, who form the network of the bride-to-be.

The Shebka

On the morning of the *shebka* celebration, both the 'aruusa and the 'ariis engage in beautifying activities. The 'aruusa and five or six close friends visit the hairdresser to have their hair washed and styled, and their faces made up with a variety of cosmetics; the 'ariis and his friends go to a barbershop where they are also groomed. When the 'aruusa returns to her home, she receives the guests and well-wishers who stop by to offer their congratulations. The work of cooking for and feeding these guests is done by her mother and mother's sisters, and any close friends of the family who wish to volunteer.

The guests, as well as the bride's extended family and her friends, for their part, give *nokut* to the 'aruusa. Nokut is a gift, most usually in the form of money, given to the 'aruusa and the 'ariis. Members of the groom's extended family and his friends give *nokut* to him also. Often the membership of these groups of relatives overlaps. Meticulous records of these gifts are kept, and each is conscientiously reciprocated: The exact amount of *nokut* is repaid, plus a little bit more, at whatever future life-crisis ceremony arises for the giver. In this way, people are motivated to give at *shebkas* and *farraHs*, knowing that they will receive at least as much as they gave when they themselves marry, or, in the case of older men and women, when their children do.

That evening, a large meal is prepared by the bride's family for the guests who have come to witness the presentation of the engagement gifts to the 'aruusa' and the 'ariis. Callender and El Guindi report that, for Old Nubia, the shebka extended over a three-day period, but during the time of my fieldwork there was only one night of celebration. At this time, the 'ariis formally and publicly presents to his 'aruusa' the gold jewelry (a gold ring, bracelets, a chain, and a medallion) that serves as a visual reminder of the ties between the two families. The young woman will wear these symbols of the married state for the rest of her connubial life. In addition to the shebka jewelry, the 'ariis may give her lingerie, dresses, perfume, and make-

up. These items, taken earlier in the day from his house to hers by his mother, are sitting on display in a nearby room. There is usually a band playing both traditional and modern music for the entertainment of the guests, who may also dance and sing along to the music.

During the days after the *shebka* ceremony, the 'aruusa and her relatives bake sweetbreads and cookies, and take or send them to various members of the 'ariis's family. Between the *shebka* and the *farraH*, the couple, now engaged, begin to spend more time with each other. Several of my informants argued that the couple, because they had signed the papers legalizing their union, is now, in reality, husband and wife. They do not begin to live together at this time, however, but they may go to the movies together if they wish. He may visit her often, and they may sit and talk, making plans for their future. Some couples buy household articles together, such as the refrigerator and the stove, dishes and glassware, and some men may allow their fiancées to choose the upholstery for the living-room couches; in most cases, however, these purchases are the prerogative of the 'ariis.

As the date of the wedding ceremony approaches, the bride-tobe is expected to travel to the various villages in the vicinity, to personally invite her friends and relatives to the ceremony. It is at that time that she may receive gifts of jewelry from her female relatives. Her mother may take this opportunity to present her with the gold that she herself wore at her own wedding, and her mother's sisters may give her some older, traditional pieces. In addition, she will attempt to borrow as many of the traditional older Nubian gold necklaces as she can, and as she takes tea at each house, she allows everyone to admire the beautiful heirlooms as well as the newer, more modern items.

The FarraH

The night before the wedding is called *leylet-el-henna* (henna night), during which there are separate parties at the homes of the bride and the groom for their respective kinsfolk. Throughout all of this day and the next few days, the women of both families, along with their networks of relatives and friends, work preparing the food for the feasts that take place on this evening and the next four nights. Although each kin group eats with its own relatives, the *'aruusa'*s family sends some food to the house of the *'ariis* and his family. Before the guests leave in the early hours of the morning, each receives a handful of henna for good luck and, traditionally, sleeps with it in or on his or her hands all night. The following day, both the *'ariis* and the *'aruusa*, along with their respective bridal parties, go to the hair-

dresser as they did for the *shebka*. Before the coiffure, however, the bride is bathed, hennaed, and depilated in her own home. She sits first in a room in which incense (sandalwood from Sudan and cologne) burns over a low fire, while a paste of milk, egg, and a finely ground, cornmeal-like substance is massaged upon her face and body. This procedure opens the pores and sloughs off dead skin, making the body smooth and soft to the touch. Next, she is washed with warm water, and her bodily hair is removed with a mixture of sugar, water, and lemon. This mixture is put on while it is warm and left on until it becomes viscous. Then the hairs are pulled off in a painful but effective manner; body hair is considered repugnant to a newly married couple. Her friends then draw designs upon her hands and arms (up to the elbow) and feet and legs (up to the knee) with the henna.

At the hairdresser's, her friends help her put on the white, Western-style wedding dress in which she will sit, silent and expressionless, later on at the *farraH*. From there, the entire bridal party goes to a photographer, one of the many in Aswan who specialize in such things, to pose for wedding pictures. When they return to the village, upon disembarking from the ferry they will all pile into taxis and drive the length of the road, from the first *neja* to the last, singing wedding songs, honking horns, and calling out joyous salutations. Finally, they part—the groom and his friends going to his home; the bride and her retinue going to hers.

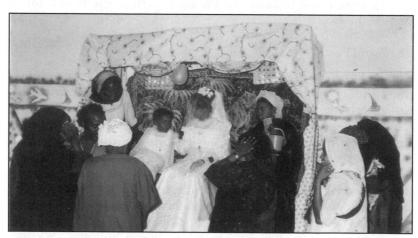

The 'aruusa on her bridal chair

The bridal chair is placed upon a raised dais, and the 'aruusa sits in full view of all the guests, the bridal party surrounding her as she receives the good wishes of her neighbors and relatives. Her best friend sits next to her and records the *nokut* she receives from each guest. The guests sing and dance for her, calling out congratulations and ululating in joy.

During the *farraH*, once more there is celebration and feasting in the households of both the bride and the groom, with each family cooking for its own guests. While some foods are cooked especially for weddings, most of the wedding feasts I have eaten were composed of everyday dishes: various stews made of string beans, eggplant, squash, or okra with onions, pepper, and large chunks of meat; in addition, there was always rice, potatoes, beans, and *molokhia*, with the robust Nubian bread. Special wedding dishes include *fatta* (Nubian bread soaked in lamb stew with rice), *sheriya* (a sort of sweet noodle pudding, which is traditionally eaten at dawn on the first day of the *farraH*), and stuffed pigeon with a thin pancakelike bread called *fitir*.

Late that night, the 'ariis and his party arrive at the home of the 'aruusa. He ascends the dais and sits next to her; amid cheers and ululations, they feed each other pieces of cake and sips of sorbet, to symbolize the sweetness of unity and sharing in married life. Then the 'ariis leaves quickly, back to his own home. The guests who arrived with him now congratulate the bride and her parents, and stay to drink tea and eat sheriya as the sun is coming up. At the home of the 'ariis, his mother eats sheriya that has been prepared by the 'aruusa and sent to her earlier in the day.

Marriage, then, economically, socially, and ceremonially, is the most momentous occasion in the life of a Nubian man or woman. Rich and elaborate in detail and execution, the ceremony involves the entire community and serves to focus and reemphasize the basic needs and values of the family and, ultimately, the community. (Fernea and Gerster 1973: 30)

The mother, aunts, and sisters of the bride, along with their networks of friends, the female relatives of the groom, along with their networks, and the friends of the bride herself all work tirelessly to ensure that this is the most enjoyable and memorable occasion in the life of the marrying couple. The reciprocal exchanges that occur during this time cement the bonds between these families and highlight the importance of women's networks to this series of ceremonies.

▲ The Well-Respected Woman

Both before and after marriage, most Nubian women live in extended-family situations. Although nuclear families do exist, most of Gubba's households are composed of a woman, her husband, and her children living with one of her parents. Postmarriage uxorilocality is of ancient tradition, with the newly married couple living in the bride's family's home until he has amassed enough money to build them a house of their own. This typically takes several years; many of the women I knew had lived uxorilocally for an average of ten years. In past generations, when most men were migrant laborers, this served the purpose of allowing a young bride to remain with her parents while her husband was away, but nowadays, if the groom has a good job in Cairo or Alexandria, the bride may leave with him almost immediately and set up a household there instead.

Typically, a woman's day begins around 6:30 or 7:00 A.M. She makes her ablutions and says the morning prayer. If she has a husband and/or children, she awakens them, and all family members gather for tea with milk and sugar, and garagish (hard, toastlike breads that soften when soaked in tea). Most children are assigned household tasks that they must do before going to school: Little boys take the family sheep and goats and the donkey, if there is one, to pasture; and little girls go to the canal for water. After the children have gone to school, the women of the household will share such tasks as sweeping out the rooms and courtyard, washing the dishes left over from the night before, and making the midday meal.

Although most homes have refrigerators and gas stoves, few women in this community can afford such labor-saving devices as food processors, mixers, or blenders. Food preparation is therefore a time-consuming process. Breads, soups, and sauces are made from scratch; chickens must be killed and cleaned before cooking. Small pebbles and dirt must be separated from the rice, vegetables must be brought in from the fields and washed, and edible leaves must be stripped from their branches before anything further can be done to them. When a woman drops in to her neighbor's house during the day, to borrow an egg, perhaps, or to chat for a while before resuming her own duties, she will invariably sit down to help her friend with one of these ongoing tasks.

If there is farming to be done, a woman will go to the fields either in the morning or in the late afternoon, so as to avoid working in the heat of the day. Approximately once a week, a woman will go into Aswan to shop for groceries. Such staples as rice, sugar, and tea are bought there, as well as meat, chicken, and fish. If a woman has grown an abundance of fruit or vegetables, she may take some to the market to sell. The Nubian women's market occurs on Thursday mornings, where they gather to sell mainly eggs and fowl, as well as

homegrown produce.

The midday meal is flexible and is eaten at different times in different households, but is usually between the hours of 11:00 A.M. and 1:00 P.M. A typical midday meal is composed of a meat or vegetable stew, bread, and *molokhia*. Tea with sugar is a necessary conclusion to every meal. Afterward, the woman washes the dishes and straightens up around the house. Perhaps she does a bit of mending or, if the weather is hot, takes a short nap during the heat of the day. At any point during this time, a friend or neighbor may come to visit, or she may go out to visit someone. Around 1:30 P.M., the children come home from school and are fed whatever leftovers remain from the midday meal. If a woman has no children who need attention in the afternoon, she will say the afternoon prayer; otherwise, she will wait until evening to do so.

A woman bakes bread for her family every week or so. Nubian bread, shaped in round, thick, robustly textured loaves, is baked in the large clay ovens that can be found in almost every home. In Old Nubia, women cooked a lighter, thinner kind of bread, on a large griddle, for every meal. Nowadays, however, this is done only for spe-

cial occasions, such as wedding feasts.

In the late afternoon, the women rest, usually sitting in groups on the *mastabas* in front of their houses to catch the evening breezes while crocheting small round bags and caps in bright colors, which they sell to tourists. Some time between the hours of 4:00 and 6:00 P.M., tea with milk and sugar is served to all inhabitants and visitors in the house. Often, *biskweets* (small breads, baked specifically for this delightful ritual) are served as well.

Dinner is eaten in the evening, also at different times in different houses, after the sunset prayer. Most men are home from work now, and the whole family is present for this meal. The evening meal is similar in composition to the midday meal, except that the amount of food is greater. There is usually a chicken or fish dish, rice or potatoes, and two kinds of vegetables, along with bread. Tea with sugar is then drunk. In many homes, the traditional pattern is followed whereby the man or men of the house eat first and then the women and children eat, but in other homes everyone eats together. If there are guests, they eat with the man of the house. It is at this time of day that men and women talk most, exchanging news and making plans

for the next day. After dinner, the men go off to meet one another to smoke and talk.

The well-liked and highly respected village woman is one who most closely approaches the ideal of Nubian womanhood. She is pious: prays daily, fasts, lives as much as possible according to the tenets of Islam. She is obedient to the wishes of her husband and the older males of her family, and indeed "listens to the talk of" all senior individuals. Her demeanor is subdued and respectful toward all, and her dress is appropriately modest.

Relationships with other women are of major importance to her. Most women in the village have a special group of very close

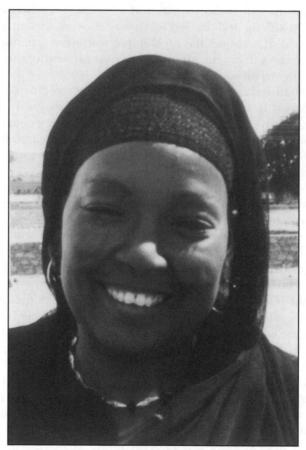

Sabaha, a well-respected woman

friends-sometimes only three or four-with whom they do most of their socializing. This convivial group expects to meet every evening after dinner to talk, joke, gossip, watch TV, and otherwise pass the last few hours before bedtime. Other women may join them-everyone is welcome—but attendance is "mandatory" for the core group, and if one of them is not present that evening, an explanation is sought. Although most of these women have seen one another off and on throughout the day, they agree that it is important for close friends to relax together (twannis) at the end of the day. Friends give each other a great deal of positive affect and support; one helps with the housework or goes to the market if the other is ill, or watches the house when the other goes out. In addition, friends share good things: food, music, good conversation. Friends go places together and enjoy each other's company. Several informants stressed that a good friend is one with whom you can speak without worrying that she will repeat what you have told her to others, and she does not gossip with others about you; you can relax with her.

When a woman eventually moves into her husband's house, it is cause for a celebration: the *degir*. On this occasion, she packs up all of her household goods, and with the help of the village women, moves them to her husband's home. The wife enters their new residence first, and as she does, she takes a sip of milk from the glass being held by her mother-in-law standing just inside the door. As the women enter behind her, some may also take sips, to symbolize their hopes that they, too, will soon move into their husbands' homes. Although Callender and El Guindi report that the food and drink for this occasion is provided by the wife's family, my informants stated that the feast is given by the husband's female relatives. Additionally, in Old Nubia, an animal was sacrificed at the gate by the husband's family, and the wife stepped into the *hosh* over its blood, but I did not see that done in West Aswan.

The young married woman typically experiences no sudden break in the relationships that she has built up over the years, and even when she moves into her husband's house, the move may take her only as far as another *neja* of the same village. In many instances, the husband has had an adjoining wing added on to his own natal home, so that the conjugal pair and their children, if any, will now be living close to his natal family rather than hers. In traditional times, husband and wife were, ideally, closely related, so that the wife often was not moving in among strangers, but into just another branch of the family.

As long as she remains in her natal home, she interacts on a daily

basis with the members of her two significant networks. When she moves away, she has to develop a new peer-group network among neighbors in her new environment, upon whom she will lean more heavily. She also sees her mother less often, but draws closer to the women on her husband's side of the family. No matter where she is living, a woman tries to have her firstborn in her mother's house, with the help of her female consanguinity.

As the years pass, she may "loan out" one of her daughters to her mother or to one of her sisters, or she may "borrow" a niece to help her for a while. Her networks will serve her and her children at the time of their weddings, just as her mother's networks did when she was married, and she will reciprocate at the ceremonies of her siblings' children.

As an old woman, she will not live alone; one of her children (typically a daughter, her husband, and children) will remain with her in (ideally) her husband's house. If her husband is dead, the house is referred to as hers, but, in reality, it is the property of the extended family.

Traditionally, when a woman's husband died, she had to stay inside of her house for a period of four months and ten days. The members of her networks did all of her shopping and other outdoor activities for her. In modern times, this practice is slowly being eroded due to the inconvenience it causes. When she herself dies, her networks will once more galvanize for action, although they will no longer be those of her mother and mother's sisters, but those of her daughters and sisters' daughters. There may be members of her peergroup network still remaining as well.

Among Nubians, condolence obligations are very strictly observed. Relations and close friends are expected to sit with the bereaved family for days, sharing their sorrow and helping them through the shock of the death by just being there. A very important function of a woman's closest networks is this consolation process ("giving azza") and the housekeeping duties that go along with it. Because the bereaved woman must not cook or clean for seven days following the death of a close relative, other women in the community take turns fulfilling these responsibilities; and although almost every woman in the village eventually contributes food and time to this, it is a woman's peer-group network that is at the core. There may be thirty to forty women living and sleeping in the house during this time, so that the need for a core group of women to take control of household functions is great. After the seven-day mourning period is over, and the hordes of women go back to their homes, this group

continues to visit every evening for the remainder of the forty-day mourning period. At the end of this time, there is a ceremony (the *arbaeen*) that acknowledges the end of official mourning.

▲ Women's Property

The most visible kind of property for women is their jewelry, to which every Nubian female is entitled at some point in her life. Tourists and visitors to a Nubian village are often surprised at the amount of gold jewelry that is worn by women there. The importance of such adornment is well known in Egypt: A Nubian woman takes pride in her ornaments and the way in which they enhance her beauty.

As recently as the mid-1970s, women wore both silver and gold jewelry (Fernea and Gerster 1973). Gradually, however, perhaps because of the rise in economic fortunes since the High Dam was built, they began to replace their silver jewelry with gold. Nowadays, four different kinds of gold ornaments may be worn by village women: a set of three pairs of earrings, a group of necklaces, a set of

three bracelets, and a pair of rings.

Three pairs of gold earrings are worn. The upper pair is hung through a hole in the cartilage near the top of the ear; the middle pair is worn in a hole approximately 2.5 centimeters lower in the cartilage; the third pair is worn hanging from the earlobe itself. The upper and middle pairs are called tameem, and the third pair is named zumam kabir. The earrings are crescent-shaped, generally of 22-karat gold, and display intricate designs. Measuring 4–6 centimeters across, the top tameem can be so heavy that they pull down the cartilage, bending it over. Less tradition-minded women point to this fact as a reason to discontinue wearing the tameem. Younger women have stopped wearing the zumam kabir, as well, and prefer just a gold hoop in the lobe.

Three kinds of necklaces are worn. The shortest is composed of plain gold beads, each about 3 centimeters long, strung on cord or twine. Each bead is called a *zatun* (Arabic for "olive," as the bead has that same general shape); the necklace, a *zatuni*. Sometimes the *zatuns* are interspersed with other—glass or agate—beads; eight or nine *zatuns* is the preferred number for a *zatuni*. If, however, they are interspersed with gold disc-shaped beads called *sheff*, the necklace is called a *sheffi*. The *sheffs* themselves may be gold coins or medallions that have been made into beads, or they may be discs cut out of gold sheeting and embossed with a curvilinear pattern; they usually mea-

sure about 2.5 centimeters in diameter. The longest and most elaborate necklace is called a *nugal*, after the beads of which it is composed. These beads are about 3 centimeters long and tube-shaped, adorned with two thick discs attached to them. The *nugal* usually incorporates a pendant, which may be a large coin, medallion, or gold star-and-crescent, which hangs at midtorso. I saw the *nugal* worn very rarely, only during ceremonials connected with weddings.

Egyptian-made bracelets are about 3 centimeters wide, composed of thin 22-karat gold. Most women wear three of them on the right arm. Bracelets from Saudi Arabia arc narrower, and a woman may wear more of these. Two kinds of rings are worn: The *dibla*, which is worn on the third finger of the right hand, indicates that the woman is engaged; whereas the *khaatib*, worn on the third finger of the left hand, shows that she is married. Most rings are simple gold bands, but the *khaatib* may have a stone.

Usually, jewelry is received as a gift. A Nubian girl may receive gold jewelry from her parents when she is still an infant—an expression of their love and joy at her birth. As a girl gets older, her mother may give her a pair of her own gold earrings, and later on, she may get her mother's jewelry at a more solemn occasion: When a woman's husband dies, it is socially inappropriate for her to continue wearing her gold. Although a widow may keep one or two favorite pieces, she will give the bulk of it to her daughters. If they are still single, her daughters will put the jewelry away until they become married women, as unmarried girls do not wear much jewelry.

Although a young woman may receive presents of jewelry throughout her life, it is not until she is engaged that she receives her most significant prestations, from the family of her fiancé during the *shebka*. Men who are migrant laborers in Saudi Arabia return with items for this occasion; and the *sheffi* and the *nugal*, traditional *shebka* gifts, are quickly being replaced by a long, Saudi-made gold chain and accompanying medallion. Jewelry bought in Saudi Arabia enjoys a prestige that Egyptian-made jewelry does not, perhaps because it is associated with the place of pilgrimage or with the abundance of money that the migrant laborer earns there. As the size and length of the chain and the ornamentation surrounding the medallion reflect their cost and, correspondingly, indicate to the recipient, her friends, and her family the extent to which her future in-laws value the union, everyone is anxious to view them.

Although a married woman's gold is generally considered hers, there is a time when a man might lawfully demand that she return it to him. If he should divorce her and they have had no children, he

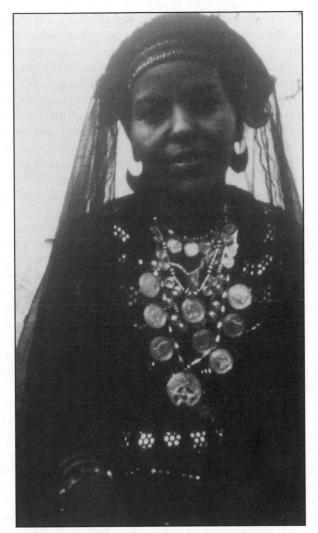

The 'aruusa wearing traditional gold jewelry

takes back all of the jewelry he bought, as well as the household articles and furniture. It is assumed that she will remarry and, in doing so, her new husband will supply her with new goods; her ex-husband will need his belongings to present to his new wife.

One of the most important activities of a married woman begins after she moves into her husband's home. Some years after she and

her family are settled into the new house, she begins to think about enlarging and/or improving it in some way. The purpose of these actions is varied: The installation of plumbing, along with faucets and sinks, makes for greater convenience, while the addition of tiles in the courtyard contributes to the beauty of the home. The construction of additional rooms and floors serves another purpose, however, and is the pride of a Nubian wife. In their various interviews with me, the women of Gubba proudly pointed to the additions that they had made over the years. They spoke of their actions as "building the house" and took the major credit for so doing, in spite of the fact that the expenses were paid from their husbands' paychecks.

A major investment of time and capital, "building the house" is, customarily, a right and duty of a married woman. The mistress of the house supervises the workmen. In addition to a sum of money, she must also provide meals twice a day and tea three times a day, while they are employed. In this way, five, ten, or even twelve rooms are added to family domiciles in Gubba over a ten-to-fifteen-year period. Much of this building takes place in view of the day when a woman's daughter(s) will marry and live in the household uxorilocally. A couple living in this way must always have a private apartment in the home, with a separate entrance if at all possible. These apartments, which in newer homes tend to be on the second floor and in older ones are built within the courtyard of the parents' home, all have at least three rooms and a kitchen.

Because construction work is of low status, Nubians hire Saidis when they can to do the manual labor. This is one of the reasons, so I was told, that the newer houses no longer look like traditional Nubian homes: Neither the Saidis nor the younger Nubians know how to build them anymore. When the additions are completed, friends and neighbors visit in order to look over the new rooms and congratulate their owners.

Nubian women have traditionally (stemming perhaps from pre-Islamic times) had the right to earn extra money; in the past, they raised sheep and goats to sell, which helped support them when their husbands were migrant workers, but which they continued to do even when their husbands were living at home (Callender 1983). Today, in the Aswan marketplace, Nubian women sit in a section reserved for them, where they sell eggs and fowl. Fernea and Gerster (1973) reports that women had the traditional right to own part of the date palms:

The initial ownership of a palm tree was usually based on a threeway partnership between a land-owner, the owner of a palm shoot, and the person (usually a woman) who watered the shoot constantly over the many months before it got its growth and could draw sufficient moisture through its own roots. (1973: 18)

It was assumed that when part of the crop from these trees was sold, the women who had watered the shoots would get a share of the proceeds. The money that a woman makes today, in the market and through the tourist trade, is hers to do with as she chooses.

Women in Gubba also organize themselves into moneymaking groups that they call jam'iyyas. These are rotating credit associations into which each woman pays a certain amount for a certain period of time (for instance, five Egyptian pounds [EP] each month for twelve months). At the end of that time, one of the women is designated to receive all of the money, which she will use for whatever expenditure she wishes to make, and the system begins again. The jam'iyya continues in operation until each of the women has received her share. A woman may use money from her jam'iyya on any expense, ranging from gold jewelry to the installation of plumbing in her house. Several of my informants used jam'iyya money to enlarge their homes; it is really the only way in which a village woman can get large sums of money for expenses that she considers vital.

In West Aswan, a married woman is prized for her ability to manage the household, not to earn money: Both males and females recognize that it is the husband's duty to support his family financially. A good wife aids him by managing his paycheck in such a way that the family lives well, but not extravagantly. The small amounts that she may make through her own efforts should, ideally, not be used to

support the family, but spent on nonnecessities.

The village woman's other economic duties are also recognized as important to her family's way of life. Her role of wife and mother is basic to the well-being of the family: Not only is she involved in childrearing and homemaking, but she also raises and tends the domestic animals, helps weed and harvest the crops, and processes the products of the field for human consumption. Egyptian villagers explicitly state that "without a wife a man cannot have a home or the assistance in the field which make him a self-supporting, independent adult" (El Hamamsy 1970: 595). In Gubba, women have control of the daily running of their households, and even though men are the primary wage earners, women suffer no loss of respect because of it. A woman's ability to allocate household resources successfully comes only after long experience, and both men and women recognize this; a young girl is not expected to have mastered this art until she has been married for several years. The well-liked and highly

respected village woman is deferred to by her husband in day-to-day household matters, accorded ascendancy in terms of private sphere concerns, and expected to be competent and knowledgeable within her domain.

4

Growing Up Male in West Aswan

Much of the information in this chapter is, of necessity, secondhand. Since Nubian society is one in which females and males do not spend a lot of time together, it would have been impossible for me to collect certain data through participant observation. While I did not cut myself off from the company of males to the extent that most village women did, I was nevertheless constrained in this respect, as women in the United States are not accustomed to such distance between the sexes.

On my first visit to the field, I spent approximately 95 percent of my time with the village women. Most of the information I obtained about the village and its inhabitants was from them, and my first impressions about their lives were formed through my observations of their doings in the women's sphere. It was only when I returned home to write my dissertation that I realized just how constrained I had been. The household in which I had lived had no adult men in residence, and the few males I had seen had been very close relatives of the women with whom I had lived; and they had not talked to me a great deal. Consequently, although I could write knowledgeably about the women of West Aswan, I had very little information concerning men's experiences or relationships with one another.

So, when I went back to the field in 1986, I let it be known that I wanted to talk with men about their lives. As I found out later, the family assigned one of Nabawiyya's sons, Ahmed, to me as a chief informant concerning the male sphere and as general guide and chaperon in the world of men. Through Ahmed, I became known to a segment of the village males—mainly those between the ages of sixteen and twenty-five—and also got to know several of my male "relatives" much better.

Ahmed and his best friend, Mohammed Orabi, took me on excursions to other *nejas* of the village, as well as into the town, where I watched their interactions with other men and asked questions

about their activities. I usually wore Nubian clothing upon these occasions and rarely spoke to strangers. In the evenings, Ahmed and Mohammed, along with two or three of their friends and/or relatives, would come to the house to visit. Ahmed brought only those males who could, through an extension of fictive kinship ties, be considered "brothers" or "sisters' sons." We would sit around listening to music, drinking tea, talking and joking, and smoking honey-flavored tobacco in the water pipe. Saadiya was usually in another room with visitors (female) of her own; even under these circumstances, the sexes rarely mixed. Because I was a foreigner, however, the strictures were relaxed for me, and I could hang out with my "brothers," smoking, as long as Ahmed was present. With him as chaperon, I was able to interview these young men upon several occasions.

I was very rarely visited by the older, married men of the village. This is partially because it would have been improper for even a

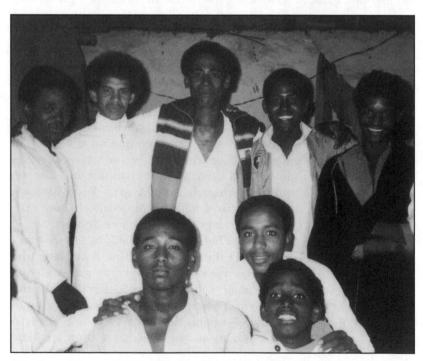

Top Row: Sihan, Abd El Shaeffi, Ahmed, Mohammed Orabi, Hassan Bottom Row: Hamdi, Izzu, Mohammed

foreign woman to relax in a room of mature men. In addition, however, men are most at ease in the company of other men of the same general age and status; the group that visited me was composed of immature, unmarried, largely unemployed youths who would have felt uncomfortable in the presence of men of higher status. When I wished to interview a more established man of the community, I spoke with Saadiya's brothers, Abdul Hafuz and Mohammed Hassan, or with Nabawiyya's husband, Abdel Razzik.

The periodic visits by spirited young men were quite enjoyable during the early months of my fieldwork, but as I became more socialized into the Nubian way, I began feeling less comfortable with them. Enculturation brought with it a greater internalization of social norms and a mounting desire to do what the other village women were doing. I began spending more of my evenings with my female friends, as I had done in 1982. This, not so much because I was concerned with what the neighbors might say, but because I missed their quiet camaraderie. While I did not completely stop seeing my male friends, I set limits on the amount of time they could sit around in my room. As I became more of a Nubian woman, I became more interested in the concerns of Nubian women, and less interested in the concerns of Nubian men.

In addition, as I participated more in village life as a village member, I became more reluctant to speak to strange men who had not first been introduced to me by one of my male "relatives." This had never been a problem before, as I had considered myself a lone wolf, proud of my self-reliance and independence, whose primary job was to get the information. I had readily acknowledged my debts to my informants, of course, but totaled up these debts in monetary terms, and expected to pay them as such. I never expected my informants to demand that I change my attitudes as part of their bill. Slowly and imperceptibly, I became less independent, less self-assertive, less audacious, and more compliant, more obedient to my "brothers" and "mother's brothers" (although not to any other males). I acted less often with only my own goals in mind and became more reactive to the wishes and desires of those whom I now called my family. This metamorphosis was achieved largely through the efforts of the males of the family. While Saadiya and her sisters taught me how a Nubian woman acts mainly by example, my "brothers" instructed me verbally, attempting every day to turn me into the kind of woman they felt I should be. It was through them that I finally understood that my behavior could at no time be independent; that whatever actions I took, either good or bad, while living in the village would reflect directly upon the family; and that they, especially the older men, were ultimately responsible for such actions. My reputation was their reputation, and any repercussions from untoward behavior on my part would probably be felt more by them than by me. I also came to realize that, while financial remuneration was expected, I could best show my admiration and respect for them by being obedient to their wishes. Money was all very well, but it was my actions by which the villagers judged whether or not I understood their lives. Consequently, I began to try to live up to their hopes for me, and probably went a little overboard in that direction. Unfortunately, I did not stay there long enough to identify the extent to which this ideal of Nubian female behavior could be stretched to accommodate less-than-ideal actions, or to find a happy medium between my natural intransigent bent and the obedience desired from my male instructors.

In this chapter, I discuss the activities and behavior of the typical Nubian male, as related to me by informants under the conditions referred to above. While some of this data was verified through my participant observation, much of it could not be.

Young village boys have chores that they must perform, but these differ from house to house. In families that have livestock, boys may take them out to pasture before going to school and bring them home in the evening. In the afternoon, and again at night, they take donkeys and cows to water, and bring fodder to them as well. Older boys may help around the house by fixing broken appliances and furniture, or by repairing plumbing and electrical wiring, but in general they have few household chores. In families with farmland, young men and boys plant seeds and reap crops as their parents direct.

Men expect to have their meals cooked, their clothes washed and ironed, and their rooms cleaned by their mothers, sisters, and later on, their wives. A young man going out in the evening will typically call on a sister to wash and iron a clean gallebeya for him, although this will differ from family to family. A considerate youth (or one with no sisters) will regularly wash and iron his own clothes, and sometimes cook his own meals and wash his dishes. Parents encourage their sons to study hard in school and aim for college if they can. Since boys have few household chores, they have more time for homework than do girls. They also have more time to develop hobbies, such as fishing and hunting (with guns, nets, and/or falcons), or engage in sports such as soccer. Young men also expect to be called on by their mothers' sisters and/or mothers' brothers for any agricultural or household help that might be needed, and they discharge these duties assiduously, much as young women do.

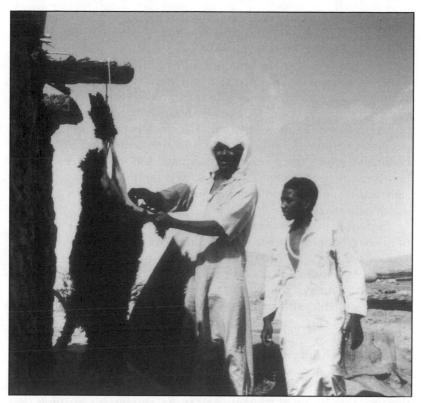

Young boys learn how to perform tasks from their older relatives: Abdul Hafuz teaches Hamdi how to prepare a sheep for a celebration

Young men, like young women, tend to develop close friendships with one another. Two boys of compatible personalities will spend a lot of time together, going into Aswan, visiting other young men, going to weddings or to the movies with each other, watching the girls, or just relaxing in each other's company.

A boy who is interested in making a little money after school can work with an older male relative on his boat. During tourist season, especially, the need is great for a youngster to do odd jobs, such as washing down the boat every day, which more experienced hands disdain. If the boy finds himself attracted to the boating life, he will persist in the work until he becomes old enough and experienced enough to assign the more tedious tasks to a younger boy. If he finds the money good, a young man may even quit school and go to work full-time on the boats. There is great incentive, for if he is willing to

work hard, a man can make a great deal of money as a boatman. With such earnings, an ambitious young man may eventually buy his own boat. Working for himself, he is no longer subject to others' rules, and the pay is better. In time, he may even become *il rayyis*—the boss—with his own employees to sail the craft while he remains ashore, making arrangements with the tourists. His aim is to own several boats and, in doing so, become financially comfortable. Nevertheless, it is a difficult occupation: The work is hard and uncertain, dependent upon the tourist trade and the health and skill of the boatman himself. It is a low-status occupation to some extent, as most boatmen are grade school dropouts, and the job is dirty and physically taxing; all this is mitigated, however, by the wealth that can evidently be earned.

A man may earn a living from tourism in other ways as well. One of my neighbors in Gubba started out, years earlier, as the owner of a kiosk selling cold drinks and trinkets to the tourists who came to see the Aga Khan's mausoleum. From his profits he bought livestock-most often a young cow-raising it and selling it to buy another, more valuable, animal. Finally, he invested in young camels, which he trained to carry tourists up the hill to the mausoleum and to the monastery of St. Simeon in the desert. When I knew him, he was reputedly a wealthy man, owning three such camels plus a younger one still untrained, a water buffalo, and a cow, as well as his original souvenir kiosk. He was at that time building a very large and impressive two-story house of concrete and stone, sinking his earnings into a showplace for his sons and their families to inhabit. A man such as this, with several working camels, will allow a younger man to take over the care and feeding of one of the animals and work with it transporting tourists. At the end of the day, the proceeds are shared by employer and employee. In this way, a young man may earn as much—or as little—as his ambition and the vagaries of the tourist trade allow.

The major employment opportunity for village men is the government job. The Egyptian government provides jobs in hospitals and hotels at all levels, as well as in schools and offices, on public conveyances and railroads, in the police department, and at the High Dam. Government jobs are steady and secure; there is a waiting list, but once a position is obtained, it is difficult to lose unless the job itself is just a temporary one. Men and women who are high school or college graduates are accorded job status commensurate with this, wear suits and ties or Western-style dresses to work, and receive

respect from others due to their positions. Unfortunately, the Egyptian economy is such that the pay from such employment is meager, and the hours are only part-time. Most men with such jobs are dependent upon a second income: Either they themselves work two jobs, or some other member of the family contributes in some way. If a man is lucky, his second job is involved somehow with the tourist trade. After a young man graduates from high school he is eligible for mandatory military service, but if he has been accepted into college this is deferred until he finishes.

A proportion of Nubian men are living outside of Nubia, working in the Gulf States, or in one of Egypt's own petroleum-producing areas, or in Cairo or Alexandria. In the cities, a man's best opportunities still lie with the government. Nubian men are found in all kinds of government jobs there, from clerical to manual labor. The traditional jobs for the Nubian male—those of servants and doormen-still exist, but most people are ambitious for something better for their sons. If a man can afford it, he will have his wife with him in the city; if not, he regularly sends a small amount of money to the village for her upkeep. A man may also marry a second wife, the urban wife, sometimes an Egyptian, who lives with him in the city, while he lives with his country wife, a Nubian, when he returns to the village for a visit. Most Nubian wives are quite unhappy with such an arrangement (mainly because it means sharing their husbands' already limited income), but since it is a right protected by religious and civil law, they feel powerless to prevent it.

Urban-dwelling Nubians have formed several voluntary organizations, well known in the cities of Egypt, as both conduits of information between the city and the countryside, and safe havens for new arrivals from the villages. Nubian clubs help recent migrants find jobs and places to stay, collect money for expenses, help city dwellers send letters and packages to families in the countryside, and conduct funeral obligations for those who have died in the city. In addition, they provide companionship and social support for members of a minority group who are living far from their homeland.

▲ What the 'Ariis Must Do

When a man has completed his military service and has secured a good job, his thoughts turn seriously to marriage. He will begin to save a portion of his pay periodically toward that end; some men give a little money to their mothers each month, which she invests in her *jam'iyya* for him. After several years, there should be enough to buy the gold for the 'aruusa.

At the same time, he begins to buy household furniture. He will commission a carpenter to make a bed and cabinets for the bedroom and sofas for the living room and pay him in installments over the next several years. If he has been working in Saudi Arabia or on the Red Sea, however, he will have had enough money to buy everything there, including the 'aruusa's gold, and have it all shipped home.

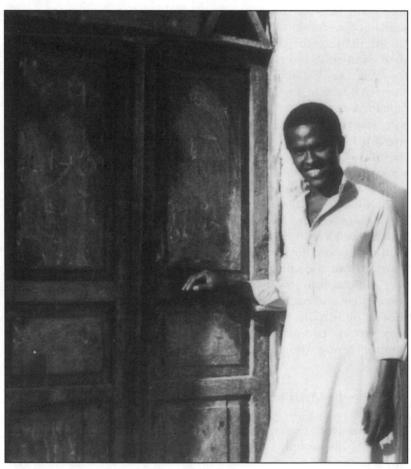

Ahmed's good friend, Mohammed Orabi

When all is in readiness, if he doesn't already have a "steady girl," he will begin looking for a young woman to marry. He may tell his mother that he wishes to marry within the family (perhaps one of her sisters' daughters, for instance), in which case she will canvass whomever of her relatives has available daughters and begin the matchmaking process. Many young men nowadays prefer to find their own brides, however, and do so with alacrity. One young man of my acquaintance came home on holiday from a good job in Saudi Arabia in order to find a bride. He saw a young woman at a wedding, decided to marry her, courted her, married her, and installed her in his new home filled with goods from Saudi Arabia (including a videocassette machine, a color T.V., and a six-burner stove) all within twenty-five days. After a honeymoon of one month, he went back to work in Saudi Arabia. Although many of the young people I spoke with in Gubba said that they would prefer to build a relationship slowly over time so that they could get to know their future spouse and vice versa, most marriages have been of the kind described above (albeit not as dramatic), rather than a result of a long-term romance.

When the couple (and/or their parents) agree to the marriage, the *shebka* is planned. As described in the previous chapter, the *'ariis* brings gold jewelry to his fiancée during this ceremony, as well as new dresses, perfume, and articles of personal adornment. In addition, the terms of the *mahr* are discussed. The *mahr* consists of gifts, usually money, from the groom's family to the bride. Legally, it can be paid in installments: The first part (the *muquaddam*) is given to the bride at the time that the marriage contract is signed; and the second (the *mu'akhar*) is deferred until a later date, for instance, at the time of a possible divorce, at the time of the husband's death, or at any time that the wife chooses to demand it. Typically, Nubian brides use the *mahr* to help defray the expenses of the *farraH*.

During the period between the *shebka* and the *farraH*, which may be several months or several years, the young man periodically gives his fiancée presents of clothing, lingerie, perfume, and money, perhaps as an indication of his acceptance of his husbandly duties toward her. During this time, he goes to see her every day, spends time with her, and may take her to parties or to the movies in Aswan. The young man may also at this time plan the *liHaff*, during which his friends and neighbors are invited to view his new furniture and their accoutrements. Throughout the day and into the evening, tailors whom he has commissioned from Aswan are sewing quilts, pillows, pillowcases, and upholstery for his new home. Friends of the *'ariis*, who themselves are considering marriage, view the furniture

with a special interest; if they are impressed, they will ask him for that carpenter's name and address, in order to use him themselves when the time comes. Food for the guests at the *liHaff* is provided by the women of the 'ariis's family, but the 'aruusa's mother sends sweets, some cake, and sometimes, a live sheep. In return, the *nokut* from the guests is sent back to her.

At some time within a week or so of the wedding, the 'ariis, his family, and friends take his furniture, bedding, kitchen equipment, dishes, and so forth, to the home of the 'aruusa. After setting up the furniture, they all have dinner there and then depart. As the date of the farraH grows nearer, the 'ariis and several close friends will go from village to village inviting people to the wedding, just as the 'aruusa does. His family will have already sent out printed invitations to relatives and friends living in the cities; he may also hire a truck with a loudspeaker to announce the date of the farraH to the various nejas of West Aswan. If he has sisters, they, too, along with some friends, will visit nejas and villages.

At the home of the 'ariis, leylet-el-henna and leylet-el-farraH celebrations are more elaborate and better attended than are those at the home of the 'ariusa. In addition to the large amount of food served, the 'ariis provides cigarettes, water pipes and tobacco, and all manner of other refreshments. There is usually a singer with a band, playing both traditional and modern Nubian love songs. In instances where the 'ariis is particularly well liked, and/or the music is especially moving, large crowds of men will surge toward the singer's platform, dancing and singing in unison. Women dance in their own group farther off, ululating periodically. At any wedding, relatives and close friends of the couple getting married are expected to show their joy by dancing a great deal.

Late in the night of the *leylet-el-farraH* (or very early the next morning), the 'ariis and his attendants go in to his parents and sing for them, receiving their blessings and good wishes. Outside of his home, his close friends surround him and sing in his honor, perhaps dancing a little in celebration, before leaving for the home of the 'aruusa. The procession that the 'ariis and his bridal party, along with his friends and wedding guests, form as they walk from his home to the 'aruusa's, singing and ululating, is called the *zeffir*. His female relatives carry baskets of sweetmeats and boxes of household articles on their heads; chairs are carried along, so that the 'ariis and his attendants may sit periodically to watch their friends dance and sing in the road for him. At the home of the 'aruusa, he ascends the dais in order to share cake and sorbet with her, and then he returns prompt-

ly to his own home. Some time during the following day, the 'ariis moves into the 'aruusa's house, and for the next three days the couple remains together in the bridal room. Three or four female relatives of the 'ariis live in the house during that time, in order to minister to the needs of the couple.

On the third day after the farraH (yoom-iS-SubuuH), the 'ariis returns to his natal home in the late afternoon or around sundown. bringing food cooked by his new wife. His family does not eat this food, chief among which is the prized delicacy hammam wi fiteer (pigeon wrapped and cooked in flaky dough) but, rather, distributes it all to their neighbors. The 'ariis relaxes among his family and friends, perhaps eating dinner with them or maybe only drinking sweet sorbet, and returns to his wife's home later that evening. Each evening during this time there has been a singer with a band outside of the 'aruusa's house, and guests have been invited to dance and enjoy themselves at the bridal feast. On this last day, there is another zeffir, smaller than the previous one, during which the mother and sisters of the 'ariis carry food—live pigeons, bread, potatoes, tea, sugar, and flour—for the 'aruusa to cook for the many guests who will be visiting over the next week or so. On this last evening, also, the band is larger, the music is more celebratory, the food is more plentiful, and the guests are in higher spirits than before; girls wear their prettiest dresses, and young men are more flirtatious.

The exchanges of food and other items between the families of the bride and groom thus serve as an announcement to the community that these two families are joining together. Such reciprocal exchanges tie the community ever more tightly together, through the bonds they reinforce, and point out the importance of women's networks in both the bride's and the groom's families. The shebka and the farraH, with their attendant ceremonials, are a major rite of passage for a young man: an acknowledgement that he wishes to accept the responsibility of taking care of a wife and family, and that he is capable of doing so. The groom assumes the greatest share of the expenses incurred during these occasions. The jewelry and clothing for the 'aruusa, the furnishings for the household, the mahr, the entertainment and most of the food at both the shebka and the farraH, as well as the several incidental activities, should all come out of the 'ariis's pocket. While people are impressed if a man has earned enough to pay for the whole thing by himself, in the end it is rarely necessary that he do so. This very ability is taken as a sign of maturity, and relatives usually wish to help in order to demonstrate their approval and support. A young man expects to get the most help

from his male relatives—his father, his brothers, and his father's brothers—but his mother may even sell her jewelry to help him.

While a man is living in his wife's home, he and his mother-in-law observe an avoidance relationship. They are never in the same room at the same time, nor do they ever speak directly to each other. These strictures are gradually loosened as time goes on (after all, some men live uxorilocally for five to six years or more), or alternative living arrangements are made if it appears that a man will not be able to move his wife away within a reasonable amount of time.

As soon as they are able, the young couple begins to save money toward building their own home. A man usually builds his home near his father's house, on land belonging to his patrikin. In the past, it was common for the young husband to build additional rooms within the courtyard of his parents' house, if it was large enough, or for two brothers to divide their father's house by building a wall through the courtyard. Another alternative was for the couple to inhabit the rooms that were originally built for a sister and her husband to live uxorilocally, but that were vacated as this couple moved to the sister's husband's home. More recently, young people are opting for separate houses where they can live and rear their children as a nuclear household. While a few speak of living in apartments in Aswan or even Cairo, most wish to remain near their parents, albeit not in the same homestead.

▲ The Well-Respected Man

The well-liked and highly respected village man is honest and hard-working. He speaks in a polite and respectful manner to everyone, young and old. He is a good Muslim who prays, fasts during Ramadan, and tries at all times to act in accordance with the tenets of Islam. He does not annoy women, or fight, and he "listens to the talk of" those older than he.

A man is more highly respected if he is married rather than unmarried, for it is then assumed that he has shouldered the major responsibilities of taking care of a wife and family. This is his primary duty. The Nubian ideal is that the husband is the breadwinner, but many of my informants seemed sanguine about their wives earning additional income. Two reasons for this are most apparent: The first is just changing times; as one husband put it, "Gamal Abdel Nasser decreed that women could go to work just like men, so why not?" The second reason is the nature of the Egyptian economy; the pay from a

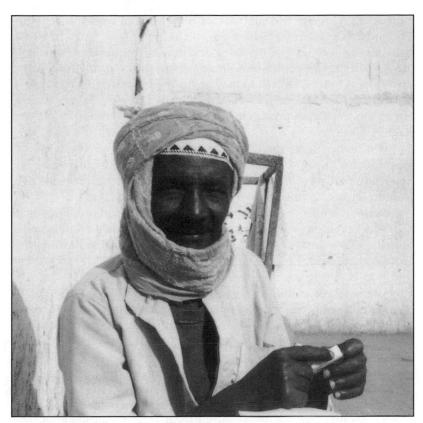

Mohammed Hassan, a well-respected man

government job, which most Nubians have, is inadequate for raising a family and must be supplemented in some way. In any case, the amount of money that my informants' wives brought in was small and could in no way constitute a threat to their status as breadwinner.

Protection of the family extends beyond the practical, into the supernatural realm as well. In a man's efforts to provide well for his wife and children, he leaves himself vulnerable to the ill will of those envious of his successes. There are those in the village who do not believe in the evil eye and who scoff at prophylactic charms, but there are many more who feel the necessity for the supernatural protection of word or action. The villager who is building a new house, or who has just bought a boat, may take steps to ensure that the eye will not harm him. Before the foundation of a house is laid, a sheep or goat

may be slaughtered and some of its blood mixed with the cement. The meat is cooked and shared with the neighbors (this, in itself, goes a long way toward diffusing feelings of resentment and jealousy), or it is given to the mosque for distribution to the poor. After the house is built, an old shoe may be hung over the doorway to avert the evil eye. Traditionally, incense was burned inside of a new home; often, one sees handprints (in blue paint, most commonly) on the walls of houses.

The owner of a new boat may hang a charm on the mast, or splash its hull with blood from a sacrificed animal; his wife may lay her gold jewelry on it for a few minutes, to both counteract the eye and attract wealth to its owner.

Babies are also draped with charms, most often right after some life-crisis ceremony such as excision, but also during teething and weaning times. Infants of both sexes wear little bags filled with herbs around their necks, or sewn into their clothes, and little girls wear tiny gold Hands of Fatima braided into their hair.

A man's responsibilities toward his sisters do not end upon marriage (neither his nor theirs), but continue indefinitely and extend finally to her children. As in many matrilineal societies, the mother's brother is a potent authority figure with significant rights and obligations. He is shown deference and respect by his sisters' children, and he has the right to punish them even against the wishes of their own father. Upon him also, however, falls the duty to support them if their father dies or is unable to support them somehow. Implicit in this is a brother's acknowledgment of his sisters' domestic help while they were growing up in the same household.

The duties of a respected villager include taking part in the social, the political, and the religious lives of his community. He is expected to visit friends and family members often; those who are sick and certain close relatives (siblings, mother, and mother's sisters, especially) should be seen every day. Weddings and funerals involve additional responsibilities, which the ideal community man does not shirk. For weddings, this involves helping with some aspect of food preparation, serving food to the guests, building temporary structures for the ceremony, and policing the village. For funerals, it involves burying the body, providing shelter for male visitors who have journeyed from far away for the funeral, serving food to the male guests, and giving support to the bereaved. In these, as well as all ceremonial occasions, he is expected to be in the thick of things, accompanying his friends, and enjoying himself (except in the case

of funerals). The success of such occasions is measured in large part by the number of people who participate in them; the villager considers it his duty to contribute his time and presence as often as is needed.

The people of West Aswan are encouraged to support their Local Council by electing representatives and going to Council meetings. The men of Gubba also periodically meet in order to discuss issues of importance to them, but I know little about this. Hussein Fahim reports that men in the relocated village of "Kanuba," near Kom Ombo, regularly met in the mosque after Friday noon prayers to discuss village business:

Some of the main problems discussed in these meetings were related to the reclamation of and irrigation of desert land owned by the people, the registration of women to vote, and a plan to provide the village with a railway station. The political leaders of the village thus get a chance to consider different points of view and to promote their own ideas. . . . General announcements of importance to the whole village are often made then. (1978: 27)

There is no reason to doubt that this continues today in Gubba as well. Village political leaders tend to be the lineage heads, who bear the most responsibility toward the people in their lineage. They represent members to outsiders, read telegrams and letters from migrants to the people in the village and reply to them, and are responsible for financial and other kinds of obligations of the people in their lineage segments (Callender 1966). In Gubba, men gather in the khema, a men's house, belonging to the qabila (major lineage) of the region, next to the mosque. If there is more than one qabila in a village, which is the case in West Aswan, each of them has its own khema for the use of its members. The khema is run like a jam'iyya, with each member contributing a certain amount of money toward its upkeep and in order to keep it stocked with tea and sugar. The members have unlimited use of it, can go there at any time of the day or night, and can even sleep there if they so choose. When a villager dies, the men gather in the khema for three days in order to pay their respects to the male kin of the deceased.

If a man is particularly devout he may join a Sufi brotherhood (tariqa), of which there are two in West Aswan: the el Burghamiyya and the el Mirghaniyya. Every Thursday evening, they gather to read and discuss the Quran and other holy books. They hold moulids and zikrs on certain ceremonial occasions, and on the fortieth day after a

man's death, if requested to do so by his kin. While joining a *tariqa* is not to every man's taste, those who do belong achieve a certain amount of prestige in the eyes of their fellow villagers.

Each household head is also expected to contribute something to the welfare of the less fortunate. This, called *il hassana* or *sadaka*, can be done in a variety of ways—including donations of money or food to the mosque, or gifts of food on specific feast days—but it is best done anonymously. A man may also redistribute his wealth more publicly, by way of a thanksgiving feast called a *karama*. Callender and El Guindi define the *karama* as a multifaceted festivity:

The Kenuz defined this term in various ways. The referent that was most specifically relevant to life-crises denoted the gift of food by an individual or a group. . . . The gift of food was in itself a generous act and thus meritorious behavior, conceived as a form of charity. . . . Although the beneficiaries of a karama were relatives, friends, and neighbors rather than the poor, residents of Dahmit explicitly regarded these categories as equivalent. In another dimension, a karama was also a religious event. . . . Its purpose could be the expression of gratitude for obtaining something one had greatly desired, or for safe passage through a life-crisis or any danger. (1971: 18)

When Selwa, Nabawiyya's daughter, became pregnant with her first child, her husband, Hamdi, gave a *karama* in order to express his thanks and joy. Hamdi, along with Selwa's father and brothers, slaughtered the goats, and Selwa's maternal kin—Nabawiyya and her neighbors, Saida and her daughters, and Saadiya—cooked the food. They cooked the traditional Nubian dish *fatta*: meat with soup and bread, rice and *molokhia* served together in a bowl. The girls of the neighborhood carried the *fatta* on large trays to the mosque, where the men had gathered to partake of the feast. After the men had finished, the women ate at Nabawiyya's house.

A man of substance and standing in the community may wish to consider the option of marrying a second wife. Men say that they want to get married again because they want more children, but I suspect that they also desire the status that a man with two wives acquires. When a man wishes to marry again, he may tell his wife, and she may agree. The great majority of Nubian women, however, would violently and vociferously disagree. It is for this reason that most men keep it secret from their wives, telling only their mothers and sisters—women who can be trusted to not tell the wife, and to help him look for another marriage partner. He marries secretly, refraining from visiting his first wife for two to three weeks. During this time, he

asks a relative or a close friend of hers to break the bad news (one wonders if she may not already suspect it, since he's stayed away from her for so long), and later on he visits, bringing her some money as a peace offering (between 100 and 500 EP, depending upon their relationship, and the extent of her anger).

Nubian men often reiterate their fantasy that cowives would get along so well that they would even be willing to share the same house, but none of the women with whom I spoke about it would even consider such a thing. The man who marries two wives must try to be fair in his dealings with them: He should buy them things—clothing, jewelry, household goods—that are identical or of equal value; he must spend an equivalent amount of time with each; and he must not compare one to the other. Women know that this is an ideal that cannot always be achieved, however, and rivalry between women, usually couched in terms of demands for things for the children, can be intense. There is great jealousy at the thought of having to share a husband, and resentment about sharing his income; sharing a home with a co-wife is an idea greeted, by women, with ridicule. Indeed, my informants who had remarried placed their wives in widely separated villages, as dictated by necessity and practicality.

The man who wishes to get a divorce may also discover that he must compromise a bit in order to achieve his goals. In most Muslim countries, Islamic law (Sharia) gives a man the right to unilaterally divorce his wife (a right that has been abolished in Tunisia and Yemen, and had been so in prerevolutionary Iran), something that she can do only with the greatest difficulty. And yet, his legal rights in this matter appear more easily exercised in ideology than they are in reality. For instance, although it has been stated that a man can obtain an immediate divorce by uttering the words of repudiation three times in a row (Coulson and Hinchcliffe 1978), others maintain that this is illegal—he must space them out over a period of time (Rosen 1970; various informants, personal communication). It seems that the various schools of law and the sects within Islam differ with regard to this subject. The amount of time between each successive pronouncement of the words of repudiation—which should be one month—gives the husband time to reconsider, and friends and family are expected to do what they can to prevent him from going through with the divorce. An extreme example of this is one in which a Moroccan villager wished to divorce his wife immediately after a heated argument with her, but could not persuade any of his neighbors to act as witnesses to his statement, making it impossible for him to do so (R. Joseph, personal communication).

There are, in addition, several social, economic, and legal means through which a man's wife and her family may prevent a divorce.

A woman's legal rights, though limited, can be supplemented with significant economic and social powers. This is so because of the malleability of various relationships each of which contains wide behavioral alternatives that can be developed into diverse patterns. (Rosen 1970: 37)

The most effective means of control seems to be economic: While *mahr* is agreed upon before marriage as stipulated by Islamic law and custom, not all of it need be paid at that time. The portion that remains to be paid should the husband repudiate his wife can be used as leverage to curb his enthusiasm for divorce (Keddie and Beck 1978; Rosen 1970). Sometimes, certain stipulations can be written into a marriage contract, such as that the wife may be granted a divorce when she wishes it, which greatly strengthens the position of the wife in the marriage. "The extent . . . to which a husband may be put at an economic disadvantage by a wife who is herself at a clear legal disadvantage will be a function of the relative power of the persons involved" (Rosen 1970: 36).

In Egypt, cases concerning marriage, divorce, and the custody of children are the only ones still judged by Islamic law. All other cases are judged according to civil and criminal laws based upon the Napoleonic code, although the Sharia does remain in the background as an ultimate guide for social interaction (Mohsen 1974). Nevertheless, additional laws have been enacted, through the years, in order to "reinterpret" or to "clarify" Sharia laws when this was considered necessary. So, for instance, Sharia jurists, in the late 1920s, placed restrictions on the husband's right to unilateral repudiation, making it illegal for him to divorce in anger, drunkenness, or as a threat. In 1979, a law was passed stating that if a man initiates divorce, he must relinquish his house or apartment to his wife if there are children and pay three years of child support, instead of just one as in the past. In addition, Egypt enacted laws that made it easier for a woman to obtain a divorce; for instance, the concept of "cruelty" (one condition under which a woman could initiate divorce proceedings) was expanded to include mental cruelty, insulting behavior, and the taking of a second wife by the husband without the first wife's permission (Fluehr-Lobban 1984). This law was revoked in 1985, and a new law was passed that has once again limited women's rights in this area.

If a Nubian man has been married for a number of years and has had children, yet wishes to divorce his wife, he must be prepared to defend his decision in discussions with his family as well as hers. He must attend lengthy meetings with senior lineage members whom he must convince, as he will ultimately have to abide by their decision. And he must be willing to spend weeks in reconciliation attempts, as the elders generally hope that a man will reconsider if given enough time. If he still insists, he walks away from his wife and children "with nothing but his clothing," leaving his house, his furniture, the household appliances, and her gold. If, on the other hand, they have had no children, he takes all of these things, and she goes back to her parents with only the things they originally gave her at the wedding.

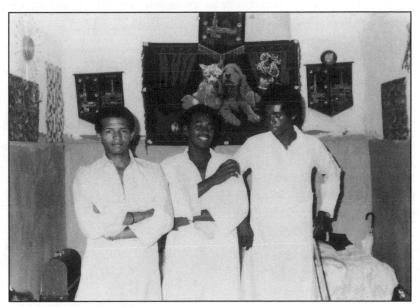

Hamada, Hamdi, and Saad: "sisters' sons"

Village men, like women, have a group of close friends with whom they spend much of their leisure time. These men gather every day, usually in the evening at the same place and time, to exchange the news of the day, watch TV, or perhaps play dominoes while sharing a water pipe. There is much laughing, joking, and

lighthearted banter among friends during these occasions, which last until bedtime.

Old men are shown the greatest amount of respect in the village. By the time a man is of mature years, he should have fathered several children who themselves have had children, made the pilgrimage to Mecca, and learned much of life; each of these experiences imbues a man with status in the eyes of the villagers. Old men usually can be seen each day sitting with their friends around the mosque, or in the shade of a large tree, or in the *khema* sharing good conversation. When they visit the homes of their daughters or daughters-in-law, they are given the most comfortable seats and served the best portions of food. Young people and children show them respect by acting in a reserved and formal manner with them.

Upon an old man's death, men gather in the *khema* to commiserate with the family of the dead man, and women gather in his home, as they do for the death of a woman.

▲ 5 Village Networks

The women of Gubba form two kinds of networking relationships with one another: peer-group networks, or friendship groups, and networks of relatives. Friendship groups are usually small and single-sex, while networks of relatives are wide-ranging and involve connections with both men and women. Although these two kinds of informal associations are conceptually distinct in the minds of most women, there may nevertheless be some occasional overlap. Sisters or cousins who are close in age and similar in temperament may be in the same friendship group, for instance, but this is rare.

Friendship groups in Gubba are usually composed of four or five women who meet together at the end of the day, after their chores are done. They congregate at one another's homes to watch T.V. and/or sit with their friends on the *mastabas* outside, crocheting small bags and caps for the tourists to buy, and sharing jokes and gossip. Although they may have seen one another during the day—been in and out of one another's houses to borrow this and that, or gone shopping together in Aswan—they still expect to spend the last few hours of evening with one another in good company.

The networks of relatives that Nubians form, on the other hand, tend to be far-flung, for often the members of one family live in various cities throughout Egypt, as well as in different villages surrounding Aswan. Most of Saadiya's family, which I will be discussing in this chapter, live in other *nejas* throughout West Aswan; thus it is relatively easy for its members to get together several times per week for various activities. Saadiya's children play with the children of her siblings more often than they play with unrelated children, and every day Saadiya visits or is visited by some member of her natal family.

My purpose in comparing these two kinds of informal associations is twofold. First, I wish to contrast the nature of friendship relations among women in Nubia with that of their kindred groups, in order to show the ways in which they are similar or different in terms of the benefits that women derive from them. Second, I wish to demonstrate the manner in which women can use their different kinds of networks in order to influence happenings in spheres that are, ideologically, outside of their jurisdiction as women.

▲ Relationships Among Friends: Zuba's Group

In the evenings, after dinner is eaten and prayers have been said, the people of Gubba go visiting. As the rays of the setting sun turn the dun-colored hills on the eastern bank to a deep red, men gather in the courtyard of the mosque or the *khema*, or they spread mats on the sand outside of a friend's home to enjoy the end of the day in one another's company. Women get together in the courtyard of a house, or sit on the *mastabas* around the door. Occasionally, they cluster near the spot where the men are relaxing, in order to exchange pleasantries with them. The group of women who met at Zuba's house each evening was typical of this kind of association, its members coming together one last time each day to *twannis* before retiring.

Definitions of groups have been of two kinds: the interactionist and the corporationist (Boissevain 1968). Interactionists, such as George Homans, define a group as "a number of persons who communicate with one another often over a span of time, and who are few enough so that each person is able to communicate with all others, not at secondhand, through other people, but face to face" (1951: 1). Using these criteria, the interactionist can identify a group, distinguishing it from other types of social relationships, by counting the number of interactions that occur between subjects. This definition is insufficient, however, in that it does not take into account the affect that may be attendant upon such interactions. While some interactionists do include a consciousness of "groupness" among their criteria, most seem not to (Horton 1965; Vander Zanden 1965).

The corporationist definition, however, adds such criteria to the definition of a group as common interests, reciprocal rights and duties, and organization and structure, along with the element of group consciousness already mentioned (Bottomore 1962; Chinoy 1961). But the criterion of interaction between individuals is not a necessary one here. Most corporate groups, furthermore, are defined as permanent bodies, often sharing common property interests (Mair 1965).

The aggregate of women that I call "Zuba's group" seems to fall

somewhere in between those two definitions, as it possesses some aspects of both. On the one hand, the women meet together periodically in specific face-to-face situations, enabling an interactionist to identify them as a group just by counting their social interchanges, as I did. On the other hand, the group has qualities that are among the criteria used by corporationists: It is characterized by ties among its members that contribute to a consciousness of common interest, and it has social and economic exchanges among individuals that are based upon reciprocity. It also possesses some of the emergent properties of groupness (cf. Armstrong 1982), such as continuity through time, mutual cooperation, and group-specific norms with enforcement sanctions. It differs, however, from corporate groupings in that the members do not share property in common, and from corporate kin groups in that membership is not ascribed. Corporate groups are formal entities, which have a structure and existence above and beyond the specific individuals who are in them. Zuba's group, in contrast, is informal and unstructured, and though it has continuity through time (these women may meet together for years), it has no existence without them.

While it may be possible to refer to this assemblage as a network, as each woman is tied to the other via lines of interconnectedness, it would be more accurate to speak of it as a group, because networks have generally come to mean unbounded social structures that ramify throughout a society in ever-widening fields (Barnes 1954; Bott 1957; Mayer 1966; Mitchell 1974). Although each woman in Zuba's group is a member of networks in West Aswan, I wish in this chapter to focus upon the linkages they form that exist apart from any particular networks to which the individual members might belong. The group is bounded, being composed of a finite number of women (although this number can expand and contract) who generally meet at the same time and place each evening. Although they may also meet one another in other places several times throughout the day, this evening gathering at Zuba's house is the criterion employed (by them) to separate group members from nongroup members.

Nubian women's friendship groups are more fluid than I had realized they were during my first fieldwork in 1982. When I returned to Gubba in 1986, I expected to meet with the same group of women at Zuba's home; however, I had reckoned without the interplay of time and human emotions upon their social ties. It seems that anger and resentment over past slights, which had been delayed expression by my presence in 1982, had eventually erupted into arguments that resulted in the splintering of the group. In addition,

Zuba's mother had become seriously ill by 1986, which made her a less vivacious presence and which distracted Zuba, so that their house seemed a less inviting one in which to congregate and relax.

Below, I will discuss the members of Zuba's group as they appeared to me in 1982, adding what I learned about them when I returned to Gubba for my additional fieldwork. I refer to this assemblage of friends as "Zuba's group," although I doubt that any of the other women who regularly met with her did. I thought of Zuba as the center of the group mainly for three reasons. First of all, for a subjective reason of my own: My friendship with her was warmer than it was with any of the other women. Her door was always open to me, and we quickly did away with formality. She eventually became my chief informant. The first time I met Zuba, she invited me into her home for tea, as is customary. She then urged me to return in the afternoon, as there were usually groups of tourists in the village during that time, and she thought that I might be interested in seeing them. When I returned in the afternoon, she enjoined me to stay for dinner. Throughout this day, I met several of her neighbors who came in to chat or to borrow something. After dinner, three or four of these women returned to Zuba's to watch T.V. and talk with one another until about 10:00 P.M. Eventually, after repeated urgings from Zuba, I fell into a pattern of visiting her every evening after dinner, and became aware that the same three or four women visited her then also.

Second, and more objectively, because Zuba's friends gathered at her house every evening in this way, I came to view her as the focal point of this group. Callender mentions that women in Old Nubia organized informal groups, based primarily on residence and age, and that "each group has a recognized leader, whose position depends partly on her personality and partly upon other sources of prestige such as economic status and migrant experience. She is often the wife of a lineage head" (1966: 18). I could not discern any obvious signs that Zuba had a superior economic status; each woman has a television set in her home, and Zuba's house was no more comfortable or luxurious than anyone else's. Zuba has never been a migrant, nor was she married at the time. This latter is a condition that might have been expected to work against her "leadership," as this is a community in which all women expect to become wives and mothers. Nevertheless, Zuba did not appear to be pitied or scorned by other women; on the contrary, she seemed to be well liked and respected by them. I do not believe that Zuba was a "leader" as that term is commonly understood but, rather, that her friends were simply responding to the atmosphere of warmth that Zuba, her mother, and her sister created in their home, and this is why they made it the central meeting place of their group.

Third, as I observed Zuba and her neighbors, it seemed to me that there was an imbalance in their visitation patterns: Zuba's friends appeared to visit her more often during the day than she visited them. My tally of their daily visitations supported this observation: Zuba made frequent visits to neighbors during the day, but she consistently received more visits than she made.

It is for these reasons that I refer to the women whom I will talk about in this chapter as Zuba's group. She was the focal point of her friends' daily visits and the one in whose home the same group of women congregated each evening. The women were: Zuba herself, her mother, Fatima Ismail, and her sister, Mona, who lived together in the house at the northwest corner of the *melaga* (see Map 5.1, house no. 1); Askara, who lived with her sister Asia in the house at the northeast corner (house no. 6); and FatHiyya, who lived across the alley from Zuba (house no. 2). In my interviews with these women, I asked them questions designed to determine who each one's closest friends were and why. I will first give a short life history of each of these women, and then discuss the results of my interviews with them, giving an account of my participation in the life of Zuba's group.

Fatima

Fatima Ismail, in her sixties in 1982, is the mother of Zuba and Mona. When I first met her, she was living with her daughters and her unmarried son, Mahdi, together with Mona's husband, Ramadán, in a large house at the northwest corner of the *melaga*. Their house is quite large, with several rooms opening onto two separate courtyards, and a second story. Zuba and Fatima have rooms in the larger section of the house, which also includes the kitchen, bathroom, storerooms, and a guest room. At that time, Mona and Ramadán shared one room, and Mahdi had another, which opened onto the smaller courtyard (separated from Fatima's and Zuba's part of the house by a high wall). When I returned to the village in 1986, Mona and Ramadán had moved into his house, next door (house no. 9), and Mahdi was using their room to store furniture and household articles in readiness for his upcoming wedding.

The three rooms that comprise the second story of Fatima's house are used by her third daughter, Ratiba, and her husband when

Map 5.1 The Southernmost Square of Gubba

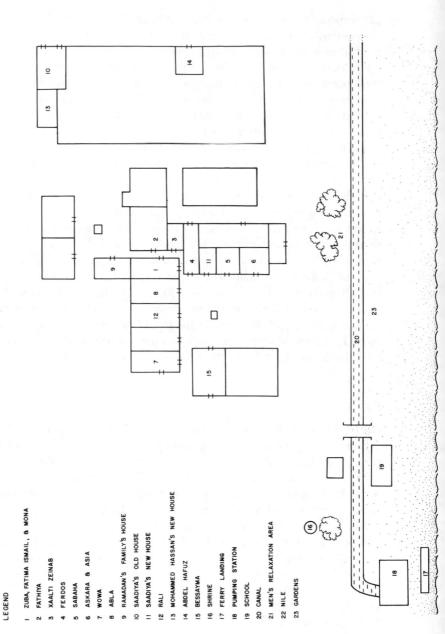

they come to visit from their home in Assiut. Fatima's eldest son, Hamid, is married and lives with his wife in Aswan.

Fatima was born on Sahel Island, in Old Nubia, near the First Cataract, which is approximately 10 miles south of Aswan. After several years, the family moved to Sohag, a small town near Assiut, where her father opened a coffee shop. When she was fifteen years old, Fatima's parents arranged her marriage to her father's brother's son, Selim Mohammed Dahab, whom she had never met.

In the old days, it was socially inappropriate for a young woman to meet and converse with young men, including her fiancé: "Contact between an engaged couple was explicitly forbidden, even when they were close relatives" (Callender and El Guindi 1971: 50). One or two of my informants recalled that her husband-to-be had seen her and then asked for her, but most stated explicitly that they had never even met their husbands before their engagement ceremony, and had not seen him again until the wedding night. In Fatima's case, this situation was exacerbated by the fact that the two lived in separate villages, miles apart.

After approximately two years of uxorilocal residence, the couple moved to a small town near Cairo, where Sclim got a job in a sugar factory. They lived there for thirty years, although Fatima returned to her parents' home for the births of each of her eight children. She also made periodic trips to Cairo, where she could shop for certain kinds of items unattainable in a small town and visit with relatives living there. When her husband retired, they moved to West Aswan, his natal village. With their savings, Selim invested in a boat to take tourists to Abu Simbel. He, as *il rayyis*, was not expected to actually man the craft, but he made the reservations and claimed half of the profits. With part of this money, Fatima "built the house" in which she and her children are now living.

Originally, the house was built by Selim and his brother, and Selim's part consisted of two rooms. Fatima paid laborers to construct the resulting fourteen-room structure gradually over a period of four years. Fatima's "building the house," a customary right and duty of the woman of the house, eventually also included adding the second story for Ratiba's period of uxorilocality.

Selim died several years before I met them, and the last time I saw Fatima she was infirm. But in 1982, she was, although elderly, still lively and gregarious, interested in the steady stream of visitors to the house. She was, in the evenings, a central participant in the convivality of Zuba's group. However, in late 1985, she suffered a stroke that left her partially paralyzed; in 1986, she went blind, perhaps as a

result of the diabetes from which she had suffered for many years. Toward the end of my second stay, Fatima rarely left her bed, becoming more and more dependent upon Zuba, and less concerned with happenings in the world outside of her room. Ratiba and her husband had come back to Gubba from Assiut when she became ill, moving into their second-story rooms in the house. This was not only a traditional Nubian reaction to the serious illness of a loved one—the belief that suffering is lessened when undergone in the company of friends and family—but also a practical one: They wanted to be available in case of any emergency. Hamid visited her every day for these reasons also.

Zuba

Zeinab Selim Mohammed Dahab, called Zuba, was in her early thirties and unmarried when I met her. Although she wanted very much to have a husband, there were, evidently, no eligible male relatives, and no other suitable aspirant had asked for her. "Most men want a vivacious, flirtatious girl," said Zuba, "and I'm not that way." While it is true that she does not flirt with men, believing it to be immodest to do so, she can be quite outgoing and talkative with her female friends.

Zuba was born in her maternal grandparents' home in Sohag and lived there for a year; she grew up, however, in Gubba. She is responsible for much of the day-to-day running of the household that she and her mother share. Since Fatima has become ill, this duty has rested more heavily upon her shoulders. Zuba also bears the chief responsibility for welcoming tour groups into her home and serving them tea, and she receives whatever tips they may offer.

In 1982, Zuba visited her friend Askara several times each day. They were "best friends" and shared foodstuffs, as well as articles of clothing such as scarves or gallebeyas, as good friends do. Zuba might have baked a large batch of biskweets one morning, for instance, and taken some down to Askara's house. She might, later on, have helped Askara with one of her chores for a while, or just sat and talked for fifteen to twenty minutes before returning home. During my second stay in the village, I noticed that she did none of these things but, instead, spent much of her spare time with us. When asked why, Zuba told me that she and Askara were no longer close; Askara had become extremely argumentative and disagreeable, so Zuba had gradually disengaged herself from their relationship. This was not just Zuba's evaluation; other villagers had remarked upon the change

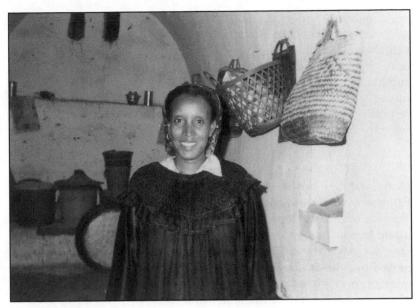

Zuba

in Askara's personality, and I noticed it myself. Zuba and Askara still visited each other from time to time—there was no rancor between them—but the old camaraderie was gone.

Zuba also visits and is visited by her next-door neighbor Abla (house no. 8), who is also her father's brother's daughter. These two often share food items, one borrowing a loaf of bread or a couple of tomatoes from the other. FatHiyya, who lives in the house across the alley from Zuba's, used to visit and chat with her, yet this, too, had changed by the time I returned to the village in 1986. Evidently, she and Zuba had had a fierce argument right before my arrival in 1982, but had hidden their animosity, presenting me, the outsider, with an appearance of harmony. It is my belief now that FatHiyya visited Zuba mainly when I was around and avoided her at other times; by 1986, she no longer even pretended to get along with her.

Zuba continues to maintain contact with other neighbors, however, and is in general the amiable and well-mannered village woman that is the Nubian ideal. She is conscientious about sustaining her social relationships, and usually visits Saadiya twice a day. When Wowa, who lives at the southwestern corner of the *melaga* (house no. 7), completed the construction of the second story on her house for her daughter's period of uxorilocal residency, Zuba visited to see it and congratulate her (an important social obligation). When a neighbor falls sick, Zuba does not fail to visit, another such obligation. Often, she will go to another neighborhood, or even travel to another neja to see a friend, but most of the time she stays within the square where her house is located. In 1986, because her primary responsibility was to her mother, Zuba rarely stayed out of the house for very long periods of time.

Mona

Mona and her husband, Ramadán, lived, in 1982, in Zuba's and Fatima's household, and the three women interacted every day. These interactions were not always peaceful; occasionally, tensions would break through the usually placid surface of their relationship. One day, for instance, I asked why Mona and Ramadán had not yet moved into his house, which at that time was standing empty. The question precipitated an argument between Zuba and Mona, during which Zuba referred to Ramadán as a freeloader. Mona bristled at this, hotly defending her husband, and stated that each day, without fail, he came home with something from the market to share with the whole household. During my first fieldwork, I was rarely privy to such instances of discord, and this was my only opportunity to witness the manner in which some people were trying to cope within a tradition of postmarriage uxorilocality, when they might really rather be living under some other kind of arrangement. Ramadán's conscientious daily efforts to contribute to the household of his wife's family, and not just to his own, may indicate that he, too, was aware of these feelings.

Chubby, with a lively personality and a lovely, ready smile, Mona Selim Mohammed Dahab was born in 1953 in Sohag and grew up in the house in Gubba. Mona and Ramadán were married when she was eighteen or nineteen (they are relatives: Ramadán's father is mother's sister's son of Fatima's father), but the couple are as yet childless. Ramadán's family owns the house standing to the west of Fatima's, sharing a common wall with it, and the couple moved into it during the period between my first and second visits to Gubba. Upon my second visit, Zuba reminded me of the arguments that she and Mona used to have, remarking that the house was much calmer since they moved out.

In 1982, Mona reported visiting FatHiyya every day, and seeing Askara, Asia, Abla, and Rali regularly, as well, although perhaps not

every day. Since moving away from her mother's, however, Mona has found another group of women with whom she gathers before bedtime. They are those who live in the houses around the smaller *melaga* behind FatHiyya's house, and it is with these women that Mona now spends most of her time.

Askara

Askara Mohammed Abdu lives in a large house in the northeastern corner of the square (no. 6). She lives with her daughter, Bessima; her son, Moustapha; her older sister, Asia; Asia's husband, Abdu; and Asia's five children. Askara's husband, Nadi, and Asia's husband, Abdu, are brothers, and both are mother's brother's sons to Askara and Asia.

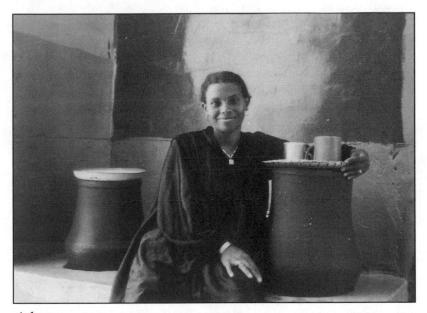

Askara

Askara was born and raised, as was Asia, in West Sahel, an old Nubian village near the First Cataract. Two years after her marriage to Nadi (when she was sixteen or seventeen years old), she moved to Gubba and has lived there ever since. Nadi, however, left West Aswan

in the 1970s and has not returned, except to visit. He lived first in Cairo, and then for several years in London, working for an Australian artist. With the money that Nadi earned working for the Australian, Askara built the second-story addition to their home. During my first fieldwork, Nadi was living once again in Cairo, with a second wife and three children.

In the early years of her marriage, Askara had three children, of whom only one—Bessima, now a young adult—survived. Beautiful but shy, Askara was given the opportunity to live in Cairo with her husband many years ago when Bessima was still an infant. But she does not like the city, preferring to live where she is now; she feels that this is the major reason that Nadi married again. During the time that I was absent from the village, Nadi's second wife died, and Askara went again to Cairo to live with her husband. As a result of this brief stay, her son was conceived, and she returned to the village in order to give birth and raise him there.

In 1982, Askara told me that Zuba was her closest friend, and that Fatima Ismail was like a mother to her. She and Zuba saw each other two or three times each day. In addition, they used to go marketing in Aswan regularly and often attended social functions, such as weddings, together. During the time that I lived in the village in 1986, however, they saw each other far less frequently.

Askara had not been completely well since Moustapha's birth, and it made her irritable, she explained to me one day. Therefore, things which she used to take in stride now annoyed her to an exceptional degree. She lost her temper with me one day, for instance, when I bought a toy pistol for Saadiya's son, yet had not bought one for Moustapha; what surprised me more than the fact that she was angry was the vehemence of her indignation.

The villagers told me that Askara needed an operation involving some aspect of her digestive system and/or intestinal tract, and indeed she went into the hospital, late in 1986, for that purpose. She only stayed three days, however, and left before the operation could take place. Evidently, a patient in the next bed had undergone a similar operation the day after Askara arrived, and had died during the night. Askara, who had been dreading her own operation to such an extent that she had been putting it off for several years, understandably became so frightened that she checked herself out the next day. She told me that she had no plans to return to the hospital; instead, she seemed to me determined to put on a brave face and carry on despite the appearance of very real physical debilitation.

Because Askara, Asia, and their families are sharing the same

household, their domestic duties are intertwined. When someone from the household goes to the market, she buys for the entire household, not just for her own family, and whoever cooks makes enough for everyone. Thus, the sisters' dependence upon each other in day-to-day activities could be readily observed, even though Askara did not name Asia as a close friend. This was not uncommon: None of the women whom I interviewed named their sister as one of their closest friends.

In addition, Askara interacts daily with her next-door neighbor Sabaha, who is the wife of another brother of Abdu and Nadi. These two women loan each other needed foodstuffs or household objects, pick up something at the market for each other occasionally, and perform various other small neighborly acts. In 1986, both Askara and Asia sat with Sabaha in the evening, usually in front of the latter's house.

FatHiyya

FatHiyya Ali Nur Eddin lives across the alley from Zuba, in a beautiful, big, old house that was once her maternal grandfather's. She was born in the house in 1942, and lived here for the first fourteen years of her life with her grandparents. At age fourteen, she was married to Mohammed Hassan, a brother of the women with whom I lived, and also FatHiyya's father's sister's son. They moved to her parents' house in a neighboring *neja*, where they lived for five years. After five years and two children, they moved to her grandparents' home in Gubba, where they have been living ever since.

FatHiyya's grandparents are now dead, and she and Mohammed Hassan live in the house with their five children. Mohammed Hassan is in the process of building a large, modern house on the plot of land next to the house I lived in during my first fieldwork (no. 13). When younger, he was a chauffeur and car mechanic in Cairo, but after an accident that left him crippled, he returned to Gubba. As part owner of one of the boats that carries passengers to and from the village, he is able to supplement his income as a dishwasher in Aswan's municipal hospital, even though he cannot sail. His brother, Abdul Hafuz, is a felucca *rayyis*, as is one of FatHiyya's brothers; as such, they consider it their duty to send tour groups to FatHiyya's house for tea. As a result, hers is the house in which the largest groups of tourists may be seen most often, on a daily basis.

This is the topic over which FatHiyya and Zuba had their argument some months before I came to the village in 1982. According

to informants, FatHiyya had, for several years, been the only village woman to open her home to tourists on a regular basis, as she was greatly dependent upon the extra income this provided. One day, however, she was not at home when a tour group was brought to Gubba. So the tour leader knocked upon Zuba's door instead; Zuba extended her hospitality to the hot and tired foreigners-a traditional gesture, but one that angered FatHiyya when she learned of it. Zuba contends that FatHiyya reacted as she did because she had come to assume a proprietary air about all tour groups, whereas FatHiyya maintains that this group was hers by right of the agreement that she had made with her brother, il rayyis. Their argument became quite heated, with FatHiyya saying, according to Zuba, all manner of unforgivable things not only to herself, but to the tour leader as well. FatHiyya's words so infuriated Fatima Ismail that she decided that they, too, would invite tour groups into their home, to spite her. The money that could be made in this way was also an important factor, as Zuba's father had recently died and the family was living on a very small income. Their actions sent the relationships between the women to a level of animosity and competition that only increased as time passed.

I learned all of this only in 1986, when I saw that Zuba and FatHiyya were not speaking to each other—a common method of conflict management among the villagers. During my first fieldwork, they did speak, but not a great deal; not knowing their personalities well, I had just assumed that FatHiyya was relatively quiet. Also, we were always in the company of others, who were chatting and laughing. I now believe that either they did not wish me to be aware of their hostility, or that their resentment toward each other, while not unmanageable in 1982, became deeper and more inextricable between the time of my first and second visits.

Significantly, FatHiyya did not name Zuba as a close friend in 1982, although I, in my ignorance, expected her to because they are next-door neighbors. The woman who most often helped FatHiyya serve tea to tour groups was the one whom she named as her closest friend: Rali, who lives two doors away, in the house next to Abla's (no. 12). They visited together almost every day, and during the tourist season, I observed Rali helping FatHiyya serve tea and wash dishes daily.

FatHiyya was also very close to her other next-door neighbor, an old woman whom the villagers call xaalti Zeinab. The word "xaalti," defined as "my mother's sister," is used to convey affection and respect toward older women. In 1982, xaalti Zeinab lived alone in a

small house (no. 3), a somewhat unusual situation for a Nubian woman, and periodically received small articles of food (a couple of potatoes, some cooked fish, a loaf of bread, etc.) from the women who lived in the neighborhood. She visited FatHiyya every day, often bringing her something small, such as a couple of eggs, and she often stopped in at Zuba's as well. When I returned to the village in 1986, *xaalti* Zeinab had moved and was living with her daughter and her husband in another part of Gubba.

In 1982, FatHiyya looked in on Zuba and Fatima Ismail daily, though she did not visit for long periods of time. In the evenings, she usually could be found sitting with Zuba's group, nursing her youngest child on the *mastaba* outside her front door. In 1986, she was no longer nursing and no longer a member of Zuba's group; she, like Mona, met with the group of women who gathered either outside of her back door or in the spacious sandy courtyard within her house.

After several weeks of participant observation, during which time the women of Gubba observed and inspected me as I adjusted to village life, I asked several of them if they would permit me to interview them while I taped their answers. Some women refused, but all those of Zuba's group agreed. It may be that they all agreed to help me because they considered me a group member and, as such, deserving of their support. Or they may have done so because Zuba said yes and they wanted to follow her example, or simply because she asked them to. Whatever the reason behind their actions, the fact that all of the group members agreed to my request indicates their awareness of their relationship to one another as constituting a bounded entity and their acceptance of me within that entity.

Most of my questions concerned their life histories, but I also wanted information about their friendships with one another. Because I thought that the nature of these questions might possibly cause embarrassment to some, I asked women to provide specific names only when we were talking in private. Since privacy was rare at any time, and became harder to achieve as time went on, I was able to get complete information from only five informants: Zuba, Fatima Ismail, Mona, Askara, and FatHiyya. Each was asked to name her closest, next-closest, and third-closest friend. Their phrase for "my best friend" is *sahbi sheddida*, a phrase that they introduced to me, indicative of the fact that this kind of relationship is not foreign to them.

Fatima named a woman with whom she used to be very close, but who had some years previously moved to another village. They are no longer close, and Fatima has not formed any other such friendship. "Everyone in the village is my friend," she says.

Zuba named Askara as her closest friend, and FatHiyya as her next-closest. Her third choice was a woman named Amal, to whom she used to be very close, but who, like her mother's friend, had moved away some time before.

Askara reciprocated Zuba's affection, naming her as her closest friend, and Fatima and Mona as her second and third choices.

Mona named Ferdos, a young woman who had just recently moved away, and FatHiyya as her two closest friends, with no third choice.

FatHiyya named Rali as her closest friend, *xaalti* Zeinab next, and Zuba third.

Only two of the five women interviewed named each other as closest friends: Zuba and Askara. The reciprocity of feeling between these two would, excluding those links among Zuba and her mother and sister, make this link the strongest in the group. Another kind of reciprocal feeling—that of mutual ambivalence—was observed in the relationship between Zuba and FatHiyya. Zuba named FatHiyya as her second-closest friend, but with reservations (understandably so, in light of their argument); FatHiyya said that Zuba was her third-closest friend. FatHiyya was an integral part of the group that met at Zuba's every evening, and yet she named none of the other women in that group as a close friend.

Most of the women who were named best friends were not next-door neighbors, but lived farther away. Askara and Zuba live at opposite ends of the *melaga*; Rali lives three houses away from FatHiyya. Next-door neighbors were named as second-closest friends by Zuba, Mona, and FatHiyya: Both Zuba and Mona named FatHiyya as their second-closest friend, while FatHiyya put *xaalti* Zeinab in that category. Zuba did not mention her next-door neighbor Abla as a close friend, nor did Askara name Sabaha. Perhaps there are some unexpressed feelings of ambivalence toward next-door neighbors that lead village women to seek their best friends in those living farther away.

As mentioned above, sisters did not name each other as first-, second-, or third-choice friends at all. One reason for this may be that I asked about friends, not relatives. Another reason may be that there was an implicit assumption that siblings should be closer than friends, so there was no need to mention them. A third reason may be that these women purposefully seek to form dyadic, reciprocal-exchange relationships with nonrelatives in order to maximize their

social and economic security; such relationships with relatives are, as discussed below, part of the normal course of events for all villagers. This explanation may also apply to their relationships with next-door neighbors.

Social and Economic Support

Friendship groups among Nubian women appear to have primarily two purposes: social and economic support both on a daily basis and during ceremonial occasions, and information sharing. Nubian society is divided along gender lines to a large extent, with women forming their most important social relationships with other women, and men forming theirs with other men. On a day-to-day basis, a woman's close friends act as confidantes and advisers, giving her the kind of emotional support that she may not get from her husband. Such bonds among women are further strengthened by the practice of generalized reciprocity (Sahlins 1972), whereby they exchange small items and services of various kinds, with no expectation of immediate payback. Ostensibly, those immersed in this kind of reciprocal involvement do not measure these exchanges, trusting that in time everything will even out. Among the members of Zuba's group, for instance, the sharing of foodstuffs was very common: In my notes, I made reference to the circulation of bread, coffee, eggs, tomatoes, lemons, milk, zucchini, and greens among them. Zuba seemed to especially enjoy helping her friends cook and periodically made biskweets with Askara. Personal items, also, such as head scarves and sandals, may be borrowed by various group members. When a woman falls sick, although she may be visited by all of the women who live in her immediate vicinity, it is her special friends who visit most often and keep house for her until she is no longer bedridden. In this way, women in friendship groups are linked together through a host of mutual-aid activities that are based upon the expectation that their relationships will continue over a long period of time. For this reason, women tend to be selective concerning from whom they borrow items, usually engaging in this activity with those with whom they already have other ties.

The preparation of food for feasts demands a more concerted outpouring of aid from group members. Although they are not the only ones who contribute their time and energy, it is expected that they will be at the hub of the activity. Such life-crisis occasions as the birth of a child, marriage, or death always see a core group of women working closely with the relatives of the central participant, usually staying afterward to clean up as well.

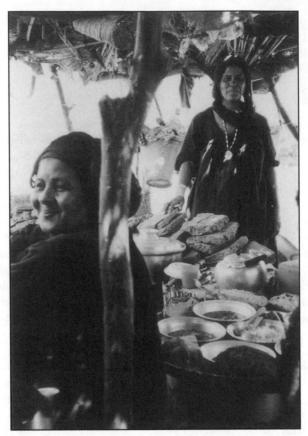

Women serving trays of food at a wedding

I had assumed that the women in these groups formed bonds that were persistent and enduring, but in reality, friendship groups may be quite fluid. This was made apparent to me when I returned to Gubba in 1986. As discussed above, the illnesses of some group members, and arguments between others, had led to the disintegration of Zuba's group. In the face of these unfortunate events, the women had merely turned to the more genial fellowship of new companions and spent their evening hours with other groups of neighbors.

Women's groups must necessarily be open to considerable inand out-migration on the part of its members, as any woman may, for one reason or another, move about a great deal throughout her life. As a young girl, for instance, she may be "loaned out" to a relative in another *neja* in order to help in the house. Or as a young woman, still unmarried, she might relocate to Cairo for a time: Saadiya's sister-in-law, Ferdos, was sent to live in Cairo with her brother, Saadiya's husband, Hegazi, when his second wife died. It had been decided that Saadiya should remain in Gubba with the children, so Ferdos took over the household duties that fall within the woman's sphere of responsibility.

In addition, when a woman marries, although she does not immediately leave her own *neja* for that of her husband, she expects to eventually, and when she does she will leave her old friends behind. The same thing happens if a woman is summoned to the city to live with her husband there. In each of these cases, a girl or woman is expected to attach herself to some group of females who live nearby and to interact with them much as she did with her former friendship group. This is, by and large, what women and girls do. Women's friendship groups appear to be completely receptive to this behavior, with very little hesitation about opening their ranks to new members. While each woman may have her best friend, groups as a whole are not exclusive and cliquish. Village women are heavily dependent upon one another both socially and economically, so they cannot afford to offend others through clannish behavior. Any personal animosities that they may feel are usually quite successfully hidden.

Information Sharing

One of the most significant consequences of talking with friends in groups is the dissemination of information. In a society that has few telephones, individuals are relied upon to spread news by word of mouth; and information concerning births and deaths, especially, travels rapidly in this manner. In addition, conversation about husband/wife relationships, recent marriages and rumors of divorce, illness, and sexual misconduct can be heard in groups of close friends.

Women's groups are also used for arbitration among disputants. During my second visit to the village, I observed an argument between Zuba and Askara during which they never spoke to each other face-to-face, but attempted to use the neighborhood women as a forum for their grievances. One day, as Saadiya, Sabaha, and I were relaxing in front of Saadiya's house, first Zuba, and then Askara, came over at separate times to sit with us. Zuba spoke angrily with us for a time and then left, whereupon Askara approached our group and did the same. Each accused the other of actions on a previous

day that had been purposefully calculated, they felt, to embarrass and shame the other in front of friends and neighbors. Both knew that such actions, and the reasons for them, were sure to be gossiped about by these people. Both Zuba and Askara were using Saadiya, Sabaha, and the other women who sat nearby not only as sounding boards upon which to present their individual sides of the story, but also as conduits through which other villagers would receive this information. Since the women living around the *melaga* would form their opinions of the actions of the adversaries based upon what information they heard, it was important to both Zuba and Askara to air their stories as fully as possible.

The two women were so very concerned about presenting their stories to their best advantages, because their neighbors had the power to censure them for conduct that the villagers might consider inappropriate. In Muslim villages, women's groups play a principal role in the collection and distribution of information for purposes of social control (Ammar 1954; Aswad 1967; Farrag 1971; Tapper 1978). In many Muslim societies, one's reputation, inextricably entwined with the reputation and honor of one's family, can be damaged severely as a result of pernicious gossip. Honor is not solely the value of a person in his or her own eyes, for it must be corroborated by the society of which the person is a part (Bourdieu 1966; Peristiany 1966). One's reputation does not just happen, but is "constructed" by the actions of each member of one's family and by those who observe these actions and communicate this knowledge to others. Women's networks are used as channels through which critical commentary is passed; it is this arena that can make or break a reputation. Thus, one's actions should always be weighed with the thought of protecting or enhancing one's reputation.

Although the reputations of both men and women are subject to damaging gossip spread by women's networks (Cunnison 1966; Zeid 1966), for a woman, the most devastating would be gossip about some moral lapse on her part. Women are all the more vulnerable, since not only does a woman's behavior reflect more seriously upon the honor of her family than does a man's, but women also have greater access to more information about the actions of women. This is the reason that men are so dependent upon women's networks in the area of marriage arrangement: Only women are able to learn about a prospective daughter-in-law's true personality, moral character, and in some societies even her physical appearance, as this is the kind of information that is, in many cases, available only in the female domain.

I was surprised to discover, therefore, that there are times when

a woman wants to be the subject of village gossip. I discovered this following a conversation that I had with Saadiya's husband's brother. This young man, Yahya, was a student in Cairo and spoke English. Whenever he came home, which was rarely, he would seek me out in order to practice his English. On the afternoon in question, he told me that he was looking for a wife, and asked me who I knew among the village girls that I thought would be suitable for him. Naturally, he knew them all better than I did and had some objection to each one I mentioned. I purposefully left Zuba's name out of our discussion, since I considered her a close friend, and I wanted no accusations of gossipmongering to be leveled against me. I was also, frankly, quite surprised that we were having this conversation at all, since I hardly knew this young man, and I wondered what his ulterior motives could be. The next evening, while I was visiting at Zuba's, Fatima told me that she had heard of my conversation with Yahya, and the group chuckled. Not Zuba, however; she was miffed and asked, "But why didn't you mention my name?"

Thus, I learned that a young woman who wants to marry hopes to be spoken about to any young man of the community who is looking for a wife, and expects her friends to do so. My reticence to speak of Zuba (in order to "protect her honor") was not appreciated by her; perhaps Max Gluckman is right when he states that "gossiping is a duty of membership in a group . . . for when you gossip about your friends to other mutual friends you are demonstrating that you all belong to one set which has the duty to be interested in one another's vices as well as virtues" (1963: 313). My error lay in not recognizing what was happening before my very eyes. Misled by the informality of the setting, and by the casualness with which my conversation with Yahya was conducted, I failed to realize until later that Nubian women's networks are key in the dissemination of information about young women to eligible bachelors. In addition, I had not understood that I was being viewed by other villagers as a (perhaps marginal) member of Zuba's group and, as such, someone from whom information could be obtained. As time went on, and I became more enculturated, my "duties" in this regard became clearer.

▲ Relationships Among Relatives: Saadiya's Family

There are several points of contrast between Zuba's social relationships, discussed above, and Saadiya's, to be examined here. The most salient difference between them is that of their composition: While Zuba's group is composed mainly of friends (who are female), Saadiya's relationships seem to be primarily with kinsfolk, both male and female. In addition, Zuba's group is bounded, self-selected, and meets regularly at a specific place and time; Saadiya's is more openended. If we were to trace the linkages completely, we would see how they ultimately articulate with others in the community. The members of Saadiya's group are more widespread geographically than are Zuba's, as some live in a neighboring *neja*; furthermore, they do not meet regularly at any specific time and place. It is this widespread, unbounded quality of Saadiya's coalition of interacting kinsfolk that encourages me to view it as a different type of social form than Zuba's: a network rather than a group.

When, in 1982, I asked Saadiya to name her closest friend(s), she said that she had no special friends, and indeed she seemed not to. Although she was friendly with her neighbors, she seemed not to have the same intensity of relationships with them as Zuba had with hers. At that time, we lived at some distance from the *melaga*, so there was not the almost constant stream of visitors to the house that there was to Zuba's, nor was Saadiya the focal point of an obvious friend-ship group. In 1986, when we lived on the *melaga* in Saadiya's new house, she most often sat around in the evenings next door, with Sabaha. Along with them would sit various women of the community: Sometimes Sabaha's sisters would visit from around the corner, sometimes Zuba would come down, but at no time did I have the sense that these women formed the kind of group that met at Zuba's in 1982.

While Saadiya's close friends seemed few, her family is large and widespread. As discussed in Chapter 2, she has four sisters, two of whom are living in another *neja*, and two of whom now reside in Cairo, and three brothers, two of whom are living in Gubba, and one of whom is working in Saudi Arabia. Two sisters-in-law (FatHiyya and Samira) also live in Gubba, whereas her own husband lives in Cairo. Many researchers who describe cooperative coalitions of kinspeople emphasize the importance of residential proximity to them (Eickelman 1984; Larson 1983; Stack 1974; Abu-Zahra 1974), yet I found that Saadiya interacted primarily with her kin despite their geographical distance from her. In 1982, she consistently borrowed foodstuffs, not from her close (nonrelated) neighbors, but from relatives who lived at a greater distance from the house. In 1986, she borrowed most often from these same relatives, but also quite a bit from Sabaha. In 1986, as in 1982, she most often visited and was most

often visited by the members of her sibling group: her sisters and brothers, and their children.

Although the differences between Zuba's group and Saadiya's network are significant, there are also important similarities. Both are based upon reciprocal behavior among their members, and in both, the presence of love and affection is important. Also emphasized in both social forms is adherence to norms of cooperation during certain times, despite personal feelings. I observed this latter attribute upon several occasions in 1986, where women who were "not speaking" still cooperated during some ceremony or another. For instance, when Zuba hosted a dinner for her brother Hamid's first wife to meet his newly married second wife, most of the women living around the *melaga*, including FatHiyya and Askara, cooked for her. FatHiyya even loaned her a teapot and some glasses for the occasion. And when FatHiyya's mother died, Saadiya and her sisters paid their respects, although they had all had a major argument concerning the distribution of some family property some months earlier.

Below, I wish to discuss the manner in which Saadiya and the members of her immediate family (mainly her sisters and brothers) interact on an almost daily, nonformal, supportive basis with one another. These supportive relationships among the siblings is similar in purpose to the helpful dealings among the friends of Zuba's group, and the results, in terms of the maintenance of feelings of security and sustenance in the women of the village, seemed much the same. Saadiya's wider network of friends and more distant kin can be called upon to add their assistance when it is needed, as they did when her mother died. In addition, this network, like the networks of other villagers, provides her with news of the activities of her fellow villagers and information about any other aspects of life in which they find interest.

One of the many definitions of a network is "all or some of the social units (individuals or groups) with whom a particular individual or group is in contact" (Bott 1957: 320). Researchers tend to analyze networks as a series of dyadic ties, ramifying throughout society, and ultimately connecting all members (Srinivas and Beteille 1964). Because of the impracticality of attempting to trace all of the social links within a society, however, most researchers have confined their investigations to a small portion of them: a selected informant and his or her immediate social contacts. Such a partial network, defined variously as an "ego-centered" network (Kapferer 1969), a "personal" network (Mitchell 1974), a "first-order zone" (Barnes 1972), or a

"set" (Mayer 1966), is the kind of social construct with which I am concerned.

The choice of whose "ego" is being referred to in a description of an ego-centered network is in most cases arbitrary, as "the ego-centrality of the network formed by an informant and his direct contacts is usually an artifact of the investigation, even though it may be an illusion shared by the informant" (Barnes 1972: 4). There is, however, an anthropologically defined kind of network that seems to be truly ego-centered: the kindred.

The significance of kindred for the study of networks is that they provide us with a culturally recognized zone of which the individual on whom we focus our attention is truly the center, in reality and not merely as an artifact of the analysis. (Barnes 1972: 20)

The kindred, defined as a category of one's closely related kinsfolk who act together as a unit consistently or intermittently, and/or from whom one can recruit supporters for specific activities, has been identified in the literature (Fox 1969; Gulliver 1971; Lamphere 1970; Mayer 1960). While there has been some discussion in the past concerning the exact nature of kindreds (Lamphere 1970), J. A. Barnes argues that such differences can be easily resolved by regarding a kindred as "an ego-centered zone, with appropriately defined limits, in the partial network of kinship" (1972: 20).

The kindred is not a corporate group existing in perpetuity; when the ego figure dies, his or her kindred also eventually ceases to exist in that form. It is neither a residential unit nor a landholding group, either, although it may perform some of the functions of the latter. In some societies, for example, if a man dies without heirs, his land could revert to his kindred for redistribution among its members (Fox 1969). Similarly, when a Nubian householder dies, his or her house is said to belong "to the family," that is, to the kindred of the deceased, who decide among themselves who should live in it next (various informants, personal communication).

Using these criteria, I employ the term "kindred" to apply to the portion of Saadiya's network of relatives that consists primarily of her mother (until her death), her siblings along with their spouses and children, and the siblings of her mother along with some of their children. I wish to use Saadiya as the "ego" of this kindred group, because it was through her that I learned much of the information presented in this chapter. Since I lived in her house, I was able to observe her day-to-day dealings with her relatives, and she was my

chief informant concerning activities that occurred when I was not around.

Saadiya's Kindred

In 1982, Saadiya and I lived in old Hajja Fahima's house (see Map 5.1, no. 10), along with Rohiyya and her daughter, Samaa, and Saida's daughter Ahlam. The day-to-day interactions of the members of Saadiya's kindred were rarely dramatic. For most of the time that I lived with them, life went along placidly, with no major upsets and no big surprises. There appeared to be a pattern to their lives, a serene routine by which the relatives visited one another throughout the months. Abdul Hafuz visited his mother and the two sisters every day, and often twice a day. Mohammed Hassan, their older brother, also visited us daily. Nabawiyya and Saida, who lived farther away, would come to our house approximately once a week, as would their mother's brother, who visited every Friday. Saadiya would visit her mother's sister every ten to twelve days or so.

The relationship between a mother's sister and a sister's daughter has special significance for Nubian women. The sisters of Saadiya's family often sent their daughters to one another's homes when extra help was needed, and their actions were not unique. Several of my informants told me how they had lived with their mother's sisters for a period of time (sometimes years) in order to help out or to keep their aunts company. As mentioned above, one of Saida's daughters, Ahlam, lived with us in that capacity in both 1982 and 1986. At another time, Saadiya fell ill and was bedridden for about a week. Nabawiyya's oldest daughter stayed with us, cooking and cleaning until Saadiya recovered. She brought her two children along, and they were taken care of largely by Ahlam.

Help and visits of this nature, although low-key and informal, are important consolidators of the kindred unit. These actions indicate the strength of commitment that each family member wishes to convey to her or his kin group—a show of ongoing support and solidarity. These regular visits also assured the women who lived in this house that they were not being neglected by their kin group, encouraging feelings of security and continuance.

One of the qualities of kindred relations is the possibility that an individual will be placed in the position of having more potential dyadic ties than she or he wishes to make use of, leading to the necessity to pick and choose among them (Barnes 1972). Saadiya's kindred is composed overwhelmingly of her matrilateral relatives:

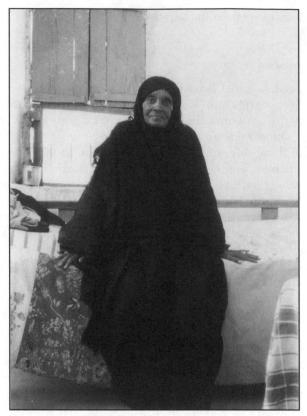

Older women are treated with affection and respect in West Aswan

mainly her mother's siblings. Although Saadiya's patrilateral relatives also live in Gubba, she socializes with them much less often. Propinquity is not an issue here: She lives closer to her patrikin than she does to much of her matrikin, but in 1982 went out of her way to interact with the latter, rather than the former. In 1986, we lived in Saadiya's new house, which was built next door to her husband's family, on her patrikin land; yet, except for her husband's brother and father, she did not speak to the inhabitants of that house. Eventually, Saadiya admitted to me that she purposefully distanced herself from that section of the family, because they had, through the years, committed several actions of disrespect toward Hegazi's father, and she did not want to be associated with them.

Another of the qualities of a kindred is the availability of a pool

of supporters for specific activities, such as ceremonial occasions (Fox 1969). Saadiya's kindred, along with a much wider network of friends and relatives (including her father's family), rallied most impressively when there was a death in the family. Callender and El Guindi, writing of Old Nubia, state that death rites entailed involvement by relatives to a greater extent than did other life-crisis rituals: "Unlike other events in the life-cycle, death required action by the entire tribe of the deceased, and many of its obligations were defined by lineage and tribal affiliation much more than by residence" (1971: 73). The death of the old Hajja during my stay in Gubba in 1982 enabled me to observe some of these familial obligations.

The Hajja apparently died of a stroke. She had been walking around a bit in the afternoon sun, and after she had lain down for a while, found that she could not get up again. Saadiya sent for the doctor, who checked her into the hospital. Relatives, having been notified by word of mouth, began to gather there that day. Family in Cairo were telephoned, and Fawzia, Rohiyya and Samaa, and Abdel Raouf's wife, Saida, with her two sons caught the train to Aswan immediately. The sisters, along with the Hajja's sister, ate and slept in the hospital by her side, as is possible to do in Egypt. The rest of us visited the hospital every day during visiting hours.

We were awakened early in the morning of the sixth day of her illness by a woman's loud screams, announcing the Hajja's death. The sisters, distraught and crying, were walking through the village from the river, wailing the unhappy news. As they passed by, village women, having paused only long enough to remove their gold jewelry, and dressed only in black, came out of their houses and gathered in our courtyard, screaming and crying unrestrainedly. Periodically, someone would clasp one of the Hajja's close relatives to her bosom and cry or scream words of commiseration into her or his ear. This action, called "giving azza," is a traditional, ritualized, and highly effective way of showing sympathy for the bereaved.

When the body was brought to the house, it was taken to the storeroom where it was laid out beneath a sheet. People, mostly women, poured into the room to pay their final respects, which consisted mainly of loud exhortations ("Mommy! Where have you gone?") and more sobbing. The only males who came into the room where the body lay were close family members: the Hajja's brother, her sons, and her sons-in-law. Callender and El Guindi (1971) report that when a man dies, most of those who enter the room are men, with only a few, closely related women present.

Outside, men were constructing a bier and sewing a shroud,

while inside, the body was being washed by two old women I had never seen before.

In every tribe a few middle-aged to elderly persons specialized in washing corpses as a charitable act. . . . From observations, these were members of the major lineage to which the deceased belonged, perhaps self-selected as fairly distant relatives whose grief did not preclude contact with the corpse. (Ibid.: 75)

These two women were later part of the group that visited the sisters every evening during the forty-day mourning period. The bier was basically an oblong box, across which three supple wooden rods had been bent and attached at the sides, forming arches at the head, foot, and middle of the box. Upon these arches, woven palm fronds had been tied. A quilt was placed inside the bier for the body to lie upon.

Elderly male relatives sewed the burial clothes from lengths of plain white cotton that the Hajja had kept in a suitcase for just this purpose. The burial garments consisted of a white gallebeya, white head scarf, and a shroud, and were handed to the women inside the room as soon as they were made. After the body was washed and perfumed, it was dressed and brought out to be placed in the bier. The members of the immediate family were not involved in either of these activities, perhaps because it was felt that the contact would have had unfortunate supernatural repercussions. In prerelocation Nubia, a woman was explicitly forbidden to enter the room where the corpse of her married daughter was being washed, for fear that she might use the body to effect sorcery upon the widower, preventing his remarriage or causing his impotence (Callender and El Guindi 1971).

We all stood as the body was brought out and placed in the bier. A cloth was thrown over the palm arches, and another cloth, green with white writing, was thrown over that. It was then carried away by several men to the cemetery, as Islamic custom dictates that the corpse be buried as soon as possible. The women, not allowed to accompany the procession, followed the men to the limits of Gubba neja, and then turned back. Burial rites have been described for Old Nubia by Callender and El Guindi (1971), who state that some tribal groups allowed women to go as far as the cemetery, but no farther.

Later that morning, the sisters began walking to and fro outside of the house and around the courtyard, stopping at all of the Hajja's favorite resting places, and crying out in beseeching tones. This highly moving ritual was led by an older woman, and several others joined the sisters in it.

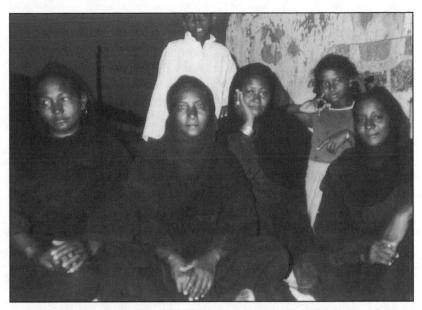

At the old Hajja's funeral: Saadiya, Nabawiyya, Mohammed (Saadiya's son), Fawzia, Samaa (Rohiyya's daughter), and Rohiyya

As mentioned earlier, it is absolutely obligatory for those who knew the deceased to visit the bereaved and convey condolences. Callender and El Guindi describe giving and receiving *azza* among men:

This activity began as soon as a death occurred . . . when people gathered at the house to give condolences to the family and other relatives. A man did this by shaking hands with a mourner, of either sex, while murmuring one of several conventional phrases. Closely related males again received condolences at the grave following the burial. They then moved to the village *khema* for formal *azza*, accompanied by all the men of their tribe and village. . . . Formal *azza* in the *khema* was received by the chief mourners, men who were marked for this role by their close relationship to the deceased or by membership in his major lineage. In this context, kinship could be defined either affinally or consanguineally. (Ibid.: 78)

In the past, men lived in the *khema* throughout the forty-day mourning period, but this practice had been curtailed by the 1960s. In Gubba, men used the *khema* for only three days. The females of the

family of the deceased remained at home. Unlike men, who delegated the responsibility of chief mourner to a senior lineage member, all closely related women shared this responsibility. Saadiya, her sisters, and their aunt each received azza from friends and distant relatives all day long for the next week. Sometimes the visitor would begin wailing while some distance away, reducing everyone to tears by the time she arrived in the courtyard. Others waited until they could grasp one of the sisters by the shoulders, and then chanted agonizingly to her. Some of these performances were better than others, but all of them were heartrending. Toward the end of the week, azza had become much more restrained, and by its end, visitors simply greeted the sisters quietly and solemnly.

For seven days following the death of a close relative, the bereaved must not do any housework. Thus, the hordes of women who lived in the house during that time were fed by the women of Gubba and Kutagele *nejas*. Each housewife contributed what she could; only unmarried women and newlywed brides were exempt. For the first three days of the mourning period, there were approximately thirty-five to forty women eating and sleeping there; food was brought to us several times each day. One woman—a neighbor of Nabawiyya's—was in charge of the kitchen during this time. She ladled out food, put it on trays, and made sure that everyone got something. After the third day, many of our visitors left, and approximately ten to fifteen women remained with us until the end of the week.

On the third day, the family cleaned house: washed the refrigerator and the dishes, cleaned the kitchen, and swept all the floors. In Old Nubia, when a male head of the household died, his widow was expected to remove all decorations from their bedroom and smash the plates and saucers that had been set into the front of the house and courtyard (Callender and El Guindi 1971). The actions of Saadiya and her sisters were perhaps analogous to those of widows in traditional times: a symbolic break with the past, expressed in terms of washing everything clean. On the other hand, they may have just wanted to set things to rights after all those people had left. In any event, they still did not do any cooking, nor did they take any further interest in the household until the seven-day mourning period had ended.

On the fifth day, several men came to pay their respects to the sisters. This was the first time that men had come to the house since the Hajja had died. The group, composed of relatives, included Mohammed Hassan, Abdul Hafuz (who stayed for dinner, as he used

to do), and a brother of FatHiyya. Abdul Hafuz had grown a beard as a sign of grief, but later shaved it off as, he explained, people told him that this was merely Nubian tradition and not orthodox Islam.

At week's end, all of the women who were still sleeping with us were family—affines as well as consanguines. Nabawiyya's neighbor had left. Two or three related women came to visit each day, but did not stay overnight. They were part of a group of five or six women who began visiting the sisters in the evening to *twannis*, just as Zuba and her friends did. By the eighth night, only the five sisters remained, with their sister-in-law FatHiyya to keep them company. All of their children slept with us as well.

The arbaeen for Hajja Fahima—a ceremony marking the end of the forty-day mourning period—was held thirty-six days after her death. As in most Nubian life-crisis rituals, the arbaeen does not necessarily fall on the exact day for which it is named. Instead, "it could be held at any time after the appearance of the first new moon following the death, but apparently had to take place before a year had passed. The intervals of time separating the arbaeens we attended from the deaths which they marked ranged from twenty-six days to almost one year" (ibid.: 84). Since the expenses of the food and the quranic readings that accompany the ceremony are borne by a small group of close relatives, unlike the costs of feeding the mourners that are shared by the whole community, a delayed arbaeen is evidently more common than an early one.

Approximately thirty women and twenty men attended. Saadiya had begun to cook again after the seven-day mourning period had ended, and the *arbaeen* feast had been prepared and was served by all of the sisters. Afterward, we drank tea as we listened to quranic readings and recitations. The men were silent and respectful, but several of the women talked with one another in low voices throughout, showing neither interest in nor respect for them. After it was over, most of the people left, but five or six of the closest female relatives stayed to *twannis* for two or three hours.

The *arbaeen* marked the end of certain restrictions under which the sisters had lived since their mother's death. They could now put on their gold jewelry again if they wished and wear their *tarhas* somewhat looser. They were no longer obliged to stick so closely to home and could now attend weddings and other celebrations.

Information Sharing

Cooperative networks of kin are also mobilized for happier occasions. As discussed previously, during *shebka* and *farraH* celebrations,

the families of both the bride and the groom are expected to indulge in lavish displays of gift-giving and feasting, indicating their satisfaction with the marriage and their good wishes for the future of the union. Kinship networks, like friendship groups, offer women both social and economic support, and also act as sources of information. Saadiya kept in touch with her sisters mainly through their children, who visited us daily in order to play with Saadiya's sons. In addition, whenever I went to visit either Nabawiyya or Saida, I carried messages back and forth between them. These messages could be as important as the news that Saadiya was going to have her baby daughter clitoridectomized and infibulated that day, or the less newsworthy information that Saida had had a headache the day before. Family members going to or returning from Cairo transmit information, as well as village-grown foods and store-bought articles, among the various branches of the family living there. It appeared to me that Saadiya's kindred was primarily her economic and social mainstay, whereas information came to her through a much wider network, which included, but was not limited to, her kindred.

Such networks—open-ended and consisting of links between males and females—convey information from various parts of the country as well as from the other *nejas* of West Aswan. Such information may be put to different uses in different circumstances. For instance, in the case of a youngster or a visiting anthropologist, actions that violate traditional Nubian practices may be observed and talked about, resulting in attempts to teach the transgressor the "Nubian way." Gossip passed through networks can also be used to control the actions of those who already know the correct way to behave, but may need to be reminded. Lastly, information for its own sake is frequently shared through such networks, just to relieve the tedium of village life and to increase the knowledge of community inhabitants.

As a newcomer in 1982, I was bombarded with questions concerning my reasons for coming to the village, my background, what the United States was like for Black people, and all manner of questions of an exceedingly personal nature. Sometimes I could overhear my answers being conveyed to others later on. As I became more integrated into village life, the questions began to center more on what I had learned from others whom I had visited that day. I was most keenly aware of the fact that information flowed through multiple channels in the village when that information was about me, since this kind of news almost invariably got back to me sooner or later. As

time went on, however, it became obvious to me that I had become a conduit in other people's information networks as well. I was always well aware of the fact that my actions were observed and talked about in the village: First of all, village life could sometimes be so slow that even the actions of longtime village residents were grist for the twannis mill; how much more exciting my foibles and mistakes must have seemed to them. Second, my friends and Nubian family would sometimes tease me about something I had done or said when I had been visiting somewhere else in the village, so I knew that it had gotten back to them through channels unknown to me. Third, I eventually learned that a stock response to questions or teasing about some secondhand knowledge was, "Who told you this?"—a question indicative of a general acceptance of a certain level of gossip among fellow villagers. My efforts to trace such networks by employing this question, unfortunately, only led to the counterquestion, "Didn't the people of Gubba see?" (anthropologists and crusading journalists are not the only ones who protect their sources). I'm sure that there must have been a proper retort to even this, but I never learned it.

Just as information about my actions in the village quickly became known to the women with whom I lived, my presence there was soon known to those who lived in other *nejas*, and even in other Nubian villages around Aswan. Nubian guides and boatmen would tell tourists that I was living among them; in 1986, *Il Rayyis* Mahmoud Morsy, through his own networks, heard about me three days after I had arrived in the village.

The use of gossip for the purpose of social control was freely admitted to me by Saadiya and her sisters, using *Il Rayyis* Mahmoud's network of village informants as their example. One evening, after having lived for several months at Saadiya's in Gubba, I asked Saida if it would be possible for me to move into her home for a while (in order to observe life in a *neja* farther removed from Aswan). She refused, saying that her neighbors would gossip that there was a foreigner living in the *neja*, a situation that they do not want. Saadiya nodded, saying, "Don't you remember when you first came here, how someone went to *Il Rayyis* about you?"

But gossip is not only about people; it communicates information about both tradition and change. It... not only transmits ideas, but also consolidates opinions about those ideas. "Gossip," says Harding (1975), "is a system for circulating real information, but that is never all that is circulated. Although overt criticism is rare, covert evaluation is constant." (March and Taqqu 1986: 24)

Not only can gossip be used to control behavior in a small community, it can also function to maintain traditional values; in West Aswan, information networks are used by both males and females, separately and together, to this end. One day, while I was eating in a restaurant in Aswan, I was approached by a man who told me that he was a Nubian, living in a nearby village. He asked why I was in Aswan, standard behavior toward visitors, and I, having no desire to become better acquainted with him, spoke guardedly. Later on, while walking back to Gubba, I was greeted by Saad Eddin, husband of our nextdoor neighbor Sabaha. Saad mentioned that he had seen me talking to this man. Not knowing whether or not Saad was a friend of the man, I didn't want to say anything that might give offense, yet I wanted him to be aware of my attitude toward the stranger. Finally I said, "If that man asks you whether I live here in Gubba, please tell him that I do not." Saad smiled at me and said, in a gently chiding tone, "I do know some things." A few days later, Saadiya told me that she had heard about my conversation with Saad and that the people of Gubba considered me to be their daughter. In traditional village societies in the Muslim world, unmarried women are felt to be under the protection of the whole community; village daughters are protected by everyone, but their actions are also scrutinized more closely than those of others (Altorki 1986). I had, unknowingly, presented the proper Nubian female attitude toward male strangers, and Saadiya reinforced the village's approval of my actions.

The points at which women's networks articulate with those of men and information is passed across gender lines is rarely dealt with in the literature concerning sex roles in Muslim societies. Here is an occasion during which this happened, my assumption being that the account of my behavior that Saadiya heard had started with Saad. Although I was unable to discover the exact pathways this information took, it seems to me that Saad had only a few options open to him: He could have mentioned our conversation to his wife, who then might have told Saadiya; he could have told the men in his own friendship group, who might have passed it on to their wives, who then might have informed Saadiya; or he could, of course, have spoken with Saadiya herself. Any combination of the above is possible, as well, although not probable. The sharing of information between men and women happens most often, I believe, in private one-onone conversations, which is why I suggest that the first alternative is the most likely (Saadiya and Saad are not closely related, so ideologically they should not have spoken together privately). However, since women and men do twannis together in a group sometimes, it

is possible that Saad could have recounted his tale for several people at once, Saadiya being one of them.

I also suggest that, while both men's and women's gossip can be used for the purposes of socialization and moral constraint, they are employed in different ways by them, as a result of the gender role dichotomy in society. Men, while pursuing their concerns in the public sphere, maintain an eye on the activities of villagers there. If one of them observes some act that might reflect negatively upon or become dangerous to the group as a whole, he would attempt to stop it, either personally and directly, or by ensuring that knowledge of what he had seen reached someone who was better able to do so. Women, on the other hand, receiving news of such an act through their networks, would admonish and instruct within the privacy of the home. I experienced both approaches; perhaps the villagers wanted to make sure that I, as a foreigner, knew the rules, or perhaps both approaches are used on all deviants.

While I had little opportunity to observe Nubian men's information networks, I do remember one occasion in which they helped me to learn proper behavior. I often spoke with Nabawiyya's husband, Abdel Razzik, a mature, established man of the community, about men's activities and attitudes. He was fond of instructing me in the Nubian way, especially those of older, more traditional times. Often, when visiting Nabawiyya and her family in the neja of Kutagele, I stayed there all day and walked home in the cool of the evening. As I did so, I would call out greetings to the various groups of villagers whom I passed as they sat around outside, talking together. One day, after I had done this a few times, Abdel Razzik turned to me and said. in a conversational tone of voice, "A Nubian woman, when she is walking down the road alone in the evening, does not speak to any man she may pass on the road. He acts as if she is not there, unless of course they are closely related, and she acts as if he is not there. This is the way we do things." He did not tell me, but I surmised, that information about my behavior had come to him through his networks, which were active and varied. Several of his friends were in the group of men who habitually sat in front of the khema in Kutagele and whom I had often greeted on my way back to Gubba; they probably mentioned my actions to him. My attempts to be courteous to the people whom I regarded, collectively, as my hosts, was seen as a violation of the norms of feminine behavior, and I was gently rebuked.

I undertook research in Nubia to test my expectation, discussed

in the Introduction, that Muslim women are active participants in vital decisionmaking areas of their societies through their associations. I argue that these associations, whether they be friendship groups, patron/client ties, or networks, are important in the articulation of the women's desires to the male sphere of their societies.

My knowledge of women's associations being put to this purpose is based upon the anthropological literature from West Africa. Although the literature provides examples of women's voluntary associations in many traditional African societies (Green 1964; Hoffer 1972; Lebeuf 1963; Leis 1974; Paulme 1963; Van Allen 1976), those that have received the most attention have been the ones that are structured, formal, and thus highly visible, such as the Sande society of the Mende, in Sierra Leone (Hoffer 1972). Many more informal, unstructured groups have remained essentially unknown to Europeans, however, unless the researcher was specifically looking for them (see, for instance, Van Allen [1976], on the *mikiri* of the Igbo and Ardener [1975], on groups in Cameroon).

I had hoped, in Nubia, to learn of the existence of women's groups that, while perhaps not as militant as those in West Africa, would at least be organized on a villagewide basis, as those were. However, I never saw the women of Gubba coming together in a group for any purpose that might be termed political, as West African groups do. Nubian women do act jointly during certain ceremonial occasions, such as a wedding or a death, during which time it is possible to observe ten to twenty women at a time bringing trays of food to a specific house. They also may act cooperatively for the common good, as they did one day when each woman around the *melaga* chipped in to hire a workman to repair the leaking central faucet. Thus I could see that the basic structure for a villagewide cooperative group was there; but, they did not, to my knowledge, ever step into the public sphere as a body, or claim to speak with one voice for all women in the political arena.

I had expected, also, to find women's groups organized around the zar ceremony, which was traditionally important in Nubia (El Guindi 1966; Kennedy 1967b), as well as in the rest of Egypt, Sudan, Ethiopia, Kenya, and the Arabian Peninsula (Barclay 1964; Boddy 1989; Lewis 1966; Trimingham 1965). The zar ceremony was, ostensibly, a means of dealing with the spirits that caused illness through possession. Although both sexes could be possessed by zar spirits, it was mainly a women's ailment. People so possessed were never cured, but were obliged to propitiate their particular spirit with periodic feasts, and to attend the zar ceremonies of others. Thus, every village

zar ceremony had as its core a group of women who had been possessed at some time in the past, and an officiating woman, the *sheika*, who directed the exorcisms. Spirits could be propitiated through gifts of jewelry, new clothing, expensive goods, liquor, and cigarettes.

Harold Barclay (1964) compares the *zar* cult as a woman's association to the Muslim men's religious brotherhoods. Although they differ in purpose and organization, they are functional equivalents in that they provide for similar emotional outlets and social interaction. Here, in the *zar* ceremony, is a chance for women to express their feelings of aggression and hostility toward the more dominant members of their society: men. One of their methods of doing this—to demand exotic foods, luxurious clothing, jewelry, perfume, and so on, from their husbands in the name of the spirit—has been well documented (Trimingham 1965; Kennedy 1967b; Barclay 1964). I. M. Lewis (1971) suggests that the *zar* cult, like the *bori* of the Muslim Hausa, could be used by women "to achieve . . . positions of independence and power" (1971: 97) by forming alliances in village politics.

I was disappointed to discover that there was apparently neither a zar cult nor zar ceremonies in Gubba. This may have to do with the fact that there had been, in the 1960s, a major overhaul of religious activities in a neighboring Nubian village, which resulted in several non-Islamic traditional practices being purged from Nubian ceremonies. Especially proscribed were those in which women had played prominent roles, such as zar ceremonies and death rituals (Fahim 1978). I am unsure of the extent to which West Aswan was affected by this purge, especially since it still maintains a Sufi sect (another activity rejected by the neighboring village as nonorthodox). An alternative explanation for the lack of the zar may be the existence of a modern hospital, the nearness of which may have made it difficult to sustain any major alternative health-care institution, such as the zar cult was.

The women's groups that I became aware of in Gubba were all like Zuba's: associations of close friends tied together through mutual-aid activities, information sharing, and regular visitation patterns. These groups remain, for the most part, within the women's domain and do not lobby as an entity in the "public" sphere in order to address some grievance or demand some change; in this, Nubian women's groups are more similar to those in most Islamic societies than they are to those in non-Muslim Africa. The literature provides some examples of the ways in which Muslim women in groups are able to affect matters in the "public" domain through the processes

of social and economic support, alliance, and information management in the "private" domain (Aswad 1974; Davis 1983; Makhlouf 1979; Wright 1981). As this chapter has shown, Nubian women's groups and networks do this also.

In sum, networks are vital conduits for information that flows between female and male spheres, information about what other members of the community are doing outside of the village as well as within its boundaries. Such intelligence heavily influences public opinion within the community and is thus used for purposes of social control. The women who make up informal associations are not merely sharing news, but are also using this knowledge to influence decisionmaking in the male, as well as the female, domain. Women's networks also bring them significant information about the character and behavior of other women and girls. This knowledge, gained through both observation and gossip, comprises important input when the male members of their families are considering marriage.

In addition, women's networks and groups in the village bring people together for traditional life-crisis ceremonies. Had it not been for the activities of Saadiya's network during the time of her mother's death, for instance, it would have been impossible for her (and the rest of her family) to observe the mourning duties basic to Nubian ceremonial life. Not only did these women cook for Saadiya's female kindred, who were staying in her house during that time, but they also took food to her male kindred, who were living in the *khema*. They continued to cook for these men (as well as for the men's friends) until the end of the seven-day mourning period, since the men's wives were prevented from doing so under the rules of the mourning customs.

The same is true of *shebka* and *farraH* prestations, as it is the women of the two families, along with the members of their kinship and friendship networks, who furnish the workforce that enables the prestations to be made. This ceremonial reciprocity, as an announcement of the union of two families, is a fundamental component of the marriage ritual, and the essential contribution of women to these occasions is universally recognized; without it, there can be no pretense of a wedding.

A 6

Culture Change and the Village

Nubian culture has been open to foreign influences for millennia, but Nubians have always been particularly adept at choosing only those aspects of foreign cultures that have appealed to them, while maintaining their own sense of Nubian-ness. Ancient Nubia had three major efflorescences, with several population shifts and concomitant adjustments in tradition in between, including an interval in which there appears to have been a nativistic movement (Adams 1977). The Nubian homeland was invaded variously by the armies of Rome, the Mamluk sultans of Egypt, Arab mercenaries, and later on, British imperialists. It has also been host to immigrants from the surrounding deserts, Coptic Christian missionaries from Egypt, and peaceful Arab merchants. Thus, Nubian history can also be seen as a chronicle of its people's continuing ability to maintain cultural integrity in the face of this almost continual influx of foreign cultures and religions. This ability to embrace and control change while maintaining core elements of one's traditional culture has been noted by other researchers who are interested in cultural transformation and syncretism (Boddy 1989; Fahim 1983; Knight 1985; O'Brien 1986; Martin 1973). Among the Nubians it is especially evident:

The Nubian experience also demonstrates the narrowness of our belief that rapid change and adaptability is the special province of technological societies. [The Nubian] took from the new situation only what he needed and wanted, and rejected the remaining elements in favor of his own values. (Fernea and Fernea 1991)

Some pre-Islamic elements of ancient Nubian culture have been identified in the literature. *Mushahra*, mentioned earlier, is a belief adhered to by people throughout Egypt and northern Sudan, but may have originally been uniquely Nubian (Callender and El Guindi

1971; Kennedy 1967a). Religious practices having to do with the propitiation of Nile spirits (El Guindi 1966) and the use of Nile water (Jennings 1991) have also been noted. Remnants of other pre-Islamic Nubian practices that are also pharaonic involve matrilineality, seen in the importance to the villagers of the mother's brother and indeed the mother's side of the family, and in the centrality of postmarital uxorilocality. I noticed the current use of ancient pharaonic names, such as Eunas and Ani. In evidence also were pharaonic hairstyles for women—hair plaited in numerous long tiny braids—and men often wear the *emma* in exactly the same way as ancient Egyptian males wore headcloths, as shown on statues and carvings. These are small but significant indicators of the persistence of ancestral traditions in contemporary village life and the interest Nubians have in maintaining them.

The building of the Aswan High Dam in 1964, resulting in the relocation of thousands of Nubians, also resulted in the first publications by cultural anthropologists about Nubian culture. We are fortunate to have this record of Nubian life as it was then, as we can document the transformations that have occurred since. My own interest in this topic among the people of Gubba stems from my awareness of the changes that had taken place between my first and second visits. Many were easy to observe, such as the differences in house styles, but others, such as changes in the Nubians' attitudes about their own culture, were revealed only in conversation or in chance remarks. It seems to me, however, that such attitudinal changes—questions being asked about what it means, after all, to be Nubian—are at the heart of the alterations that can be more easily observed. Some of these changes seemed to me to be a direct result of the increased tourism to the area; others seemed more difficult to explain.

▲ Tourism

Aswan has historical importance as ancient Egypt's major supplier of granite for the building of pharaonic temples and monuments, and as an important trade center linking Egypt with other parts of Africa. Ptolemaic temples abound here. Some nobles of the Middle Kingdom (ca. 1800–200 B.C.) built their tombs in the hills of the west bank, and Muslim viceroys, in the Fatimid period (A.D. 696–1171), left impressive mausoleums in the cemetery near the southern end of town. The monastery of St. Simeon (sixth century A.D.), in the Western Desert, is evidence of the Christian period in Aswan as well.

One of the Aga Khans (grandfather of the present one) was buried here, and his mausoleum sits on a hillside overlooking the Nile.

But for most of the twentieth century, Aswan reverted to the status of a small town. As the site of the Aswan Dam, it held some importance in the country, but it was not until the 1960s, with the building of the High Dam, that the town again came into national prominence. Then, Aswan was invaded by large numbers of foreigners, as well as by people from other parts of Egypt. In order to house the engineers and architects who worked on the construction of the dam, and the workers who moved to Aswan afterward in order to maintain it, new housing was constructed. A huge chemical fertilizer plant was also built, for future use when the High Dam would prevent the nutrient-laden silt from flooding the fields of Egypt (Adams 1977).

Visitors have been coming to the west bank of Aswan for more than a century in order to see the pharaonic tombs and the monastery of St. Simeon, and Nubians have been meeting tourists there in order to offer aid and advice, or just out of curiosity, for almost as long. It wasn't until the High Dam was built, however, that the tourist industry in Aswan began to bloom. Several new hotels have been constructed since the mid-1980s in order to accommodate the rapidly expanding tourist industry, and Aswan is the site of a new airport as well as the older railroad station. In 1986, there were thirty to forty tourist cruise ships sailing up and down the Nile between Luxor and Aswan, the largest of which carried two hundred people. In addition, visitors came to Aswan by airplane, train, tour bus, and hired car. They came to see the tombs, Abu Simbel, Philae, the High Dam, and the Nubian villages.

Throughout the year, but most heavily in the winter and spring, groups of tourists are brought to Gubba by felucca boatmen, in order to see the village, the houses, and the people. The leader of such groups always speaks first with the felucca rayyis—the man who owns the boat, or his representative—who then tells the boatman to which village and to which house to take the tourists. As discussed in Chapter 5, the rayyis sends the groups to the houses of his relatives, usually his sisters, who have agreed in advance to receive them. The women who live there serve the tour groups karkaday or tea with mint, and take them on tours of their large and spacious homes. Sometimes more substantial meals are cooked, if a tourist has contracted a felucca for the entire day, or if he is known to the rayyis from previous vacations, but this is rare. The women who make tea, meals, and conduct the tours hope for an ample tip from these tourists. In

addition, they hope to sell them the bags and caps they have crocheted, as well as ropes of beads they buy wholesale in Aswan for the tourist trade. They also receive a percentage of the fee that the group has paid the *rayyis*.

Several informants made distinctions between the boatmen who bring groups to the village almost daily and the ones who bring them only occasionally. Distinctions are also made between the groups that have an impersonal relationship with a boatman, and those that have a closer one, usually with the *rayyis*. The former kinds of groups are sent to homes of relatives who, like Zuba and FatHiyya, are in it for the money, whereas the latter may be brought to one's own home as guests. As Sabaha's husband, Saad Eddin, told me, "There are some tour guides who return year after year with groups or alone, and they ask for me; I usually do something special for them, like invite them to my home for a meal. When they are in my home, they are guests, and I treat them as such. I do not ask them for money, and my women do not attempt to sell them anything. I invite them to my own home because there I am sure that nobody will bother them."

The volume of tourist traffic differs from month to month; the high season, from December to April, brings an average of three groups per day into Gubba. In 1986, there was some political turmoil in the Middle East, which led directly to a decrease in tourism in Egypt. Nevertheless, some visitors still came, and during December, the heaviest month, I counted approximately 400 people visiting various houses in Gubba. On most afternoons during this time, one can see a tour group of ten to twenty people in the middle of the *melaga*, being besieged by women holding out their wares to sell and haggling over prices, and small children demanding candy and/or money.

The great increase in tourism to the Aswan area has brought some changes to the Nubians, not all of them good. The ambivalent feelings which the Nubians themselves have toward tourists and tourism were expressed to me one afternoon in a discussion I had with Zuba and Saadiya. Zuba stated that life for her had become much better since the groups began coming to Gubba: Now she could afford to buy medicines and special foods for her ailing mother and an occasional new dress for herself. Since Aswan has developed, she maintained, its market offers better food and more merchandise, and there are more opportunities for employment. Zuba's argument seemed to me to be based upon her increased feelings of personal security, stemming from her involvement with tour groups. She no longer felt so completely dependent upon her mother's small

monthly government check, or upon her brother's financial contributions.

Saadiya disagreed, however, saying that in the past, when everyone was poor, people were more neighborly, more willing to help one another. There was a genuine feeling, she argued, of togetherness. Nowadays, people are more possessive of their belongings, more acquisitive, more miserly. Saadiya did not, on the other hand, disdain the tourist money which she occasionally received, and she always hoped for more. It was she who finally expressed for me the nature of the ambivalence that many of her fellow villagers feel toward the tourist trade, as one day I was arguing against their practice of demanding baksheesh from the foreigners who walked through Gubba. "We ask for money," she said, "because many of them take our pictures and pictures of our houses. Then, when they go home, some of them may sell those photos to magazines. They make money from us; why shouldn't we make money from them?" I couldn't argue with her reasoning, as I had seen, in Cairo and in Europe, postcards and notepapers decorated with photos of the distinctive Nubian houses.

Tourism is sometimes blamed for moral lapses and/or societal problems. Excessive drinking of alcoholic beverages is, for instance, attributed to outside influences. I was told that the men who live in the resettled villages of New Nubia, near Kom Ombo, drink less at wedding celebrations than do those who live close to Aswan, because the former have less contact with tourists. These men more often get jobs in the Gulf States, and so are more in tune with the strictures of Islam than are those who get jobs in Aswan. Men who work more closely with tourists are more influenced by them, and so become habituated to drinking beer and wine. Whether this is true or not, there are those who believe it to be so, and who therefore view tourism as a mixed blessing for Nubia.

Nubian village society is now in the midst of change in terms of the economic status of women vis-à-vis men, as a direct result of the tourist trade. Women still maintain their traditional importance as household workers, while men are the primary wage earners. Women are dependent upon the financial help that their husbands and/or brothers provide, and men need their wives and sisters to do the many various tasks peculiar to women in agricultural societies. It may be, however, that as men are able to make more and more money from tourism, the balanced and complementary nature of the contributions of the sexes is becoming skewed, or is being perceived as skewed. As a result, women are beginning to seek opportunities to

make more money as well. While the influx of cash in the hands of men has marginalized and impoverished women in many developing countries (Moghadam 1993), I believe that this will not happen in Nubia. The desire of women here to earn their own money points to an effort to maintain balance between the female and male spheres.

So far, there has been little speculation in the literature concerning the impact of culture change upon the status of Muslim village women; Susan Rogers, however, considers the changes that can occur when a domestic-centered community, characterized by complementarity between the sexual spheres, is impacted by modernization. Her model is mostly, but not exclusively, concerned with peasant societies in which the "myth of male dominance" is espoused, but in which there is, in reality, a balance between female and male powers. Such communities, usually villages, possess the following components:

- 1. Women are primarily associated with the domestic.
- 2. The society is domestic-oriented; that is, the domestic sphere is of central importance, and has important implications for life beyond the domestic.
- 3. To the extent that the distribution of jural and other formal rights belie the power of women, most ordinary and important interactions occur in the context of a face-to-face community, where informal relationships and forms of power are at least as significant a force in everyday life as formalized relationships and power.
- 4. Men have greater access to jural and other formal rights.
- 5. Men are occupied with activities which may at least be overtly considered important.
 - These five elements together give male dominance a mythical nature, and felt lack of power on the part of men, often another element in the model, enhances both the relatively powerful position of women and the mythical nature of male dominance.
- 6. Men and women are approximately equally dependent upon each other economically, socially, politically, or in other important ways [and] . . . because the two sex groups are mutually interdependent, neither can be more autonomous than the other. (1975: 730)

Rogers hypothesizes about two of the many possible changes in the relationship between the sexes as a result of outside influences. The first concerns what might happen if the first three components remain unchanged while either of the next two are negated: "Men will become relatively more dependent upon women, women's power will increase, and the 'myth of male dominance' will no longer be expressed" (ibid.: 749). She gives, as an example of this, the history of newly industrialized Europe, where men left their families to seek work elsewhere, and women, left in control of the home, became the family's primary contact with the community and even may have taken over villagewide community activities.

She therefore usurps such formerly male prerogatives as overt household decision-making. . . . Despite the fact that women no longer contribute significantly to the family income, this decision-making power may include control over financial matters. In at least several areas of Europe where women traditionally handled the family budget, they continued to do so during the early stages of modernization through control of the spending of their husbands' paychecks. . . . The "myth of male dominance" is thus abandoned, both in the household and in the community, and women are overtly in actual control. (Ibid.: 750)

Conversely, if the second and third components are negated while the others remain unchanged, women will become more dependent upon men, lose some of their power, and male dominance become a reality. When the locus of social identity shifts outside of the family and community to the workplace (resulting from either a move away from the village to an urban area, or the transformation of an inner-centered peasant community to an outer-centered bedroom community), the man's extradomestic activities become perceived as most important, and women's socioeconomic roles are seen as limited in comparison. Women's informal power, so important in the traditional setting, becomes less effective in the larger, modern world, and their commitment to the domestic domain limits them both physically and socially (ibid.: 751).

When this model is applied to Nubia, it can be seen that Nubian society, in the traditional village setting at least, possesses all of these components. Villagers still consider female and male spheres to be of roughly equal importance: While women are dependent upon men for money, men are equally dependent upon women for the maintenance of the home and family. Nevertheless, wage work for males in the form of increased tourism to the area, employment in the fertilizer factory and other areas in Aswan, and migrant labor to Saudi Arabia is bringing more money into the village. Since this increased

wealth is mainly available to men, and to women only through men, the question for future research is whether this state of affairs will lead to the devaluation of the women's domain, as Rogers's model suggests.

An example of such a thing happening in a Muslim society has been observed in the recent history of Morocco. There, in many formerly domestic-centered villages, changes wrought by colonialism and the introduction of capitalism made access to male domain activities of superior value to the villagers:

Women tend to have only mediated access to the market economy, which, together with its companion, secular education, has considerably modified their social environment in such a way as to place at a severe disadvantage those groups that are unable to operate its terms to their own benefit. (Maher 1978: 54)

Mernissi (1987) argues that the extent of women's marginalization will depend upon the degree to which they were previously dependent upon men. Nubian women already have a tradition of earning their own money independently of men (as far as that was possible in a traditional society), but are now dependent upon male relatives for access to the tourist trade. The women of Gubba do not approach tourists in the marketplace in Aswan, but only in the village, where tourists are brought to them by their relatives. Only the future can tell whether or not this dependence will become a problem. I believe that Rogers's assertion that men's work must be perceived as more important than women's work for marginalization to occur is valid in this context. As long as the women's domain is perceived as valuable, women's contributions to their families' welfare will be considered valuable. When the female sphere is devalued, however, so will their work be, no matter how hard they work or how economically independent they may be. There are other African societies, some Muslim, some not, in which women have had a long tradition of moneymaking, yet must defer to their husbands' decisionmaking authority in their own homes (Callaway and Creevey 1994; MacGaffey 1988; Sudarkasa 1973). Sondra Hale (1986), on the other hand, reports that market women in Omdurman, Sudan, have been able to extend the economic autonomy that they have achieved in the marketplace into the female domain. As mentioned earlier, the desire of Nubian women to earn money from tourism may be an attempt to maintain the perception of high value in the face of social and economic changes.

Among the transhumant, cattle-keeping Baggara of central Sudan, women have begun to expand their traditional milking activities into the right to sell milk and butter in women's markets and to government cheese-making plants (Michael 1987). Through the money which they make at this, they may supply 35-40 percent of the total household budget during the rainy season. They can often influence camp movements, since the necessity to remain near outlets for their products is many times a prime consideration. Women are also beginning to make decisions concerning herd management, formerly a male occupation, as they have become interested in maintaining cattle more for their milk-producing capacities than for their beef, as the men are. Here is a situation in which Muslim women, while working from within their traditional gender-identified area, have nevertheless been able to enter the market economy, achieve decisionmaking power that affects the whole group, and yet remain independent from the male sphere. They have been able to do this perhaps because women's occupations still command respect among the Baggara. Men support women's remunerative efforts, because they not only enable the family to buy more and better foodstuffs, but they also lessen men's economic burdens.

As for the Nubian village, the act of bringing strangers into the so-called private sphere of the home may seem a surprising departure from the commonly understood public/private dichotomy, but hospitality to strangers is a tradition that Nubians value highly. What is new is that women are now charging money for home-based domestic activities and, in this way, adjusting the definition of their private sphere duties. I believe that in the future, they will begin to redefine their gender role expectations to include these new kinds of moneymaking occupations, much as the Baggara women are doing. This is happening in other areas of the Muslim world as well, where women's activities that take them into the male domain are rationalized as an extension of their domestic duties (Smock and Youssef 1977). It may be this rationalization that enables their male relatives to support their actions. Another question for future research is whether or not such new occupations, if seen as "women's work," will become yet another chore that a woman must perform, rather than something of benefit to her.

At the present time, Nubian village women's tourist trade activities do benefit the women who engage in them. Women's sphere activities are still seen as important to the whole society. Their earnings generally go toward food, children's clothing, and schoolbooks, and while the women of Gubba assert that they work with tourists in

order to buy the things they need, I believe that one of the less recognized results of the use of the money they make is the reaffirmation of gender parity in Nubian village life. The custom of "building the house" by Nubian women reaffirms the importance of their domain. Although most of the money that goes toward the house comes from the husband, it is the wife who takes full responsibility for its construction, and it is she who is congratulated when the house is finished. Beautiful, imposing, and "built" by the wife, the Nubian house is a symbolic statement of the contributions of women to the village; it demands that the inhabitants of the women's domain be acknowledged as valuable.

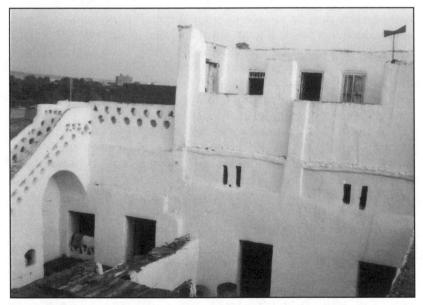

Nubian village house, "built" by the woman of the family over a period of four years

The involvement of village women with tourism is a prime example of women's informal economy activity. The "informal economy" can be defined as a variety of occupations in which people work for goods instead of money, or for money that is not reported to the government and so remains unrecorded in official figures and left out of official reports. It has been used in the literature synonymously and

interchangeably with the term "informal sector," which in turn has been defined as "those activities which are not officially notified through registration and taxation procedures, and which range from small-scale businesses to sporadic individual and sometime illegal activities" (Hopkins 1991: 1). Formal sector activities, on the other hand, "take place within a visible institutional hierarchy or structure of some kind (a ministry, a firm, etc.) which are licensed, and which (if appropriate) may keep accounts" (ibid.). Data concerning women's remunerative occupations in the Muslim world are seriously lacking, not only because Muslim males have so often denied that their female relatives and wives work outside of the home, but also because so many women earn their money in the informal sector. Researchers who are interested in women's work have begun to investigate female income-generating activities in the Muslim world (Boserup 1970; Feldman 1991; Lobban in press; Nelson 1981; Singh and Kelles-Viitanen 1987; Young 1988), and more investigation into the entry of village women into the tourist market would be welcome. However, since one of the major benefits of informal sector activities is that money earned remains unreported, it is doubtful that great numbers of women would be willing to discuss this topic. While the women whom I knew and saw every day were open about the amounts of money they earned, women who hardly knew me were not so forthcoming; deeper or wider investigation by anthropologists, economists, and so forth, might be seen as spying for the government.

Nubian women's activities in the tourist trade raise yet more questions for future research. If women can continue to earn remuneration for what is essentially their domestic labor, will that increase the importance of the female domain? Will those women have even more domestic decisionmaking power? Would the government be willing to assist village women's craft production through development projects? While it has been generally agreed that development schemes have rarely helped women in the past (Boserup 1970; Callaway and Creevey 1994; Davis 1992; Ogundipe-Leslie 1993), there is hope that if women were able to participate more fully in development planning, this might change (Salem-Murdock 1990; Simms 1981). If so, would this mean that Muslim women's informal sector occupations could be acknowledged and supported by the government, and if so, how would this affect gender complementarity? As the Nubians acquire more Western goods and display them proudly in their homes, will they appear to become less "authentic" to tourists? How long, indeed, will tourism continue to provide

income for the Nubians, as political turmoil within Egypt takes its toll?

▲ Attitudinal Changes

Changes in attitudes about one's own culture and ways of living usually precede any voluntary change one might make in those areas. One must become aware that one's own assumptions are not shared by others, and that one's customs may seem odd to others, before one begins to consider modifying them. The impulse to make such changes and the mechanisms employed are topics of considerable interest to anthropologists. Together with this is the subject of minority groups within a society and their relationships with the dominant culture. How much of the dominant culture is absorbed and how much rejected? How much of this process is a conscious choice and how much forced upon them? The adjustment of Nubians, a racially as well as a culturally subordinate minority group in Egypt (in contrast to the Sudanese Nubians, who can be found in the highest reaches of Sudanese political, social, and economic life), can be looked at for clues to these questions.

Members of most subordinate minority groups feel a certain amount of ambivalence toward the majority culture, and Nubians are no different. The Nubians' interactions with their fellow Egyptians have left them touchy, and although they are willing to give Egyptians the benefit of the doubt, they are nevertheless anxious about the status of their own culture. Nubian/Egyptian history bears witness to the fact that Nubians have long been at the mercy of stronger forces outside of their homeland, neglected and exploited for centuries. In relationships with Egyptians, they were despised as slaves for a time and discriminated against socially. This state of affairs culminated in the final indignity of their being relocated without their knowledge or consent, to an inferior and threatening environment.

In some respects the status of Egyptian Nubia in the twentieth century could be compared with that of the "native reserves" of southern Africa: it was left as much as possible to its own devices, and was looked on by its colonial rulers chiefly as a reservoir for migrant labor. (Adams 1977: 652)

The government's avowed aim to assimilate the Nubians into Egyptian society as quickly as possible, as symbolized by this destruction of their homeland and the dispersal of their people, as well as by the official discouragement of the use of the Nubian language (school lessons at every level are taught in Arabic), is still seen as threatening to a people proud of its ancient and unique heritage.

Many Nubians, in response to all of this, have consciously held on to many of their traditions, speak Nubian as a matter of preference, and try to shield their families and village life from encroachment from the outside world. Others, feeling humiliated in a society in which to be Nubian is to be different, and to be teased for so being, try to erase the differences as much as they can. They allude to the fact that occasionally Nubians are ridiculed in Cairo as country bumpkins, and that old movies on T.V. sometimes show a character in blackface and typical Nubian garb as a figure of fun, as reason enough to try to adopt more Western ways. The large influx of tourists also has left Nubians concerned about how they appear to foreign eyes: Are their customs, their homes, their clothing pleasing or ridiculous? Is their way of life considered delightful or primitive to people from New York, Paris, or London? Some villagers approve of the style of the newer houses, for instance, because they resemble Western houses and are therefore less obviously Nubian. Informants say, "We want houses that look like the houses in California!" meaning by that, properly aligned, cement dwellings, with firm, straight walls and sharp corners. Some villagers prefer that their children speak Arabic at home as well as in school; I have heard people say that Arabic is a "good" language, while Nubian is a "bad" one, or that, in fact, Nubian really isn't a proper language at all, but merely a dialect. I believe, however, that these latter attitudes are relatively rare among the villagers; certainly almost all of the Nubians I met were pleased and very proud that I had chosen to learn about their customs. It was as if the fact that I, an American professora, had come all the way from my homeland to study their way of life confirmed their right to be proud of it.

Changing attitudes were easiest for me to observe in the younger members of the village. Teenagers and young adults were the ones who talked to me about such things most freely, because of, I think, a combination of their curiosity about the United States and their eagerness to show off their own knowledge of Western customs. They also sometimes appeared bored and restive. In the village, young people must endure the restrictions and obligations imposed upon them by older relatives, but are unable yet to reap the rewards that accrue to their seniors. Perhaps as yet unreconciled to the system to which their elders are trying to mold them, village youths seek alternate sources of self-esteem. Perhaps replete with the conservative daily round of village life, they are more open to exciting new developments.

New attitudes are learned from television and movies, from contact with non-Nubian Egyptians in Aswan and in Cairo, from foreigners. Many young men find excitement in dealing with the tourists who come to Aswan so regularly. One such person was Khaled, whom I met in 1981 when he was twelve or thirteen years old. He was a boatman even then, taking tourists to his home village for tea in his small, boy-sized felucca. Even then, he seemed unusually outgoing and persistent, making friends with tourists and establishing relationships with them that seemed to involve mutual respect and admiration, rather than financial remuneration alone. When I returned to Aswan in 1986, he told me that he had been taken to France for several weeks by one such couple. He, and several other youngsters of similar personality whom I met in Nubia, could speak passable English and (they said) French and German, as well as Arabic and their native Nubian. I saw them as a "new breed" of child-more sophisticated at a younger age than many of their elders, more knowledgeable about the world outside of Egypt than their contemporaries. I wondered who they would become, what kind of lives they would lead, and what views toward their own culture they would have when they grew up.

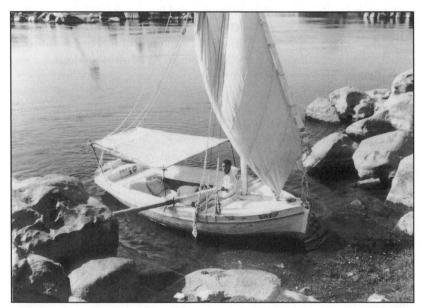

Khaled, young entrepreneur

A major attitude shift, and one that will become more apparent through time, is that toward the arrangement of marriages. As discussed in Chapter 3, more and more young people are insisting upon finding their own marriage partners, and many parents are acquiescing. This is more true of sons than it is of daughters, but even parents of girls are relaxing their stand on absolute obedience. They may have been shaken by a recent village scandal, in which a young woman, forced to marry a man she did not love, refused to cook, clean, or cohabit with him. Faced with such obdurateness, the groom withdrew, and her parents had to return the *mahr*, the wedding jewelry, and all the gifts. It was a loss of face that few others would willingly risk; far better to allow a daughter some say in the selection process. This is a significant change, considering the fact that, in the previous generation, young girls were expected to agree to their parents' choice, no matter what their personal desires might have been.

Another recent scandal involved a young man whose engagement to the daughter of one of my neighbors was arranged by his mother while he was away in Saudi Arabia. When he returned home, he did not visit her family at any time, a deliberate affront. Eventually we heard that he was furiously angry with his mother for her actions and was refusing to marry her choice for him, although she had already sent gifts of lingerie and perfume. Finally, deeply humiliated and embarrassed, the girl's family had to return everything. These changes in the attitude of Nubian youth are partially the result of foreign movies and T.V. shows, which portray young people marrying love objects, rather than strangers who have been chosen for them by others. In addition, however, young men who are making money abroad or in Cairo are more independent than were their predecessors, and so can demand more of a say in their own marriage plans.

In 1992, I returned to the village for a short visit and discovered two fortunate occurrences: Zuba had married, and Ahlam was engaged. Zuba's new husband, Mohammed, had known of her and her good reputation for some time, but he was already married. After his wife died, however, he approached Zuba's brother Hamid. Zuba was asked, but this was happening while Fatima Ismail was still alive and quite sick, and Zuba wanted to devote all of her energies to her mother. A year after Fatima died, however, Zuba agreed to marry Mohammed and has since borne a son, Islam.

Ahlam's engagement followed a less traditional path. Hosni saw her going to and from school on the ferry. He approached her older cousin Nadiya—the daughter of her mother's sister Nabawiyya. Nadiya consulted Ahlam first and got her consent before speaking with the older members of the family. Now, Hosni visits Ahlam frequently, and they sit and talk in a newly constructed, private area of the house that will be theirs when they are married. They have bought the household furnishings together as a couple, rather than the bridegroom acquiring it all himself, as was done in the past.

It pleased me to see that my friends' lives were changing in such a positive way: that while they were adapting to the new, they were yet maintaining some of the old, and that they appeared proud and happy to do so.

A more unsettling problem is the change in attitude toward the ownership of property. Nubian tradition stresses the common ownership of property—land, houses, crops, animals—by every member of the extended family, each person having rights in and obligations toward the whole. Recently in Gubba there were two bitter internecine quarrels over land, both of which arose from the members of a nuclear family seeking to appropriate what was considered to be undue amounts of land for their own private use. One of the quarrels involved Saadiya's older brother Mohammed Hassan and his wife, FatHiyya, who are building a large new house next door to Hajja Fahima's, where I lived with Saadiya and Rohiyya during my first field research trip. They wanted to tear down part of the old dwelling, but met with stiff resistance from Saadiya and her other siblings. Apart from the fact that the house had sentimental associations for them all, there were still some family members-Abdul Hafuz and his wife and children, Rohiyya and her daughter-living there. Over the months that followed, increasingly harsh words were exchanged, especially between Saadiya and FatHiyya (who, evidently, were never the best of friends), culminating in a shouting match in which ancient, rankling grievances were aired. The quarrel was finally resolved, with Mohammed Hassan incorporating only two rooms of his mother's dwelling, but resentment continues. There is strain between Mohammed Hassan and other members of the family, and none of the sisters speaks to FatHiyya; only recently have the children of these factions begun to play together again.

The other quarrel over family property, between Saadiya's husband's relatives, was similar: The head of the household wished to build an especially large and imposing dwelling on land that should have been shared equally with others. This fight, about which I heard only half-whispered rumors, was equally furious and equally estranging. It may be that these fights are the result of the intensification of nuclear-family desires over extended-family values. Times change, and traditional ways of living are changing with the times; more

money is being made than ever before, and perhaps individuals are becoming less inclined to share with the extended family what they believe rightfully belongs to their own children alone.

Nubian attitudes and behavior will continue to change as they are exposed to increasing amounts of input from abroad, as well as from other parts of Egypt. Will the distinctive Nubian culture finally disappear, as their language is said to be doing, or will it persist in altered form? The Nubians who were moved to New Nubia in the early 1960s have, in spite of dire predictions, done remarkably well in the face of massive change. Both women and men have adapted well to the challenges presented by their uprooting and relocation, and their culture shows no signs of disappearing. Educated Nubians have taken administrative jobs in the local government, and they are becoming increasingly important, economically and politically, in Upper Egypt: "Their cultural values have led to the Nubians' becoming a determining factor in the socioeconomic development of the area, filling the growing demand for special clerical skills and services, and playing a major part in the political and administrative roles in the governate of Aswan" (Fahim 1983: 105). It will be interesting to see if the Nubians living around Aswan deal as well with future economic and political challenges.

Attitudinal shifts are most successfully observed over a long time period; likewise, the changes that I predict will occur in the economic and social relationships between the women and men of Gubba would be best observed in a longitudinal study. I hope to be able to return to the village periodically over the years, not only to address these issues of cultural persistence, syncretism, change, and development among the Nubians, but to share their lives as "a relative who is visiting from abroad."

e de place par metro, que el como metros el como de persona el como de proposa de proposa de la como de persona el como del persona el como de per

And gards a work or party Phalis has required to the south as a gift has a company of the south as a gift has a company of the south as a gift has a company of the south as a

Glossary of Nubian and Arabic Words and Anthropological Terms

"Ahlan ya Ani! Rigray!

Er minabu?" "Hello Ani!" (Arabic); "Hello! How are

you?" (Nubian)

Ani My Nubian name—the villagers felt that my

American name was too short, too plain, and did not convey the proper amount

of affection

arbaeen (a.) Ceremony that marks the end of the forty-

day mourning period

'ariis (a.) Groom 'aruusa (a.) Bride

Aswali (a.) An inhabitant of Aswan

baladi (a.) Country

clitoridectomy An operation upon the female genitals,

whereby the clitoris is cut away

degir (n.) Traditional Nubian ceremony celebrating

a wife's move to her husband's home

emma (a.) Traditional male headcloth

evil eye Supernatural harm engendered by the jeal-

ousy of others

extended family Family based upon blood relations extend-

ing over three or more generations

farraH (a.) Wedding ceremony

felucca (n.) Traditional Nubian sailboat

fustan (a.)	Cotton dress
gallebeya (a.)	Traditional Egyptian male garment, which resembles a long, wide shirt
gallebeya sufra (a.)	Black overdress of the Nubian village
giving azza (n.)	Ritual of consolation, enacted for the bereaved by neighbors and friends
graffir (a.)	Traditional village peacekeepers
hassana (a.)	Donations to the poor or sick; good deeds
henna (a.)	An herb used for beautification in Muslim societies
hoha (n.)	Open-ended room
hosh (a.)	Wide, sandy-floored courtyard of traditional Nubian house
il rayyis (a.)	The boss, the leader
infibulation	An operation upon the female genitals: the clitoris and labia minora are cut away, then the patient's legs are tied together
	until the scar tissue has healed. This closes the genital opening completely, except for a small opening that is purposefully left for the emission of urine and, later on, menstrual blood
jam'iyya (a.)	Rotating credit association
jarjar (n.)	Sheer, black overdress worn by younger Nubian and Aswali women
karama (a.)	Ceremony of thanksgiving, in which food is shared with friends and neighbors
khema (a.)	Nubian men's meeting house
kindred	Closely related kinsfolk, who act together as a unit consistently or intermittently, and/or from whom one can recruit sup- porters for specific activities
kumikol (n.)	Second black overdress of the Nubian village woman
leylet-el-farraH (a.)	Wedding night

leylet-el-henna (a.)	Henna night; ceremony held the night before the wedding, during which the
	guests take home some henna for good luck
liHaff (a.)	Ceremony given by the groom, to show friends and neighbors the new furniture
	and bedding he has purchased for his conjugal home
	conjugar nome
mahr (a.)	Wedding gifts, usually money, but that may also be clothing or household furnish-
	ings, from the groom's family to the bride. The <i>mahr</i> is considered to be the bride's own property
mandil (a.)	Woman's head scarf
mastaba (a.)	Outdoor bench of clay or stone, built onto
	the side of a house
matrikin, matrilateral	Kinsfolk on the mother's side of the family
matrilineal	A principle of descent from an ancestress through her daughter, her daughter's daughter, etc., in the female line
melaga (a.)	Square in the center of a village or neja
milaya (a.)	Shawl
mosque	Muslim house of worship
moulid (a.)	Saint's birthday celebration
mu'addab (a.)	Behavior that is proper; socially appropriate
nakiba (a.)	Female custodian of a saint's shrine
neja (a.)	Hamlet, several of which comprise the vil-
	lage of West Aswan
networks	All or some of the social units (individuals
	or groups) with whom a particular indi-
	vidual or group is in contact.
	Unbounded social structures that ramify
	throughout a society in ever-widening fields
nokut (n.)	Gift, usually money, given to the bride and
(***/	groom during engagement and wedding
	ceremonies
nuclear family	Family unit consisting of parents and their dependent children
	177

voluntary associations

omda (n.)	Traditional Nubian village head
parallel cousin	Children of siblings of the same sex (for example, the children of sisters are parallel cousins)
patrikin patrilineal	A person's father's kinsfolk A principle of descent from an ancestor through his son, his son's son, etc., in the male line
qabila (a.) qubba (a.)	Major lineage of Nubian tribal organization Shrine built to a Muslim saint, to which pil- grimages may be made
Ramadan	The ninth month in the Muslim calendar, during which Muslims maintain a daily fast from dawn to dusk
sadaka (a.)	Donations to the poor or sick; good deeds
sahbi shedida (a.)	"My best friend" (female)
shebka (n.)	Engagement ceremony
sheik el balad (a.)	Traditional Upper Egyptian village leader
solidarity groups	Groups, the purpose of which is to inculcate in individuals a sense of togetherness as a result of participation in group activities
syncretism	A cultural synthesis growing out of the contact of two complexes of elements, or institutions, from different cultural traditions
tarha (n.)	Veil worn over head and shoulders by the Nubian woman
tariqa (a.)	Sufi religious brotherhood
tob (n.)	Traditional Sudanese woman's overgarment
twannis (a.)	Friendly, relaxed conversation, aimed at increasing positive feelings among participants as well as exchanging information.

Groups in which membership is a matter of choice rather than of obligation

xaalti (a.)	"My mother's sister"
yoom-iS-SubuuH (a.)	The third day after the <i>farraH</i> ; the last day and evening of celebration
zar (a.)	A ceremony, found throughout the Arabian Peninsula, as well as in Egypt, Ethiopia, Sudan, and Kenya, aimed at controlling possession by supernatural forces
zeer (a.)	Large, clay water jar
zeffir (a.)	Wedding procession of the groom and his companions, from his house to the bride's house
zikr (a.)	Religious ritual involving prayer, chanting, and rhythmical body movements. Engaged in by Sufic brotherhoods in order to communicate with God

A STATE OF THE STA

grander of the second of the s

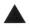

Bibliography

Abu-Lughod, Lila

1986 Veiled Sentiments: Honor and Poetry in a Bedouin Society. Berkeley, CA: University of California Press.

Abu-Zahra, Nadia

1974 "Material power, honor, friendship and the etiquette of visiting." Anthropological Quarterly 47 (1): 120–138.

Adams, William Y.

1977 Nubia: Corridor to Africa. Princeton, NJ: Princeton University Press.

Ahmed, Leila

1992 Women and Gender in Islam. New Haven, CT: Yale University Press.

Altorki, Soraya

1977 "Family organization and women's power in urban Saudi Arabia." *Journal of Anthropological Research* 33 (3): 277–287.

1986 Women in Saudi Arabia: Ideology and Behavior Among the Elite. New York: Columbia University Press.

Altorki, Soraya, and Camilla Fawzi El-Solh, eds.

1988 Arab Women in the Field: Studying Your Own Society. Syracuse, NY: Syracuse University Press.

Ammar, Hamid

1954 Growing Up in an Egyptian Village. London: Routledge and Kegan Paul.

Antoun, Richard

1968 "On the modesty of women in Arab Muslim villages: A study in the accommodation of traditions." *American Anthropologist* 70: 671–697.

Ardener, Edwin

1972 "Belief and the problem of women." In *The Interpretation of Ritual*, J. La Fontaine, ed., 135–158. London: Tavistock Publications.

Ardener, Shirley, ed.

1975 Perceiving Women. London: Malaby Press.

1981 Women and Space. New York: St. Martin's Press.

Arensberg, Conrad, and S. Kimball

1968 Family and Community in Ireland. Cambridge, MA: Harvard University Press.

Armstrong, James D.

"Life among friends: Interpersonal relations and social processes in Tel Aviv." Ph.D. diss., University of California, Riverside.

Asad, Talal

1970 The Kababish Arabs: Power, Authority, and Consent in a Nomadic Tribe. New York: Praeger.

Aswad, Barbara

1967 "Key and peripheral roles of noble women in a Middle Eastern plains village." *Anthropological Quarterly* 40 (3): 139–152.

1974 "Visiting patterns among women of the elite in a small Turkish village." *Anthropological Quarterly* 47 (1): 9–25.

Auerbach, Liesa

1980 "Women's status and power revisited: Suggestions for a dialectical model of gender roles." Forum for Middle East Research in Anthropology 4 (3): 16–18.

Banfield, Edward

1958 The Moral Basis of a Backward Society. Glencoe, IL: Free Press.

Barclay, Harold

1964 Burri al Lamab. Ithaca, NY: Cornell University Press.

Barnes, J. A.

1954 "Class and committees in a Norwegian island parish." *Human Relations* 7 (1): 39–58.

1972 Social Networks. Reading, MA: Addison-Wesley Module in Anthropology.

Barth, Fredrik

1961 Nomads of South Persia. Boston: Little, Brown and Company.

Beck, Lois

1978 "Women among the Qashqa'i nomadic pastoralists in Iran." In Women in the Muslim World, L. Beck and N. Keddie, eds., 351–373. Cambridge, MA: Harvard University Press.

Beck, Lois, and Nikkie Keddie, eds.

1978 Women in the Muslim World. Cambridge, MA: Harvard University Press.

Ben-Jochannan, Yosef

1989 Abu-Simbel to Gizeh: A Guide Book and Manual. Baltimore, MD: Black Classic Press.

Boddy, Janice

1982 "Womb as oasis: The symbolic context of pharaonic circumcision in rural northern Sudan." *American Ethnologist* 9 (4): 682–698.

1989 Wombs and Alien Spirits: Women, Men, and the Zar Cult in Northern Sudan. Madison: University of Wisconsin Press.

Boissevain, Jeremy

1968 "The place of non-groups in the social sciences." Man 3: (4) 542–556.

Boserup, Ester

1970 Women's Role in Economic Development. New York: St. Martin's Press. Bott, Elizabeth

1957 Family and Social Networks. New York: Macmillan.

Bottomore, T.

1962 Sociology: A Guide to Problems and Literature. London: Unwin University Press.

Bourdieu, Pierre

1966 "The sentiment of honor in Kabyle society." In Honor and Shame:

The Values of Mediterranean Society. J. Peristiany, ed., 193–241. London: University of Chicago Press.

1973 "The Berber house." In *Rules and Meanings*, M. Douglas, ed., 98–110. New York: Penguin.

Brown, Judith

1970 "Economic organization and the position of women among the Iroquois." *Ethnohistory* 17: 131–167.

Burckhardt, John L.

1822 Travels in Nubia. London: Murray.

Burton, Sir Richard F.

1964 A Personal Narrative of a Pilgrimage to Al-Madinah and Meccah, 1855. Reprint, New York: Dover Books.

Callaway, Barbara, and Lucy Creevey, eds.

1994 The Heritage of Islam: Women, Religion, and Politics in West Africa. Boulder, CO: Lynne Rienner.

Callender, Charles

1966 "The Mehennab: A Kenuz tribe." In *Contemporary Egyptian Nubia*, R. Fernea, ed., 260–287. Aswan, Egypt: Human Relations Area Files, Inc., New Haven, CT.

1983 "Gender relations in Kenuz public domains." Forum for Middle Eastern Research in Anthropology 7 (1): 7–9.

Callender, Charles, and Fadwa El Guindi

1971 Life-Crisis Rituals Among the Kenuz. Cleveland, OH: Case Western Reserve University Studies in Anthropology.

Chinoy, Ely

1961 Society: An Introduction to Sociology. New York: Random House.

Cole, Donald

1975 Nomads of the Nomads. Chicago: Aldine Publishing Company.

Coulson, N., and D. Hinchcliffe

1978 "Women and law reform in contemporary Islam." In Women in the Muslim World, L. Beck and N. Keddie, eds., 37–51. Cambridge, MA: Harvard University Press.

Crapanzano, Vincent

1972 "The Hamadsha." In *Scholars, Saints, and Sufis,* N. Keddie, ed., 327–348. Berkeley: University of California Press.

Cunnison, Ian

1966 The Baggara Arabs: Power and Lineage in a Sudanese Nomad Tribe. Fair Lawn, NY: Oxford University Press.

Davies, W. V., ed.

1991 Egypt and Africa: Nubia from Prehistory to Islam. London: British Museum Press.

Davis, Susan S.

1983 Patience and Power: Women's Lives in a Moroccan Village. Cambridge, MA: Schenkman.

"Impediments to empowerment: Moroccan women and the agencies." In Women and Development in the Middle East and North Africa.
 Jabbra and N. Jabbra, eds., 111–121, Leiden: Brill.

Deaver, Sherri

1980 "The contemporary Saudi woman." In *A World of Women*, E. Bourguinon, ed., 19–42. New York: Praeger.

Doughty, Charles

1953 Travels in Arabia Deserta. New York: Heritage Press.

Douglas, Mary

1970 Natural Symbols. New York: Random House.

Drake, St. Clair

1987 "Black folk here and there: An essay in history and anthropology."
In Afro-American Culture and Society, vol. 7. Los Angeles: Los Angeles Center for Afro-American Studies, University of California.

Dubisch, Jill

1971 "Dowry and domestic power of women in a Greek village." Unpublished paper.

Dwyer, Daisy

1978 Images and Self-Images. New York: Columbia University Press.

Early, Evelyn

1992 Baladi Women of Cairo: Playing with an Egg and a Stone. Boulder, CO: Lynne Rienner.

Eickelman, Dale

1984 The Middle East. Englewood Cliffs, NJ: Prentice-Hall.

El Dareer, Asma

1982 Woman, Why Do You Weep? London: Zed Books.

El Guindi, Fadwa

1966 "Ritual and the river in Dahmit." In *Contemporary Egyptian Nubia*, R. Fernea, ed., 239–256. Aswan, Egypt: Human Resource Area Files, Inc., New Haven, CT.

1981 "Veiling Infitah with Muslim ethic: Egypt's contemporary Islamic movement." *Social Problems* 28 (4): 465–487.

El Hamamsy, Laila

1970 "The changing role of the Egyptian woman." In *Readings in Arab Middle Eastern Societies and Cultures*, A. Lutfiyya, ed., 592–601. The Hague: Moulton.

El-Katsha, S.

1969 "The impact of environmental change on the marriage institution: The case of Kanuba settlers." Master's thesis, American University in Cairo.

El-Saadawi, Nawal

1980 The Hidden Face of Eve. Boston: Beacon Press.

El-Sawy, S.

1965 "The Nubian woman in Cairo: Patterns of adjustment; a case study of five families." Master's thesis, American University in Cairo.

Fahim, Hussein

1978 "The ritual of Salat al-Jum'a in Old Nubia and in Kanuba today." In *Nubian Ceremonial Life*, J. Kennedy, ed., 19–40. Berkeley: University of California Press.

1983 Egyptian Nubians: Resettlement and Years of Coping. Salt Lake City: University of Utah Press.

Fahim, Hussein, ed.

1982 Indigenous Anthropology in Non-Western Countries. Durham, NC: Carolina Academic Press. Fakhouri, Hani

1972 Kafr el-Elow: An Egyptian Village in Transition. New York: Holt, Rinehart, and Winston.

Farrag, Amina

1971 "Social control among the Mzabite of Beni-Isguen." Middle Eastern Studies 7 (3): 317–327.

Feldman, Susan

1991 "Still invisible: Women in the informal sector." In *The Women's and International Development Annual*, vol. 2, R. S. Gallin and A. Ferguson, eds., 59–86. Boulder, CO: Westview Press.

Fernea, Elizabeth

1969 Guests of the Sheik. New York: Doubleday.

1970 A View of the Nile. New York: Doubleday.

Fernea, Elizabeth, ed.

1985 Women and the Family in the Middle East: New Voices of Change. Austin: University of Texas Press.

Fernea, Elizabeth, and B. Bezirgan, eds.

1977 Middle Eastern Muslim Women Speak. Austin: University of Texas Press.

Fernea, Elizabeth and Robert Fernea, with Aleya Rouchdy

1991 Nubian Ethnographies. Prospect Heights, IL: Waveland Press.

Fernea, Robert, and G. Gerster

1973 Nubians in Egypt: Peaceful People. Austin: University of Texas Press.

Fernea, Robert, and J. Kennedy

1966 "Initial adaptations to resettlement: A new life for Egyptian Nubians." Current Anthropology 7 (3): 349–354.

Fluehr-Lobban, Carolyn

1984 "Recent developments in the Shari'a law of Egypt and the Sudan."

American Research Center in Egypt Newsletter. New York.

1987 Islamic Law and Society in the Sudan. London: Frank Cass and

Company.

1993 "Toward a theory of Arab-Muslim women as activists in secular and religious movements." *Arab Studies Quarterly* 15 (2): 87–106.

Forde, Darryl

1951 The Yoruba-Speaking Peoples of South-Western Nigeria. London: London International African Institute.

Foster, George

1965 "Peasant society and the image of Limited Good." American Anthropologist 67 (2): 293–315.

Fox, Robin

1969 Kinship and Marriage. New York: Penguin.

Friedl, Ernestine

1967 "The position of women: Appearance and reality." *Anthropological Quarterly* 40: 97–108.

Gallin, R. S., and A. Ferguson, eds.

1991 The Women's and International Development Annual, vol. 2. Boulder, CO: Westview Press.

Geertz, Hildred

1979 "The meanings of family ties." In Meaning and Order in Moroccan

Society, C. Geertz, H. Geertz, and L. Rosen, eds., 315–391. New York: Cambridge University Press.

Gluckman, Max

1963 "Gossip and scandal." Current Anthropology 4 (3): 307-315.

Green, Margaret

1964 Ibo Village Affairs. London: Frank Cass and Company.

Greenberg, Joseph

1963 The Languages of Africa. Bloomington: Indiana University Press. Gruenbaum, Ellen

1982 "The movement against clitoridectomy and infibulation in Sudan: Public health and the women's movement." *Medical Anthropology Newsletter* 13 (2): 4–12.

1988 "Reproductive ritual and social reproduction: Female circumcision and the subordination of women in Sudan." In *Economy and Class in Sudan*, Norman O'Neill, and J. O'Brien, eds., 308–325. London: Gower.

1991 "The Islamic movement, development, and health education: recent changes in the health of rural women in central Sudan." Social Science and Medicine 33(6): 637-645.

1994 "The risks of resisting female circumcision." Paper presented at the annual meeting of the Middle East Studies Association, Phoenix, AZ.

In press "The Sudanese are arguing this one out for themselves: The cultural debate over female circumcision." *Medical Anthropology Quarterly*.

Gulliver, P.

1971 Neighbors and Networks. Berkeley: University of California Press.

Hafkin, Nancy, and Edna Bay, eds.

1976 Women in Africa. Stanford, CA: Stanford University Press.

Hale, Sondra

1973 "Nubians in the urban milieu." Sudan Notes and Records 54: 57–65.

1986 "The wing of the patriarch." Middle East Report 16 (1): 25–30.

Hatem, Mervat

1987 "Class and patriarchy as competing paradigms for the study of Middle Eastern women." *Comparative Studies in Society and History* 29 (4): 811–818.

Hicks, Esther

1993 Infibulation: Female Mutilation in Islamic Northeastern Africa. New Brunswick, NJ: Transaction Publishers.

Hill, Polly

1969 "Hidden trade in Hausaland." Man 4 (3): 392-409.

Hoffer, Carol

1972 "Mende and Sherbro women in high office." Canadian Journal of African Studies 6 (2): 151–164.

Homans, George

1951 The Human Group. London: Routledge and Kegan Paul.

Hopkins, Nicholas

"Informal sector in Egypt." Cairo Papers in Social Science 14 (4): 1–7. (Published by the American University in Cairo Press.)

Horton, Alan

1964 "The Egyptian Nubians." American University Field Staff Reports Service. Northeast Africa Series, vol. 11, no. 2. United Arab Republic.

Horton, P.

1965 Sociology and the Health Sciences. New York: McGraw-Hill.

James, Stanlie M., and Abena P. A. Busia, eds.

Theorizing Black Feminisms: The Visionary Pragmatism of Black Women, 90–101. London: Routledge.

Jennings, Anne

1985 "Power and influence: Women's associations in an Egyptian Nubian village." Ph.D. diss., University of California, Riverside.

1991 "A Nubian *zikr*: An example of African/Islamic syncretism in southern Egypt." *Anthropos* 86: 545–551.

Joseph, Roger

1974 "Choice or force: A study in social manipulation." *Human Organization* 33 (4): 398–401.

1975 "Strategy, dialectics, and liminality in Berber marriage." Unpublished paper.

1976 "Sexual dialectics and strategy in Berber marriage." *Journal of Comparative Family Studies* 7: 471–481.

Joseph, Roger, and Terri Brint Joseph

1987 The Rose and the Thorn: Semiotic Structures in Morocco. Tucson, AZ: University of Arizona Press.

Joseph, Suad

1978 "Women and the neighborhood street in Borj Hammoud, Lebanon." In *Women in the Muslim World*, L. Beck and N. Keddie, eds., 541–557. Cambridge, MA: Harvard University Press.

Joseph, Terri Brint

1980 "Poetry as a strategy of power: The case of Riffian Berber women." Signs: Journal of Women in Culture and Society 5 (3): 418–434.

Kaberry, Phyllis

1952 Women of the Grassfields. London: Her Majesty's Stationery Office.

Kapferer, Bruce

1969 "Norms and the manipulation of relationships in a work context." In *Social Networks in Urban Situations*. J. C. Mitchell, ed., 181–244. Manchester: Manchester University Press.

Keddie, Nikkie, and Lois Beck

1978 Introduction to *Women in the Muslim World*, L. Beck and N. Keddie, eds., 1–34. Cambridge, MA: Harvard University Press.

Kennedy, John G.

1967a "Mushahra: A Nubian concept of supernatural danger and the theory of taboos." American Anthropologist 88 (4): 898–907.

1967b "Nubian zar ceremonies as psychotherapy." *Human Organization* 26 (4): 185–194.

1970 "Circumcision and excision in Egyptian Nubia." Man 5 (2): 175–191.

Khan, Mohammed Zafrulla

1981 The Qur'an. London: Curzon Press.

Knight, James

1985 "Gender and Twareg ideologies of production and reproduction." Paper presented at the annual meeting of American Anthropological Association, December.

Koentjaraningrat

1982 "Anthropology in developing countries." In *Indigenous Anthropology in Non-Western Countries*, H. Fahim, ed., 176–192. Durham, NC: Carolina Academic Press.

Lamphere, Louise

1970 "Ceremonial cooperation and networks: A reanalysis of the Navajo outfit." Man 5 (1): 39–59.

Lane, Edward

1836 Manners and Customs of the Modern Egyptians. London: East-West Publications.

Larson, Barbara

1983 "Tunisian kin-ties reconsidered." *American Ethnologist* 10 (3): 151–170.

Lebeuf, Annie

1963 "The role of women in the political organization of African societies." In *Women of Tropical Africa*, D. Paulme, ed., 93–119. Berkeley: University of California Press.

Leis, Nancy

"Women in groups: Ijaw women's associations." In Women, Culture, and Society, M. Rosaldo and L. Lamphere, eds., 223–242. Stanford, CA: Stanford University Press.

Leith-Ross, Sylvia

1965 African Women. New York: Praeger.

Lewis, I. M.

1966 Islam in Tropical Africa. Fair Lawn, NY: Oxford University Press.

1971 Ecstatic Religion. New York: Penguin.

Lienhardt, Peter

1972 "Some social aspects of the Trucial States." In *The Arabian Peninsula: Society and Politics*, D. Hopwood, ed., 219–230. London: Allen and Unwin Ltd.

Lindholm, Cherry, and Charles Lindholm

1980 "Life behind the veil." In *Science Digest* Special. Summer 1980: 42–107.

Lobban, Richard, ed.

In press Middle Eastern Women in the Informal Economy. Gainesville: University Press of Florida.

MacGaffey, Janet

1988 "Evading male control: Women in the second economy in Zaire." In Patriarchy and Class: African Women in the Home and the Workforce, S. Stichter and J. Parpart, eds., 161–176. Boulder, CO: Westview Press.

Macleod, Arlene

1991 Accommodating Protest: Working Women, the New Veiling, and Change in Cairo. New York: Columbia University Press.

Maher, Vanessa

1974 Women and Property in Morocco. New York: Cambridge University Press. 1978 "Women and social change in Morocco." In *Women in the Muslim World*, L. Beck and N. Keddie, eds., 100–123. Cambridge, MA: Harvard University Press.

Mair, Lucy

1965 An Introduction to Social Anthropology. Fair Lawn, NY: Oxford University Press.

Makhlouf, Carla

1979 Changing Veils: Women and Modernization in North Yemen. Austin: University of Texas Press.

March, Kathryn, and R. Taqqu

1986 Women's Informal Associations in Developing Countries. Boulder, CO: Westview Press.

Marshall, Gloria

1970 "In a world of women: field work in a Yoruba community." In Women in the Field: Anthropological Experiences. P. Golde, ed., 167–191. Chicago: Aldine Publishing Company.

Martin, LeAnn

1973 "Maroon identity: processes of persistence in Moore Town." Ph.D. diss., University of California, Riverside.

Matthiasson, Carolyn, ed.

1974 Many Sisters. New York: Free Press.

Mayer, A. C.

1960 Caste and Kinship in Central India. London: Routledge and Kegan Paul.

1966 "The significance of quasi-groups in the study of complex societies." In *The Social Anthropology of Complex Societies*, M. Banton, ed., 97–122. New York: Praeger.

Mernissi, Fatima

1987 Beyond the Veil: Male-Female Dynamics in a Modern Muslim Society. Bloomington: Indiana University Press.

Michael, Barbara

1987 "Milk production and sales by the Hawazma (Baggara) of Sudan: Implications for gender roles." *Research in Economic Anthropology* 9: 105–141.

Mitchell, J. Clyde,

1969 Social Networks in Urban Situations. Manchester: Manchester University Press.

1974 "Social Networks." In *Annual Review of Anthropology* (B. Siegel, A. Beals, and S. Tyler, eds.) 3: 279–299.

Moghadam, Valentine

1993 Modernizing Women: Gender and Social Change in the Middle East. Boulder, CO: Lynne Rienner.

Mohsen, Safia

1967 "Aspects of the legal status of women among the Awlad 'Ali." Anthropological Quarterly 40 (3): 220–233.

1974 "The Egyptian woman: Between modernity and tradition." In *Many Sisters*, C. Matthiasson, ed., 37–58. New York: Free Press.

Morsy, Soheir

1978 "Sex roles, power, and illness in an Egyptian village." American Ethnologist 5 (1): 137–150.

1988 "Fieldwork in my Egyptian homeland: Toward the demise of Anthropology's distinctive-other hegemonic tradition." In *Arab Women in the Field: Studying Your Own Society.* S. Altorki and C. El-Solh, eds., 69–90, NY: Syracuse University Press.

Mukhopadhyay, Carol, and Patricia Higgens

1988 "Anthropological studies of women's status revisited: 1977–1987." In *Annual Review of Anthropology*. B. Siegel, A. Beals, and S. Tyler, eds., 17: 461–495.

Nelson, Cynthia

1974 "Public and private politics: Women in the Middle Eastern world." *American Ethnologist* 1 (3): 551–563.

Nelson, Nici, ed.

1981 African Women in the Development Process. London: Frank Cass and Company.

O'Brien, Jay

1986 "Toward a reconstitution of ethnicity: Capitalist expansion and cultural dynamics in Sudan." *American Anthropologist* 88 (4): 898–907.

Ogundipe-Leslie, 'Molara

"African women, culture, and another development." In Theorizing Black Feminism: The Visionary Pragmatism of Black Women,
 S. M. James and A. P. A. Busia, eds., 90–101. London: Routledge.

Ortner, Sherry

1974 "Is female to male as nature is to culture?" In Women, Culture, and Society, M. Rosaldo and L. Lamphere, eds., 67–87. Stanford, CA: Stanford University Press.

Paulme, Denise, ed.

1963 Women of Tropical Africa. Berkeley: University of California Press.

Peristiany, Jean, ed.

1966 Honor and Shame: The Values of Mediterranean Society. London: University of Chicago Press.

Peters, Emrys

1965 "Aspects of the family among the Bedouin of Cyrenaica." In *Comparative Family Systems*, M. Nimkoff, ed., 121–146. Boston: Houghton Mifflin Company.

Pickthall, Mohammed Marmaduke

1953 The Meaning of the Glorious Koran. New York: New American Library.

Redfield, Robert

1967 The Little Community and Peasant Society and Culture. Chicago: University of Chicago Press.

Reisner, George A.

1910 The Archaeological Survey of Nubia, Report for 1907–1908, 2 vols. National Printing Department, Cairo.

Richards, Cara

1974 The Oneida People. Phoenix, AZ: Indian Tribal Series.

Riegelhaupt, Joyce

1967 "Saloio women: An analysis of informal and formal political and economic roles of Portuguese peasant women." *Anthropological Quarterly* 40 (3): 109–126.

Rogers, Susan

1975 "Female forms of power and the myth of male dominance: A model of female/male interaction in peasant society." *American Ethnologist* 2 (4): 727–756.

1978 "Women's place: A critical review of anthropological theory."

Studies in Society and History 20 (1): 123-162.

Rosaldo, Michelle

"Women, culture, and society: A theoretical overview." In Women, Culture, and Society, M. Rosaldo and L. Lamphere, eds., 17–42. Stanford, CA: Stanford University Press.

1980 "The use and abuse of anthropology: Reflections on feminism and cross-cultural understanding." Signs: Journal of Women in

Culture and Society 5 (3): 389-417.

Rosaldo, Michelle, and L. Lamphere, eds.

1974 Women, Culture, and Society. Stanford, CA: Stanford University Press.

Rosen, Lawrence

1970 "I divorce thee." Trans Action 7 (8): 34-37.

1978 "The negotiation of reality: Male-female relations in Sefrou, Morocco." In *Women in the Muslim World*, L. Beck and N. Keddie, eds., 561–584. Cambridge, MA: Harvard University Press.

Rosenfeld, Henry

1960 "On determinants of the status of Arab village women." Man 60 (95): 66–70.

Rugh, Andrea

1984 Family in Contemporary Egypt. Syracuse, NY: Syracuse University Press.

Sacks, Karen

1974 "Engels revisited: Women, the organization of production, and private property." In *Women, Culture, and Society, M. Rosaldo and L. Lamphere, eds., 207–222. Stanford, CA: Stanford University Press.*

Sahlins, Marshall

1972 Stone Age Economics. Chicago: Aldine Publishing Company.

Said. Edward

1978 Orientalism. New York: Random House.

Salem-Murdock, Muneera

1990 "Household production organization and differential access to resources in central Tunisia." In Anthropology and Development in North Africa and the Middle East, M. Salem-Murdock, M. M. Horowitz, and M. Sella, eds., 95–125. Boulder, CO: Westview Press.

Sanday, Peggy

1974 "Female status in the public domain." In Women, Culture, and Society, M. Rosaldo and L. Lamphere, eds., 189–206. Stanford, CA: Stanford University Press.

Saunders, Margaret

1980 "Women's role in a Muslim Hausa town." In A World of Women, E. Bourguinon, ed., 57–86. New York: Praeger.

Schildkrout, Enid

1982 "Dependence and autonomy: The economic activities of secluded

Hausa women in Kano, Nigeria." In Women and Work in Africa, E. Bay, ed., 55–81. Boulder, CO: Westview Press.

Schneider, Jane

1971 "Honor, shame, and access to resources in Mediterranean societies." *Ethnology* 10 (1): 1–24.

Shinnie, Peter

1967 Meroe: A Civilization of the Sudan. London: Thames and Hudson.

Shukairy, N.

1963 "A study of obligations on death occasions among a Nubian group from Besharan, Adendan, living in Cairo." Master's thesis, American University in Cairo.

Simms, Ruth

1981 "The African woman as entrepreneur: Problems and perspectives on their roles." In *The Black Woman Cross-Culturally*, F. Steady, ed., 141–168. Cambridge, MA: Schenkman.

Singh, Andrea, and A. Kelles-Viitanen, eds.

1987 Invisible Hands: Women in Home-Based Production. New Delhi: Sage Publications.

Smith, Mary F.

1954 Baba of Karo. London: Faber and Faber, Ltd.

Smock, Audrey, and Nadia Youssef

1977 "Egypt: From seclusion to limited participation." In Women: Roles and Status in Eight Countries, J. Giele and A. Smock, eds., 35–79. New York: Wiley.

Snowden, Frank

1983 Before Color Prejudice: The Ancient View of Blacks. Cambridge, MA: Harvard University Press.

Srinivas, M., and A. Beteille

1964 "Networks in Indian social structures." Man 64: (212): 165-168.

St. John, J. A.

1834 Egypt and Mohammed Ali: Or Travels in the Valley of the Nile. 2 vols. London: Longman.

Stack, Carol

1974 All Our Kin. New York: Harper and Row.

Steady, Filomina C.

1993 "Women and collective action: Female models in transition." In Theorizing Black Feminisms: The Visionary Pragmatism of Black Women, S. M. James and A. P. A. Busia, eds., 90–101. London: Routledge.

Steady, Filomina C., ed.

1981 The Black Woman Cross-Culturally. Cambridge, MA: Schenkman.

Stichter, Sharon, and J. Parpart, eds.

1988 Patriarchy and Class: African Women in the Home and the Workforce. Boulder, CO: Westview Press.

Sudarkasa, Niara

1973 Where Women Work: A Study of Yoruba Women in the Marketplace and in the Home. Ann Arbor: University of Michigan.

Sweet, Louise

1974 "In reality: Some Middle Eastern women." In *Many Sisters*, C. Matthiasson, ed., 379–397. New York: Free Press.

Tapper, Nancy

1978 "The woman's subsociety among the Shahsevan nomads of Iran." In Women in the Muslim World, L. Beck and N. Keddie, eds., 374–398. Cambridge, MA: Harvard University Press.

Toubia, Nahid

"The social and political implications of female circumcision: The case of Sudan." In *Women and the Family in the Middle East*, E. Fernea, ed., 148–159. Austin: University of Texas Press.

Trimingham, J. Spencer

1965 Islam in the Sudan. London: Frank Cass and Company.

UNESCO The Peopling of Ancient Egypt and the Deciphering of Meroitic Script.

Proceedings of symposium held in Cairo, January 28–February 3, 1974. Paris: UNESCO.

Van Allen, Judith

1972 ""Sitting on a man:' Colonialism and the lost political institutions of Igbo women." Canadian Journal of African Studies 6 (2): 165–181.

1976 "'Aba riots' or Igbo 'Women's War'? Ideology, stratification, and the invisibility of women." In *Women in Africa*, N. Hafkin and E. Bay, eds., 59–85, Stanford: Stanford University Press.

Vander Zanden, James

1970 Sociology: A Systematic Approach. 2d ed., New York: Ronald Press.

Vinogradov, Amal

1974 "French colonialism as reflected in the male/female interaction in Morocco." Transactions of New York Academy of Sciences 36: 192.

Wendorf, Fred

1968 The Prehistory of Nubia. Vols. 1 and 2. Dallas: Southern Methodist University Press.

Wendorf, F., and R. Schild

1984 "The emergence of food production in the Egyptian Sahara." In From Hunters to Farmers: The Causes of Food Production in Africa, J. D. Clark and S. Brandt, eds., 93–120. Berkeley: University of California Press.

Wolf, Margery

1972 Woman and the Family in Rural Taiwan. Stanford: Stanford University Press.

Wright, Susan

1981 "Place and face: Of women in Doshman Ziari, Iran." In Women and Space, S. Ardener, ed., 136–157. New York: St. Martin's Press.

Young, Kate, ed.

1988 Women and Economic Development. Berg/UNESCO Studies in Development Theory and Policy. Oxford: Berg Publishers Ltd.

Youssef, Nadia

1978 "The status and fertility patterns of Muslim women." In *Women in the Muslim World*, L. Beck and N. Keddie, eds., 69–99. Cambridge, MA: Harvard University Press.

Zeid, Abou

1966 "Honor and shame among the Bedouins of Egypt." In *Honor and Shame: The Values of Mediterranean Society,* J. Peristiany, ed., 245–259. London: University of Chicago Press.

Zuhur, Sherifa

1992 Revealing Reveiling. New York: State University of New York Press.

Index

Abdel Raouf (son of Hajja Fahima), 43, 46(fig) Abdel Razzik (husband of Nabawiyya), 43, 77, 129 Abd El Shaeffi (friend of Ahmed), 76(photo) Abdu (husband of Asia), 105 Abdul Hafuz (son of Hajja Fahima), 44, 46(fig), 77, 79(photo), 100(map), 107, 119, 124-125, 148 Abla (friend of Zuba), 100(map), 103, 104, 110 Adams, William Y., 21 Agriculture, 21, 22, 25, 27, 36; women in, 64, 72-73 Ahlam (daughter of Saida), 40, 42, 46(fig), 49(photo), 119, 147-148 Ahmed (husband of Rohiyya), 42 Ahmed (son of Nabawiyya), 75, 76 al-Buraq, 35 Alcohol abuse, 137 Amenemhet I (pharaoh), 23 Amr ibn el-As, General, 25 Animal husbandry, 21, 22, 27, 72 Arabs: depiction of, 11-12 Arbaeen, 43, 69, 125 Architecture, domestic. See Home; Housebuilding Ardener, Edwin, 9 'Ariis, 81-83; for farraH, 61, 62, 63, 84-86; and mother-in-law, 86; for shebka, 60, 61, 83-84. See also Marriage

Arts, 7. See also Music; Poetry

'Aruusa, 71 (photo), 84, 124; for farraH,

61-63, 84-85; gifts for, 60, 61, 82;

Asia (sister of Askara), 99, 100(map),

for shebka, 60-61. See also Marriage

104, 105 Askara (friend of Zuba), 99, 100(map), 102–103, 104, 105–107, 110, 113, Aswan/Aswalis, 29, 37-39, 134-135, 149. See also West Aswan Aswan High Dam, 28, 29, 35, 134, 135 Aswan Palace of Culture, 38-39 Azza, 68, 121, 123, 124 Baqt treaty, the, 26 Barclay, Harold, 131 Beja (pastoral group), 26 Beni Kanz, 26 Berber community, 7, 16 Bessima (daughter of Askara), 105, 106 Bishari, 29, 38 Boat transport, 79-80; supernatural protection of, 88. See also Feluccas; Tourist trade

Callender, Charles, 59, 60, 67, 90, 98, 121, 122, 123
Capitalism, 140
Ceramics, 21, 25
Charity, 90
Chastity, 3
Childbirth, 50, 51; with mother's family, 48, 68
Childlessness, 70, 93, 104
Children, 4, 92; daily activities, 53, 64, 65; supernatural protection, 88

Boddy, Janice, 51

Breadmaking, 38, 65

Bridegroom. See 'Ariis

Burckhardt, John L., 27

Bride. See 'Aruusa

Christianity, 24, 27

Dahmit, 60

Circumcision, female. See
Clitoridectomy
Clitoridectomy, 48–50, 51–53
Community participation, 88–89, 130.
See also Public sphere
Condolences, 68–69, 121, 123. See also
Death rites
Conflict, 15, 97, 104, 108, 148; arbitration, 113–114
Courtship, 58–59
Culture change. See Nubian culture

Danagla, 28
Date farming, 27; ownership, 72–73
Death rites, 68–69, 88, 121–125; mahr payment, 83
Degir, 67
Development projects: for women, 143
Divorce, 3, 4, 70–71, 83, 91–93; woman's right to, 92
Domestic-centered community, 10, 17, 138–139, 140. See also Private sphere Dongola, 25–26, 27; language, 28
Dowry, 4
Dress: author's, 40, 44; girls', 54–55; men's, 80; women's, 38, 40, 47–48, 49(photo)

49(photo) Economic activity. See Employment; Formal sector; Informal sector; Money earning; Women Education, 3, 4, 55, 78 Egypt, 144-145; pre-Islamic, 21, 22, 23, el Burghamiyya, 89 Elderly, 68, 108, 120(photo) El Guindi, Fadwa, 59, 60, 67, 90, 121, 122, 123 el Mirghaniyya, 89 El-Saadawi, Nawal, 50-51 Emma, 38, 134 Employment, 3, 27, 36, 79-81, 87; absentee, 64, 81. See also Money earning; Tourist trade Engagement, 59-61, 83, 147. See also Shebka Evil eye, 87-88 Executive Council (West Aswan), 31 Extended family, 64, 148-149. See also

Kindred/kinship network

Fahim, Hussein, 89 Family relations. See Kindred/kinship network FarraH, 56, 57, 59, 61-63, 84-85, 88 FatHiyya (wife of Mohammed Hassan), 43, 46(fig), 99, 107; relationships, 103, 104, 107-109, 110, 117, 125, 148; tourist trade, 107-108, 136 Fatima (host of author), 39 Fatima Ismail (mother of Zuba), 99, 100(map), 101-102, 109-110 Fawzia (daughter of Hajja Fahima), 43, 46(table), 123(photo) Feluccas, 29, 36, 44, 135. See also Boat transport Female circumcision. See Clitoridectomy Female hostility toward men, 131 Femaleness, 51-52 Ferdos (friend of Mona), 100(map), 110, 113 Fernea, Robert, 72 Fishing, 21, 22 Flirtation, 56, 57-58, 85, 102 Formal sector, 143 Friendship groups, 54, 66-68, 95, 96-99, 131-132; fluidity, 97, 112-113; infomation exchange, 113-115; social/economic support, 110, 111-113, 117. See also Zuba's Friendships, male, 79, 93-94, 96 Funerals. See Death rites Fustan, 47

Gallebeya, 38, 122
Gallebeya sufra, 47, 55
Gerster, G., 72
Giftgiving, 54, 60, 61, 63, 70, 83, 84. See also Jewelry
Gluckman, Max, 115
Gold, 22, 23, 24, 25. See also Jewelry
Gossip, 16, 56, 58, 114, 115, 126, 127–129. See also Information exchange; Social control
Government employment, 27, 36, 80, 87
Graffir, 32
Groups, defined, 96–97. See also

Friendship groups; Kindred/kinship network Gubba, 31, 32, 89, 100(map); founding of, 35–36, 37; tourist trade, 36, 134–137

Hairstyling, 60, 61–62, 134
Hajja Fahima (mother of Saadiya), 40,
41, 46(fig); death rites for, 121–122,
123(photo), 124–125
Hale, Sondra, 140
Hamada (son of Saida), 93(photo)

Hamdi (son of Saddiya), 40, 41(photo), 46(fig), 76(photo), 79(photo), 90, 93(photo)

Hamid (son of Fatima Ismail), 101, 102, 147

Hassan (son of FatHiyya, friend of Ahmed), 76(photo)

Hassana, 90

Hassanoon, Sheik (saint), 37, 52

Hausa, 16, 131

Hegazi (husband of Saadiya), 40, 41, 120

Hoha, 33

Homans, George, 96

Home, 32–33, 34(photos), 35, 142(photo); after marriage, 64,

67–68; paintings on, 33, 34(photo), 35. *See also* Housebuilding;

Uxorilocality onor, 3, 50, 114. See

Honor, 3, 50, 114. See also Reputation Honorary titles, 32

Hosh, 33, 51

Hosni (fiancé of Ahlam), 147-148

Hospitality, 16, 88; to author, 39, 40, 44, 98; to strangers, 32, 57, 141. See also Visiting patterns

Housebuilding, 64, 71–72, 86, 101, 102, 142. See also Home

Household furnishings, 61, 71, 82, 83–84, 148

Ibrahim, Sheik (saint), 37, 52 Illness, 102, 104 il Rayyis, 31, 44, 135 Infants: socialization of, 53; supernatural protection of, 88. See also Children Infibulation, 48–50, 51–53; and childbirth, 50, 51, 52 Informal sector, 18, 142–143 Information exchange, 15, 16, 111, 113–115, 125, 126; male/female, 7, 8–9, 10–11, 114, 126–127, 128–129, 132. See also Gossip; Social control

Inheritance, 2, 3, 4 Intermarriage, 26 Irrigation, 89

Islam. See Islamic law; Islamic society; Religious observance

Islam (son of Zuba), 147

Islamic law: on cultural practices, 2, 4, 49–50, 91, 92

Islamic society: anthropological study of, 1–18, 140, 141–142

Izzu Mohammed (friend of Ahmed),

76(photo)

Jam'iyyas (credit associations), 73, 82 Jarjar, 48, 49 (photo), 55 Jennings, Anne, 41 (photo); dress, 40, 44; enculturation, 77–78, 115, 128, 129; hospitality to, 29, 39, 40, 44, 98; information exchange about, 126–127; obtaining information on men, 14, 44–45, 75–77; relations with villagers, 12–18, 53, 106, 145; Zuba's group interviews, 109–111

Jewelry, 60, 61, 69–71, 82, 83; removal, 70–71, 121

Joseph, Roger, 9 Jural rights, 3, 138

Ka'ba, 35 Kamose, 23 "Kanuba," 89 Karama, 90 Karkaday, 135

Kashta (pharaoh), 24 Kemit/Kemites, 21, 22-24, 25

Kenuz, 19, 26, 28 Kerma, 22, 23

Khema, 89, 94, 96, 123

Kindred/kinship network, 3, 68, 95, 116, 117, 118, 119–121, 126; of Hajja Fahima, 46(fig); "loaning out" within, 40, 53–54, 68, 113, 119; sibling relations, 3, 88, 110, 117, 118, 119, 124 Kom Ombo, 19, 28, 30(map), 137 *Kumikol*, 47, 48, 55 Kush, 22, 23, 24, 25 Kutagele, 42, 43

Land, 33; family disputes, 148–149
"Land of the bow," 21, 22
Language, 8, 28, 144–145
Law. See Islamic law; Jural rights
Lewis, I. M., 131
Leylet-el-farraH, 84
Leylet-el-henna (henna night), 61, 84
LiHaff, 83–84
Lindholm, Cherry and Charles, 1–2
Lineage heads, 89, 98
Local Council (West Aswan), 31, 89

Mahasi language, 28
Mahdi (son of Fatima Ismail), 99
Mahr, 83, 92
Male dominance, 1, 138, 139
Male honor, 3, 50
Malki school (of Islamic interpretation), 27
Mandil, 48
Markets, 38–39; women's, 65, 79, 14

Markets, 38–39; women's, 65, 72, 141
Marriage, 2; arrangement, 3, 7, 16, 42,
44, 55–56, 59, 83, 101, 114, 147; contract, 92; domiciles following, 28, 64,
67; intermarriage, 26; obstacles to,
52. See also 'Ariis; 'Aruusa; FarraH;
Housebuilding; Information
exchange; Shebka; Uxorilocality
Mastaba, 33, 65, 96

Matrilineality, 28, 88, 119, 120, 134 Mecca, 35, 94; depiction of pilgrimage to, 34(photo), 35

Melaga, 35

Men: boyhood, 78; as breadwinner, 86–87, 137; decisionmaking, 1, 7, 17, 140; elderly, 86; family obligations of, 2, 3, 44, 86–88; friendships, 93–94; honor, 3, 50; and military service, 81; obtaining ethnographic information on, 75–77; respected qualities, 86–90, 91, 93–94; sexual behavior, 50–51, 58; in women's company, 56–57, 76, 128, 129; young adulthood, 56, 57–58, 78, 79, 145–146. See also 'Ariis; Kindred/kin-

ship network; Polygyny; Public sphere; Sexual segregation Menes (pre-pharaonic conqueror), 21 Mernissi, Fatima, 2, 140 Meroë, 22, 25; urbanism, 25 Migration. See Nubians Milaya, 48 Minority groups: effect of dominant culture, 144 Mohammed Orabi (friend of Ahmed), 75, 76, 82(photo) Mohammed (husband of Saida), 42 Mohammed (husband of Zuba), 147 Mohammed (son of Saadiya), 40, 41(photo), 46(fig), 123(photo) Mohammed Abid (cousin of Saadiya), 39-40 Mohammed Hassan (son of Hajja Fahima), 43, 46(fig), 77, 87(photo), 107, 119, 124, 148 Mohammed Orabi (friend of Ahmed), 76(photo) Molokhia, 36, 65 Mona (sister of Zuba), 99, 100(map), 104-105, 110 Money earning: tourist trade, 135, 136, 137, 141; women's, 3, 18, 72-73, 86-87, 140, 141. See also **Employment** Morocco, 6, 8, 16, 140 Morsy, Mahmoud, Il Rayyis, 31-32, 127 Mosque, 4, 38 Mourning, 68-69. See also Death rites Moustapha (son of Askara), 105 Mu'addab, 57 Mushahra, 53, 133 Music, 7, 13, 58

Nabawiyya (sister of Saadiya), 42–43, 46(fig), 90, 119, 123(photo) Nadi (husband of Askara), 105–106 Nadiya (daughter of Nabawiyya), 147 Nakiba, 37 Napata, 22, 24 Nebhapetre Mentuhotep II (third pharaoh of the Eleventh Dynasty), 23 Neighborhood squares, 35, 100(map)

Mutual aid. See Friendship groups;

Kindred/kinship network; jam'iyyas

Neja, 31
Nejm, Sheik (saint), 37, 52
Network: defined, 97, 117–118; of relatives, 95. See also Kindred/kinship network

New Nubia, 19, 137, 149

Nigeria, 16

Nile River, 19, 20(map), 21, 27, 30(map); religious practices, 52, 134

Nokut, 60, 63, 84

Nubia: Arab invasion of, 25–26; Muslim presence, 26–27; and Old/New Kingdom in Egypt, 22–25; prehistory, 19–22; present-day villages, 27, 29. *See also* Gubba; New Nubia; Nubian culture; Nubians

Nubian culture: change, 17–18, 133, 144–147; and Egypt, 17, 23–24, 134; matrilineality, 28, 88, 119, 120, 134; Old Nubian practices, 19, 60, 65, 67, 98, 121, 122, 124, 125; patrilineality, 3, 28, 120; pharaonic influences, 17, 23–24, 48, 134; pre-Islamic practices, 17, 50, 125, 134. See also Domestic-centered community; Nubia; Nubians

Nubians, 12, 13, 149; author's relations with, 12–18, 145; and development of Egyptian civilization, 17, 21–27; as minority, 144–145; relocation, 19, 28, 29, 31, 134, 137, 144, 149; Sudanese, 144. See also Tourist trade

Old Nubia. See Nubian culture Omar (first inhabitant of Gubba), 35 Omda, 32 Ortner, Sherry, 5

Paternalism, 2, 3, 4
Patrilineality, 3, 28, 120
Patron/client relations, 7, 16
Peasant societies, 10, 17. See also
Domestic-centered community
Peer group networks. See Friendship
groups
Pharaonic circumcision. See
Clitoridectomy

Pharaonic practices, 17, 23–24, 48, 134 Piankhi (Kashta's son), 24 Pilgrimages, 35. See also Mecca Poetry, 7, 58 Police forces, 32 Political participation, 5, 89; women, 130, 131 Polyandry, 3 Polygyny, 3, 41, 81, 90–91, 106, 117 Private sphere, 1, 4, 5, 10, 11; change in, 140, 141; as complementary to public sphere, 7–8, 11, 17, 18, 56, 137–141, 143; value of, 5, 9–11, 140, 141–142. See also Information exchange; Sexual segregation; Women

Property: women's, 4, 69–71, 72–73 Property ownership: common, 148 Public services, 32

Public sphere, 1, 4, 5, 11; as complementary to private sphere, 7–8, 11, 17, 18, 56, 137–141, 143. See also Information exchange; Men; Sexual segregation

Qabila, 89 Qubba, 37, 52 Quran: on cultural practices, 2, 3, 35, 49, 125

Rabi'a tribe, 26 Rali (friend of FatHiyya), 100(map), 104, 108, 110

Ramadán (husband of Mona), 99, 100(map), 104

Ratiba (daughter of Fatima Ismail), 99, 101, 102

Reisner, George A., 21

Religion: pre-Islamic, 25. See also Religious brotherhood; Religious observance

Religious brotherhood, 89, 131 Religious observance, 36–37, 52, 65, 89–90, 131, 134

Relocation. See Nubians

Reputation, 17, 114; man's, 3, 50, 78; woman's, 58, 59, 78, 114

Rogers, Susan, 9, 138–139

Rohiyya (sister of Saadiya), 29, 40, 42, 46(fig), 119, 123(photo), 148

Romantic friendships: development of, 56–60

Romantic love, 40, 58, 59, 147 Rosaldo, Michelle, 5

Saad (son of Nabawiyya; cousin of Hamdi), 93(photo)

Saad Eddin (husband of Sabaha), 128, 136

Saadiya (host of author), 29, 39–41, 46(fig), 52, 76, 90, 100(map), 103, 123(photo); family group of, 116, 117, 119–121, 125–129, 148; tourist trade, 137

Sabaha (friend of Saadiya), 66(photo), 100(map), 107, 110, 116

Sacks, Karen, 5

Sadaka, 90

Sahbi sheddida, 109

Saida (daughter of Hajja Fahima), 42, 46(fig), 90, 119, 127

Saidis, 29, 32, 38, 72

St. John, J. A., 27

Samaa (daughter of Rohiyya), 40, 42, 119, 123(photo)

Samira (wife of Abdul Hafuz), 44, 46(fig)

Sanday, Peggy, 5

Sande society (Mende) (Sierra Leone), 130

Saudi Arabia, 70, 82, 83

Seclusion, 6-7

Secret societies, 16

Selim (husband of Fatima Ismail), 101

Selwa (daughter of Nabawiyya), 90

Sexuality/sexual behavior, 2–3, 50–51, 58. See also Clitoridectomy; Infibulation; *Polygyny*

Sexual segregation, 7–8, 9–10, 14, 17, 32, 76, 129

Sharia, 92

Shebka, 59, 60-61, 83

Sheik el balad, 32

Sheriya, 63

Shrines, 37

Sibling relations. See Kindred/kinship network

Sihan (friend of Ahmed), 76(photo)

Slave raids, 27

Social control, 7, 15–17, 32, 58–59, 114, 127, 129. *See also* Gossip; Information exchange

Social networks, 11, 15–17, 63, 66–67, 68; girl's development of, 53–55. See also Friendship groups; Kindred/kinship network; Women's groups

Sommar (daughter of Saadiya), 41, 46(table)

Strangers, 32, 57

Sudan/Sudanese, 28, 38, 39, 140, 141

Sufi brotherhood, 89

Sunna circumcision. See Clitoridectomy Sunni Muslims, 27

Supernatural, 52–53, 87–88, 122, 130–131

Taharqa (pharaoh), 24 Tarha, 48, 49(photo), 54

Tariqa, 89-90

Ta-Seti, 21, 22

Taxis, 32

Thebes, 23

Tob, 38

Tourist trade, 17–18; in Gubba, 36, 65, 79–80, 107, 108, 134–137; and male/female interdependence, 137–138, 140

Trade, 25, 26

Transportation, 32. See also Boat transport

Twannis, 67, 96, 125, 129 Two Lands, 21, 23

Upper Egypt, 21, 26

Uxorilocality, 28, 41, 42, 64, 72, 86, 104, 134; and childbirth, 48, 68

Veiling, 6, 48, 54

Villages, 27, 29. See also Gubba

Visiting patterns: men's, 32, 44, 96, 119; women's, 7, 32–33, 64, 65, 96, 99, 117, 119. *See also* Friendship groups; Kindred/kinship network

Voluntary associations, 15, 16, 81, 130, 132. See also jam'iyya; mutual aid Voting rights, 4, 89

Wage earning, 3 Wall paintings, 33, 34(photo), 35 Water, 33, 35, 37 Wawat, 22 Weaving, 25 Weddings. See FarraH Wendorf, Fred, 21 West Aswan, 31-32, 89 Widowhood, 3, 68-69, 70 Women, 2-3, 7-8; daily activities, 4, 64-67, 73-74; decisionmaking, 1, 7, 17, 130, 139, 140; dress, 38, 40, 47-48, 49(photo); economic opportunities, 3, 18, 65, 72-73, 86-87, 135, 136, 137-138, 140, 141, 143; elderly, 68; girlhood, 53-55; hostility toward men, 131; in male company, 6, 7, 56-57, 76, 128, 129; male expectations of behavior, 5, 44-45, 58, 77-78, 114, 128-129; nomads, 6; respected ideal, 64-69; sexuality, 2, 3, 50, 58; unmarried, 9, 56, 70, 102, 115, 124, 128; young adulthood, 54, 56, 57-58, 145-146. See also 'Aruusa; Clitoridectomy; Friendship groups; Infibulation; Kindred/kinship network; Marriage; Private sphere; Sexual segregation; Women's groups

Women's groups, 68, 114, 130, 131–132.

See also Friendship groups;

Kindred/kinship network; Social networks

Wowa (friend of Zuba), 100(map), 103

Xaalti, 108

Yahya (brother-in-law of Saadiya), 115 Youth: attitude changes, 145-146. See also Men; Women

Zar ceremony, 130–131

Zeer, 33

Zeffir, 84

Zeinab, xaalti (friend of FatHiyya),
100(map), 108–109, 110

Zuba's group, 96–99, 100(map),
111–113, 116, 117; study of friendships in, 109–111. See also individual
members

Zuba (friend of author), 98, 99, 100(map), 115, 147; relationships, 102–104, 106, 108, 115; tourist trade, 102, 108, 136. See also Zuba's group the state of the s

About the Book

Nubia has long fascinated the outside world, conjuring up images of a romantic, ancient civilization. In this engaging ethnography of Nubian women in West Aswan, Anne Jennings journies past this idealized vision and captures the realities of everyday life in a devoutly Islamic society. In the process, she explores the concepts of gender, ethnicity, cultural persistence, and syncretism in a society undergoing dramatic change.

With the influx of an active tourist trade to southern Egypt—a flood of foreign people, foreign merchandise, and foreign ideas—Nubian women are not only gaining knowledge and expertise, but also contributing materially to their families. Contrary to the theory that women's domain becomes devalued when the traditional balance between female and male is upset by modernization, Jennings finds that these women have maintained their self-esteem, control, gender parity, and influence in village decisionmaking.

This is a clear, convincing, and richly detailed account that will easily appeal to students in anthropology, women's studies, and Islamic studies.

Anne M. Jennings is a consulting cultural anthropologist.

DATE DUE JAN UPI 261-2505 G

PRINTED IN U.S.A.